From
MaryPat
2014 Christmas
to Nann

Embroiderers of Ninhue

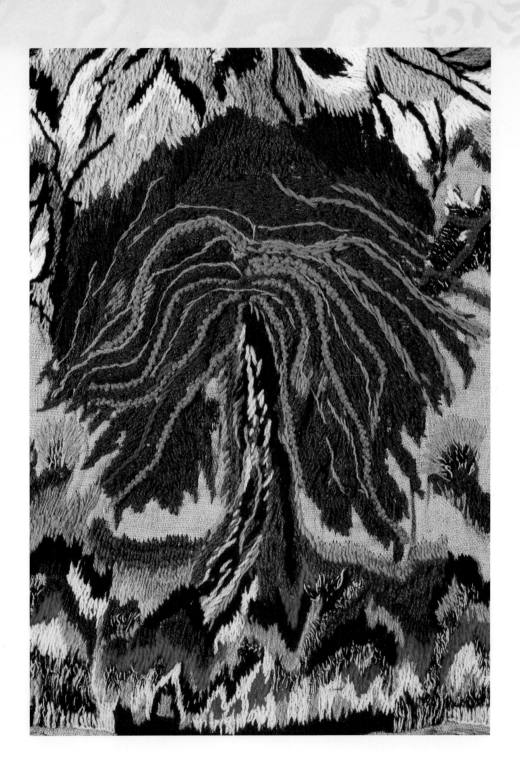

Embroiderers of Ninhue

Stitching Chilean Rural Life

CARMEN BENAVENTE

Foreword by Jean L. Druesedow

TEXAS TECH UNIVERSITY PRESS

This book is typeset in Bulmer and Dalliance. The paper used in this book meets the minimum requirements of ANSI/NISO Z39.48–1992 (R1997). ∞

Designed by Janis Owens, Books By Design, Inc.

Library of Congress Cataloging-in-Publication Data
Benavente, Carmen, 1921–
 Embroiderers of Ninhue : stitching Chilean rural life / Carment Benavente.
 p. cm.
 Includes bibliographical references and index.
 Summary: "The story of a group of embroiderers in Ninhue, Chile, from their 1971 inception. Wool embroidery—a nontraditional craft—was introduced by the author at a time of political upheaval to soothe local tensions and provide a means of income. Describes and analyzes the work of individual artisans; includes illustrations"—Provided by publisher.
 ISBN 978-0-89672-648-2 (hardcover : alk. paper)
 1. Embroidery—Chile—Ñuble—Miscellanea. 2. Needleworker's—Chile—Ñuble. 3. Ñuble (Chile)—Social life and customs. I. Title.
 TT769.C452.B46 2010
 746.44'042098338—dc22 2009022901

Printed in Korea

10 11 12 13 14 15 16 17 18 / 9 8 7 6 5 4 3 2 1

Texas Tech University Press
Box 41037 | Lubbock, Texas 79409-1037 USA | 800.832.4042
ttup@ttu.edu | www.ttup.ttu.edu

To the memory of
Eulalia and Juan
and for
Clara, Sergio, Francisco, and Federico

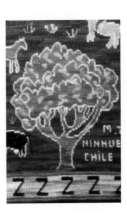

*Now faith is the substance of things hoped for, the evidence of
things not seen.*

HEBREWS 11:1

Contents

Illustrations

Foreword

The extraordinary pictorial embroideries produced by a small group of women in Ninhue, Chile, have been created by women living ordinary lives. These women bear full responsibilities as wives, mothers, and helpmates in a remote agrarian economy that yields only a modest living. Apart from working the occasional stamped commercial design in cotton floss on items of daily use such as baby bibs, pillow cases, and table linens, there was no "tradition" of embroidery in Ninhue. Crewel embroidery, done with lightly twisted two-ply worsted yarn in texture-rich stitches, was not known in the village before its introduction there by Carmen Benavente in 1971. So, unlike traditional cultures elsewhere in the world, the stitchery technique of the women of Ninhue was not passed down from previous generations. No established patterns and colors were already in use to embellish and imbue clothing and household linens with symbolic or ritualistic meaning. The art that the women of Ninhue now create comes from what they know and experience in their daily lives, but

they expand their reality with color, texture, and juxtapositions that spring from their imaginations. In many ways the embroideries represent how the women view their world and perhaps how they wish their world to be. Theirs is an art form rich in the expressive use of materials combined with an imagery unique to each woman. These wonderful embroideries have developed within the time span of a single generation.

Carmen Benavente's own introduction to the techniques of crewel embroidery came after she moved, in 1961, with her husband and five children from her native Chile to Bloomington, Indiana, where her husband had accepted a position on the music faculty at Indiana University. A revival of interest in crewel embroidery as a technique was given momentum with the publication of Erica Wilson's *Crewel Embroidery* in 1962. Wilson, born in Scotland in 1930, was a graduate of the Royal School of Needlework in London and was well versed in the style and techniques of the wool embroidery for which

England was especially well known in the seventeenth and eighteenth centuries. Her book includes detailed illustrations for sixty-four different stitches. Carmen was given a copy of Wilson's book in 1963, and as she experimented with the stitches, she became fascinated by the rich colors and textures possible when working with wool. She found herself immersed in learning the craft and passionate about her new skills. Two other books informed her study and later teaching: *The Principles of the Stitch* by Lilo Markrich, which enhanced her understanding that the aliveness and adaptability of stitches prevents a rigid or mechanical use, and *The Stitches of Creative Embroidery* by Jacqueline Enthoven, in which she found the rich multicultural heritage of stitches compiled with their origins, uses, and variations. She also found that learning the stitches stirred memories of her childhood in Santiago, where on outings to the park her nurse had embroidered as Carmen played. She remembered that she could tell where the nurse had sat the day before by the colorful snippets of cotton floss on the ground under the bench. These memories provided a means for her to stay emotionally connected to her homeland, and as she mastered the stitches, she began to wish she could share her pleasure and excitement by teaching embroidery to others, not least of all in Chile.

Carmen began to experiment with clothing designs using crewel stitches as applied deco-ration, and she created an amazing group of wearable pieces, such as long hostess skirts embroidered in abstract, geometric, or floral designs from waist to hem. In this work she was also influenced by childhood memories, this time from a book in the library at the family farm, Coroney, near the village of Ninhue. The book pictured regional costumes of the world, and the images of beautiful, brightly colored clothing had enchanted her. Again, these memories inspired her work and made a connection with a much-loved place now far away. It was not long before friends urged her to teach classes in crewel embroidery techniques, and her gifts as a creative and inspiring teacher soon came to the fore. Her classes and workshops attracted a group of devoted students, from widely diverse backgrounds, who ended up working together on individual and joint embroidery projects for more than twenty years.

In 1969, while visiting Chile, Carmen found an opportunity to do what she had long intended. A project sponsored by the government was underway to improve the lives of low-income women all over the country through the organization of Centros de Madres (Centers for Mothers). Carmen proposed to introduce wool embroidery in several locations and to encourage embroidery created and defined by the regional characteristics of each locale. Her intention was to wean the stitchers from commercial patterns so they

might create their own designs to be sold as regional artistic products. Several assumptions lay behind this proposal. Embroidery was an activity associated with women, thus was not threatening to husbands, and could be done in the home. Most women had some needle skills, and the stitches would not be difficult to learn. Finally, wool embroidery would cover more area faster than cotton floss and thus might naturally increase productivity and yield financial rewards for the women more quickly. Although the project was enthusiastically received in initial meetings, the political climate was not conducive. The government, uncertain about the outcome of the coming elections, did not want to initiate a project that might not be completed. Carmen found that she would have to wait for another opportunity.

In many ways, the late 1960s and early 1970s provided a surprisingly auspicious moment to bring together Carmen Benavente's gifts as a teacher, her interest in the traditional art of crewel embroidery, the political climate in Chile, and the needs of women in underdeveloped areas to improve their lives. The international market was eager for handcrafted products, and in the United States in particular, the designs and colors of regional traditional arts and crafts could be found influencing fashion and retail in general. Department stores did large promotions that were intended to introduce the American consumer to craft products from world markets.

Museum exhibitions and gallery shows expanded opportunities to see this kind of work and encouraged collectors. Wonderfully illustrated books and catalogues made craft techniques and materials accessible. Those interested in taking the time and in acquiring and learning to use the materials could practice any number of different crafts. The market for traditional arts and crafts blossomed, created by a desire in the general population to own something handmade from their own or another culture. An appreciation for the exuberant naiveté and authenticity of unschooled artistic expression grew.

In twentieth-century Chile, the first significant appearance of creative pictorial embroidery, designed and worked by stitchers to represent something important to them, occurred in 1969 in Isla Negra, a fishing village best known as the home of poet Pablo Neruda. A woman in the town, Leonor Sobrino, encouraged women weaving cloth in village workshops to use the leftover yarn to embroider scenes depicting their way of life. Using only a single type of stitch, they created work that Sobrino helped to promote and sell.

A few years later, in response to the atrocities perpetrated by the 1973 military coup that toppled the democratically elected presidency of Salvador Allende, a textile art known as the *arpilleras* appeared. To protest the outrageous violence of the military dictatorship of General Augusto Pinochet, a brave and inspired art

teacher, Valentina Bone, approached women who were suffering the death or disappearance of family members and encouraged them to express their personal tragedy visually by appliquéing pieces of cloth on burlap, *arpillera* in Spanish. These burlap appliqués were sold to bring much-needed income to the women in addition to helping them deal with their loss and sorrow through making these objects. The first arpilleras were dramatic and heartbreaking. Moreover, they were dangerous work for those involved. Through the Vicaría de la Solidaridad, the Catholic Church has kept them as records of those shameful times.

Between the development of the Isla Negra pictorial embroideries and the creation of the arpilleras, Carmen Benavente founded a stitchery enterprise in the village of Ninhue that would heal the wounds of political upheaval, strengthen the bonds of community,

celebrate the beauty of Chile, and yield a new source of income for the stitchers. Inspired by Carmen, who taught them *only* how to make the stitches of crewel embroidery, and who encouraged each individual to explore the possibilities of these stitches in her own way, the women developed a professional assurance in their work and have created scores of beautifully embroidered pieces. Their inventiveness and craftsmanship have developed in an atmosphere where they can conceive and realize their own work; determine their own parameters through individual choices of line, texture, and color; and receive encouragement from one another through strong friendships and working partnerships formed over the years. Their work stands today as one of the most distinctive of Chilean arts.

Jean L. Druesedow, Director
Kent State University Museum

Embroiderers of Ninhue

A Skein Is One Long Thread
An Introduction

Writing this book has been like embroidering a very large tapestry. It depicts many people—with their joys and sorrows, struggles, and triumphs—whose lives play interrelated roles against a vast common landscape that defines them. Here I have stitched together the present with the past, bringing each time frame to bear so that the women of Ninhue, their lives, and their embroidery, will emerge as clearly and true as the fine stitches that constitute their beautiful work.

I have lived in the United States for more than half my life, yet the sense that I am still living in Chile has not abandoned me. What contributes, in part, to these feelings of connectedness to my homeland is my involvement with the women of Ninhue, with whom I have maintained a close, warm association across the miles. They have become my colleagues—from whom I could certainly learn still more—but above all, they are my friends. This bond has deepened, strengthened, and actualized my knowledge of my native country. The art of the embroiderers of Ninhue has revealed to me what before I could only sense. Hence, thus equipped, it has been a delightful and rewarding job to introduce their work abroad, especially in the United States, to show the pieces' unpretentious beauty, simplicity, and charm, and to supplement each one with the details of its provenance.

The scope and diversity of the work of the embroiderers of Ninhue has naturally appealed to stitchers and textile professionals in general as well as to teachers, designers, and collectors, among them artists and

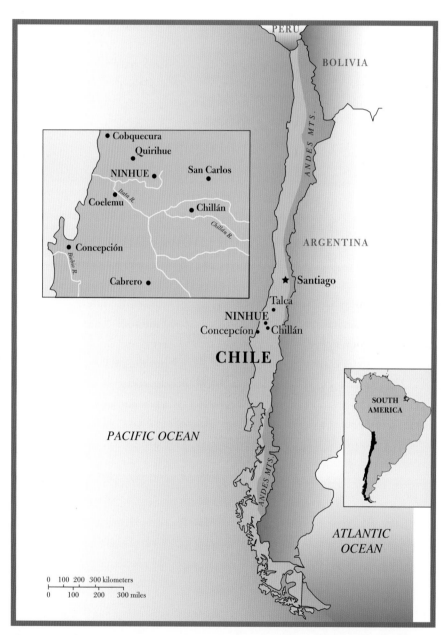

Fig. 1.1. Ninhue is situated across the Central Valley of Chile against the first foothills of the coastal range in the VIII Region of Bio-Bio in the province of Ñuble.

psychologists. The work has also attracted the attention of those interested in the historical and social aspects of craft movements and those wanting to nurture native crafts as a form of cultural manifestation.

Finally, proponents of microenterprises, who believe in the regenerative power of handmade creative projects in depressed sectors of society, have found great promise in the embroidery of Ninhue, as it has proven financially successful for many of the stitchers involved in the project. This book is meant not only to convey enthusiasm and optimism for each of these various components but also to inspire readers to action should they imagine such projects of their own. Whether for the possibility of financial reward, the documentation of sociohistorical movements, the capture of the embroiderers' interior psychological landscapes, or simply the appreciation of the beauty of the stitchery itself, it is my hope that readers will feel encouraged to follow their creative interests with confidence and devotion.

For me the greatest fulfillment resides in having had the good fortune to expose this group of friends to the luxury of discovering and shaping their concealed creativity. This book gratefully celebrates the embroiderers of Ninhue, who responded to my invitation to stitch, trusted me and themselves, and with dedication persevered in the intimate and very slow craft we call embroidery.

2

When Light and Dark Hues Mesh

On May 30, 1971, while visiting Chile, I proposed to a group of women in the village of Ninhue that we get together to share my enthusiasm for embroidery. It was a spontaneous invitation aimed at fulfilling my deep-rooted desire to work with Chilean artisans. Their response was enthusiastic, and our work together in the weeks and months that followed planted the seeds of a craft that developed its own unique style while offering to those practicing it additional income, a new sense of purpose and self-worth, and great enjoyment. This is the story of how the Ninhue embroidery group came to be.

In 1971, Chile, my native country, was reeling with change, and the world as I knew it was about to disappear. Chile's long democratic tradition was being profoundly tested. Salvador Allende, the first democratically elected Marxist ruler, had come to power the previous year. Confronted with an unsupportive parliament and pressured by members of his own coalition, he was forced to implement the changes advocated during his campaign. The swift nationalization of the copper mines and other industries and the acceleration of land reform energized the working classes and the idealistic younger generation, but they also brought fear and resentment to those who opposed the changes introduced by the socialist regime. Friction between the two factions ignited long-repressed hostilities. Eventually, the fierce opposition exerted by the right was supported by the fiscal intervention of the United States, which destabilized the economy and paralyzed the country. As a result,

Chile was not able to solve its problems within the framework of its constitution, and the growing troubles ended on September 11, 1973, with a bloody military coup that initiated sixteen years of dictatorship under General Augusto Pinochet.

During this political unrest, my father and my two brothers, Juan and Federico, were busy managing our family farms in Collipeumo and Coroney, where they introduced all sorts of improvements in agricultural practices. While Juan was modernizing the winery at Collipeumo, the farm adjacent to Coroney, and increasing its production and distribution, Federico was instituting profit sharing among the workers. They carefully and painstakingly established pastures so sheep and cattle could be raised. This preserved the soil and counteracted the continuous erosion caused by the cultivation of crops unsuited to the region.

Some tenant farmers resisted these departures from what they had practiced for generations. They perceived the innovations as unfair, depriving them of crops they felt entitled to raise. Wheat, with its virtually mythical significance, was one such crop. Under the traditional system of *medias*, in which landowners allotted tenant farmers parcels of land from which they could share the yield, wheat came to signify self-sustainability. Unfortunately, it was further depleting the soil of an already nitrogen-poor region, decreasing yields over time, and necessitating the exploitation and eventual deterioration of virgin land.

No other farms in the region were introducing such changes. My brothers, both with families to sustain, hoped to preserve the land they lived off of not only for their own benefit but also for the twenty-five or so tenant families who lived on those farms. They hoped by demonstrating the advantages of these innovations to educate the younger generation of farmers who would also benefit from their use. Unfortunately, those who failed to understand the advantages played into the hands of political agitators who operated throughout the countryside advocating widespread land redistribution through expropriation.

The agitators succeeded in January 1971, when the *Diario Oficial* published the expropriation decree of Collipeumo and Coroney

together with those of eleven other holdings in the Itata district.[1] Although the official plan was to grant reserves to the original owners in proportion to the size of their original holdings, the quality of soil thereon, and the availability of precious water, no precise terms for the reserves were yet specified. Consequently, it was difficult for landowners to know whether to accept the reserve or abandon farming altogether. Unless the quality and quantity of the reserve were enough to sustain all the people who lived on it, staying on the land would be pointless.

In April of that same turbulent year, my father fell seriously ill, and with just two hours' notice, I found myself on a plane to Santiago from Bloomington, Indiana, where my family and I had lived for the past ten years. When my father's health improved a month later, I left Santiago and headed south to the family farm of Coroney, the summer home of my childhood that lay just around the hill from Ninhue (fig. 2.1). During the ten years we lived in Bloomington, I had returned just three times to Coroney, where I was happiest and most at home, so my eagerness to join my family at the farms was great.

Federico picked me up in Santiago one day in May 1971, and we drove south toward Chillán and then west, crossing the plain toward Ninhue, a tiny hamlet at the foot of a hill. As children we had traveled overnight by train to Chillán and then by taxi the rest of the way to the farm. The journey then had taken more than ten hours; now new roads and fast trains had cut the time in half. Departing Santiago at midday, we expected to reach home before sunset. Most of the way, Federico tried to allay his and my fears about the expropriation, but since he did not know the exact terms of the land reform, he could not put our worries to rest. On one hand, the uncertainty left room for some hope that common sense would prevail—that everything my family had accomplished would be so evident that it would have to be taken into account, and they would receive an adequate working allotment. It seemed unconscionable to me that our home could be usurped. The weight of centuries pressed upon this property, and my family loved it still, just as our ancestor, who, upon receiving the grant from Spain, walked up the hill,

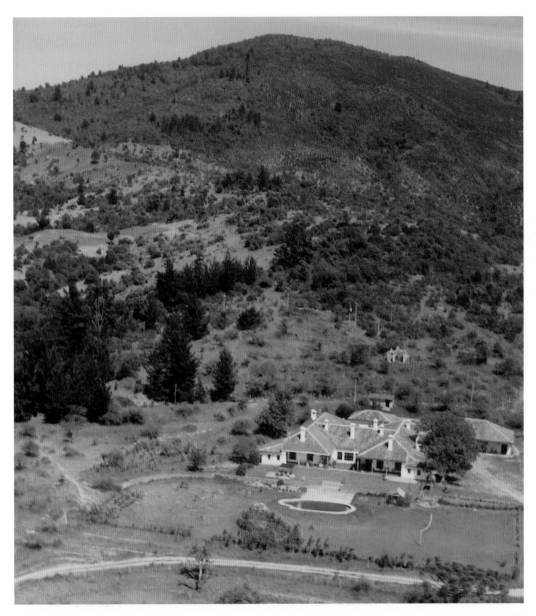

Fig. 2.1. The house of Coroney as it stands today. Following the expropriation, the native forest on the hill was supplanted with pine trees. *Photo by Antonio Aninat-Condon.*

stripped naked, lay on the earth, and rolled in it, taking possession of the land by mingling his body with its soil. This romantic gesture marked my family with a sense of place: we inhabited and shared this farm with other families who were just as deeply rooted, and together we all had derived modest and quiet livelihoods. Unlike some other farming families in Chile—the so-called "weekend" landowners—my family did not manage Coroney and Collipeumo from a distance. Rather, some family members were always present, and the land profited from the constant caring presence of its owners.

While in the United States, I had believed the Allende administration would bring positive and just changes to the affairs of my country, but when I returned to Chile, I began to see the unpreparedness, poor planning, and lack of cohesion in the new socialist government, which was only made worse by the resistance of the opposition and American intervention. What worried me most was the absence of a sound plan for agrarian reform. The sweeping and abrupt approach, which left no room for careful and accurate property assessments or provisions for establishing the rights and needs of those to whom the land would be assigned, smacked of demagoguery. I was profoundly pained and disappointed.

As Ninhue came into view, Federico and I fell silent. The proximity of the stage where the drama we had been discussing was taking place brought feelings I had never before experienced. I made an effort to view this little village as I had always seen it, with anticipation of its friendliness—even though I knew it was here that Federico had received kidnapping and death threats in the sieges of Coroney and Collipeumo. We passed through Ninhue late in the afternoon, headed toward Coroney. With curiosity I turned my head from side to side, taking in the changes to the town I remembered from the past. When we drove by the post office, I was stunned to see a sign in thick black paint that read "Muera Benavente" (death to Benavente). I looked at my brother, but he said nothing; the sign had been there for some time. When I had arrived in Chile, I was shocked at the ugliness and violence in the graffiti that

defiled the walls. Death signs were everywhere—I had seen them all along the roads, and both political sides used them. The hatred and insolence of those signs repulsed and intimidated me, but this particular one filled me with the shame and sorrow of rebuke. I felt wounded. It was directed at my brothers, but indirectly I also felt attacked. In the cold light of this early winter evening, the tragedy that might take place here was not difficult to imagine. In an instant, the haven I had known and continued to seek was transformed into a place that harbored danger.

Memories of a World That Is No More

When I was a child, the anticipation of that yearly trip to Coroney from our home in Santiago held the elements of a love encounter. For weeks I would recreate in my mind the shape of the place, its colors and smells. I knew what places I would revisit and what I would yet explore.

The actual trip was a confirmation of what I knew. Hardly anything was a surprise: the trip's regularity was an affirmation of life—a trust revalidated. The gradual changes I encountered from year to year seemed to fit the care that was lavished on the place. These changes were cause for delight because they evoked the same range of emotions I might have as the oldest child showing off a new baby brother. Discovering a new lamb or frisky colt as well as improvements to the roads or the sturdiness of a brand new fence was just as thrilling to me.

My parents Eulalia and Juan, my brothers Juan, Federico, and Felipe, our nurse Mama Aurora, and I would depart from Santiago after New Year's on the night train, arriving in Chillán at dawn. In the receding darkness of those chilly mornings, still groggy with sleep, we were met by Israel Garrido, the one and only taxi driver in Ninhue. While he and a porter took our luggage to the car, we moved toward the coffee lady whose shrill voice, soaring clearly above the engine's puffing and clanking, enticed all arriving passengers to partake of her brew. Sitting low on a stool, bent over a glowing brazier, she poured coffee from tall sooty pots into small tin mugs that she held up tentatively before suggesting

milk or sugar. Her shoulder would seek her ear, her eyes would flash, and with a conspiring smile she would drawl out the oft-repeated question, *"Señorita linda ¿con o sin malicia?"* (lovely lady, with or without malice?). I loved that moment. It was always the same. Coffee and question, proffered with theatricality regardless of the gender or age of the prospective buyer. It was Father who would take a generous dash of brandy in his cup; Mother always declined. Mama Aurora, too upset by motion sickness, paced up and down the platform, breathing fresh air instead. My three younger brothers were not allowed to drink coffee and declined the white gelatinous strips of *sustancia*, a marshmallow confection, they were offered. Instead, they stood absorbed at a respectful distance from the brazier, munching distractedly on Mama Aurora's familiar cookies.

To my surprise, on one of those early morning trips, it was decided that I was old enough to have my coffee black with malicia. Without much ado Father said, "Yes, yes, give it to her," and Mother raised no objections—I must have been about ten. In retrospect, I am glad I was allowed to try it at such an early age, not because I particularly liked it but because not much later this ritual would disappear as the trains improved and schedules changed, making the coffee lady obsolete.

Although Israel and the porter had loaded the car, Father nevertheless took his time with his coffee on the platform. He possessed the moment with a ceremonial contentment. Mother, on the other hand, did not share these feelings; she was eager to move on to Coroney, which still lay ahead of us. I took after Father. For me, thresholds are places of reflection where we make conscious and deliberate entrances and departures. Presently, Father gave us the signal to move toward the car. I gulped my coffee down, not wanting to return the mug half full, and we bid the coffee lady good-bye. She knew Father would be back each Saturday morning for two months—their leave-taking was less definitive than ours.

Tightly ensconced in the back seat between my mother and Mama Aurora, who held Federico and Felipe on their laps, I wiggled around to

gain space and see better. In the front, Father braced Juan between his legs in the passenger seat while Israel drove the long two-hour drive that stretched before us.

In the warmth of the car, I fought sleep so as not to miss the landmarks that were important to me. While we drove north leaving Chillán, I checked for *animitas*, lights alongside the road commemorating the dead. Candles flickered on the dewy grass at the foot of plain wooden crosses marking the location of accidents, attacks, or the spot where a coffin had been briefly set down so those who carried it might rest. The lights intrigued me—at some crosses there seemed to be too many, at others, hardly any. I often wondered whether the candles glowed brighter in the dead of night and whether the dawn would signal their extinction. (It took me a long while to take into account the impermanence of candles.) Perhaps, after a while, people's memories also melt, I thought.

These dark ponderings soon faded. We were about to cross the River Ñuble, spanned by two parallel bridges. Mama Aurora and my brothers hoped the northbound train would coincide with our crossing, and if it did, they would egg Israel on to race it. I, on the other hand, preferred a slower pace, so I could see the wide and already dry riverbed with its scattered boulders—pebbles of the Andes—sheltering shallow ponds where cows strayed for some water. Above all, this crossing was my last chance to look toward the Cordillera de los Andes and assess the arrival of the day. I welcomed the slightest flush of dawn—although not an actual sunrise, for that would mean that the earliest possible arrival in Coroney had been missed.

Just minutes farther up the road, we crossed the railroad tracks at Cocharcas, the tiny freight station that served as the gate of departure for the hams, turkeys, olives, chestnuts, grapes, and quince paste that reached us in Santiago and kept our yearning for the country flavors alive during fall and winter. The lantern hanging at the corner of the stationmaster's house still shed its blurry light as we turned west toward the first foothills of the coastal range where Ninhue and Coroney are

situated. It was then I felt our immersion into pure, authentic country life. Here the pavement ceased. Israel knew the chuckholes and steered deftly around them. I settled back into my seat partly to brace myself against the sudden jerks but mostly to avoid seeing too clearly what profoundly saddened and embarrassed me. The *ranchos* at the edge of the road—shacks of mud and timber, tin and cardboard, slapped together— stood out in ramshackle squalor. Their misery seemed to crush the dignity of the work already being done at that early hour: a woman fanning her brazier protectively out in the open before moving it in to start breakfast, a man saddling his horse, children scampering toward fences to wave at our passing car. Ashamed at what I saw, I transferred my discomfort to the inevitable flurry of hens, a stupid and inconveniently slow ox, and a massive filthy hog that usually barred our way.

Israel drove ahead in the increasing light, and I could once more make out the vast untilled yellow plain and beyond, the scattered gnarled *espinos* with fluffs of wool hanging from their lower branches.[2] Still no animals or people were within sight. I was suspicious of the emptiness; it seemed to be a symptom or perhaps a cause of the poverty. It was several years later when I began to take shorter trips to Coroney in the winter and spring that I saw this land turn green and sheep graze on its short, stubby grass. Yet this land did not convince me of its generosity. From experience, I knew how its tightfisted clay caked and lumped, twisting my ankles when I ventured through a field. Where it lay smooth, its surface was often covered with a bright, shiny crystal gravel, tricky and slippery, encrusting my palms and peeling my knees when I fell. I judged this land difficult and impenetrable.

As if to contradict me, loose boards on the bridge spanning the River Chañaral drew my attention to the deep water that flowed quietly below us, full of life, yet unable to change the color of its surroundings. Some distance ahead, the village of San Agustín, built on a promontory, came into view. Bushy mimosa trees squared its plaza, and eucalyptus groves bordered the road. Here, at least, the modest trickle of Coronta Creek was able to provide life-giving water to the nearby vegetation.

It was light now, and I could see the land beginning to ripple and wave, creeping westward and mounding into hills. The first rays of the sun shone on the dense, unmistakable green of the hill of Ninhue, casting shadows and silhouettes in round bosomy shapes of deep maternal greens. To me, however, this view remained but an outline since we would ultimately circle around the hill to Coroney, where in a short time we would be received onto its lap.

The greenness restored my soul. Festooning the base of the hill sat Ninhue, a sliver of a village, home to fewer than eight hundred people, and just six blocks deep with one main street (fig. 2.2). One-story adobe houses, uniformly strung together in well-behaved, dully colored rows, with narrow doors and shuttered windows—private, discreet, buttoned up—complied with the traditional conformation of Chilean villages (fig. 2.3). What set it apart was its location: from its place at the foot of the hill, the village looked across the trough of the central valley at five volcanoes. You could tell the Pacific Ocean was nearby from the lightness, if not the saltiness, of the air—the place shone even on the grayest of days. Although no existing documents attest to it, the fact that El Camino Real ran by a short distance from Ninhue led us to believe that the village was originally established as a relay post for coaches traveling between Santiago and the southern provinces.[3] The village's pleasant setting, secluded and sheltered in a recessed part of the hill, may account for its enduring presence, where small landholders have remained for generations, despite the region's remoteness and the poor quality of its soil. Its very name speaks its nature: Ninhue means "place of stones." Those who love it stay, those who don't walk away.

For some members of my family it was home. Tío David and Tía Elvira, brother and sister, born from an extramarital union between my grandfather and a young woman from the village, Doña Paula Sepúlveda, were natives of Ninhue. Theirs was the only home in the village with a glassed-in veranda facing the street, suggesting a certain availability to the villagers. Tío David was a renowned surgeon and professor at the School of Medicine in Santiago. He was short and trim, calm and

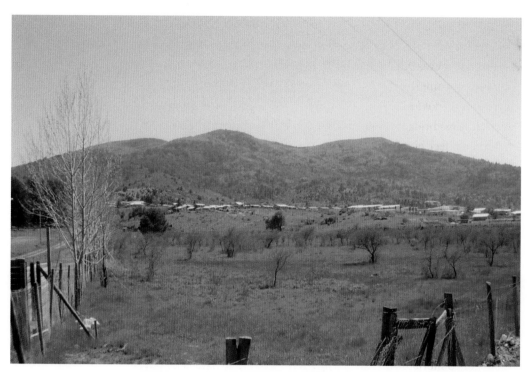

Fig. 2.2. Ninhue is
ensconced at the foot
of the Ninhue hills.
Photo by Roberto Contreras.

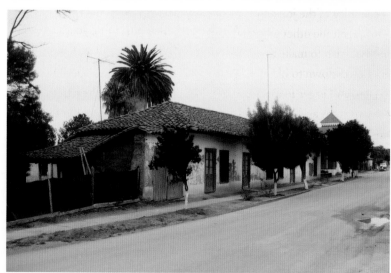

Fig. 2.3. A Ninhue
street with adobe houses
and orange trees.
Photo by Roberto Contreras.

austere, and had eyes so intense that they added further balance to his already classic features. He was not typically demonstrative with affection and rarely even reached out his hand for a handshake. When he would see us coming, fearing an embrace, he would simply say, *"de lejitos, de lejitos"* (not too close, not too close). Although always reserved, he nevertheless bridged the distance of formality with a deep kindness that all could feel, giving him a sense of accessibility. The emotions he kept so closely guarded were channeled into his infallible, probing, healing touch.

Israel pulled up to Tío David's house. We tumbled clumsily out of the car, hardly in command of our limbs. We shed our unnecessary wraps: the cool of the morning lingered, but it was summer. Nevertheless, the grown-ups told us, "Keep your sweaters on. You have to get used to the country air." Father, pushing back the hat that protected his baldness, wiped his brow and, needing no acclimatization, removed his coat and left it on the car seat. Again I detected a sense of ceremony, as he was about to enter his oldest brother's house. This time, Mother, elegant in her comfortable traveling clothes, and relieved to have completed the first leg of the journey, effortlessly joined Father in the ritual. Mama Aurora, on the other hand, was exhausted, bilious, and suffering. She did not wish to make this stop. Israel, meanwhile, asked Father if he could run down to his house to see his family while we visited. I was so excited and eager to make our arrival known that I was the first to run up the two steps and knock again and again on the door. I couldn't wait to see my aunt and uncle, and my excitement overshadowed any expression of concern I might have shown for them. I always assumed everything was fine in their world and that they would be there forever. Without knowing it, I showed a genuine and unquestioned gratefulness for them. It never occurred to me then that the world might someday change.

The front door was still locked, and we waited for Octavia to open it. We listened for her uneven limping steps as she hurried from her quarters at the back of the house. She was Tía Elvira's maid—rosy cheeked,

fresh, and full of welcome. Rosa, the housekeeper, followed her, calmly and deliberately, showing her superiority. The welcome was exuberant and loud. While Father made his way to see Tío David in his bedroom, the rest of us all went straight to see Tía Elvira in her bedroom. Ester, the schoolteacher, and young Maruca, her godchild—Tía Elvira's permanent companions—awoke and joined us there. Elvira was waiting for us, sitting up very straight in her large brass bed, propped up on starched, embroidered pillows of every shape and size. Her curly hair was mostly white, yet it still showed a few russet strands in the corkscrew curls that quivered over her enormous ears. She wore it twisted into a chignon whose position at that early hour was indeterminate. She wore her glasses to better observe how the urbanites had fared that year; in her estimation, city life left much to be desired, and she told us as much. Outspoken but shy, she would touch her forehead to ours as if playing *torito* and feel us with her hands as if to confirm what her eyes were telling her about our growth during the past year.[4] Those hands kneaded bread, and they also sewed, knit, and wove exquisitely. Later, when Father came in and bent over to kiss her, she grabbed him possessively by the sleeve, betraying her partiality and seizing the chance to feel the cloth of his jacket. There would be ample time during our stay to discuss the tweeds we wanted—those she designed and made in the company of women she had taught to weave.[5]

Her large high-ceilinged bedroom that opened on to the veranda was still dark in the early morning, illuminated here and there by the luster of the bed, the polished silver washstand set, some candlesticks, and a round candy container on her nightstand. We children milled around her bed, sat on it, darted in and out of the room's shadowed edges, and replied to a barrage of questions, whose answers would be quoted for years. For all the excitement at this stop, we were nevertheless eager to resume our journey, but not just yet, for Rosa and Octavia came in with trays of fresh coffee and milk and a tower of *mantecados*, shortbread cookies, that we could not refuse, even though some twenty minutes later we would be offered yet another breakfast. To my dismay, Mother

and Father took much too long over their coffee, telling the grown-ups all that they wanted to hear. When they finally got up to leave, plans were made for sumptuous lunches either here or at Coroney. On our way out, as we passed Tío David's rooms, Father took my brothers in for a brief hello, while Mother and I waited for a later time when he would be up and about.

Outside, Israel was waiting for us, but no sooner had we started than he had to make another stop. Gregoria and Romilia, the laundresses who lived at the very edge of the village, had gotten wind of our arrival and demanded a thorough inspection of the family. Invariably, it was I who had to get out so I could be embraced grandly, inspected, and finally pronounced scrawny.

After that, nothing but the road itself would delay us. With patience and skill, Israel negotiated the deep, eroded scratches that furrowed the climb. He was always watching for oncoming vehicles. This was my road, difficult but flanked by mysterious niches and hollows that suggested dreams. Much to Mama Aurora's annoyance, I kept turning in my seat. I wanted to take it all in, just as did Mother, who loved the variegated vistas that changed so quickly as we rose above the far-off plain and the roofs of Ninhue. Others had long ago discovered the charm of life in the midst of difficult beauty. They had wrapped the earth about them, stacking the adobe to form their dwellings, and conceded to the soil's dryness by not taxing it with too much seed. No ambitious orchards were planted here—just an occasional fig or pear tree, distressed in its compulsion to bear fruit, and perhaps a restrained vineyard. These views made my mother want to paint and compelled me to tell myself stories.

From the *alto*, the highest elevation on the road, the land relaxed, wider, more spacious. Searching down the slopes, I watched for the first view of the soft, rosy tiles of the house at Coroney, which sat unperturbed at the base of the hill. The house was one with those who lived in it—my uncle, Tío Manuel, and my aunts Tía María Ana (Tiíta) and Tía Carmela (Tata). I knew they would be waiting for us outside, having just

been alerted by Tata, who was posted in the corridor and had detected the sound of the car. A little while longer and we would be in each other's arms. I drew back into my seat, overpowered by the anticipation of the emotional reunion that was but the first expression of the constant affection we would receive throughout our stay.

As Israel approached the green mantle of pine forest that Tiíta had planted in her youth, he slowed down. Coroney was never approached at full speed; one's arrival should not be betrayed by a cloud of dust. Like welcoming sentinels, *los pinos* towered straight and supple. During our stay we would resume the work that Mother had begun years before. She had undertaken the task of opening paths where the planted trees had become too thick and impenetrable. At her request, Tío Manuel had assigned her a little hatchet which was hers alone and which he ceremoniously handed to her, newly sharpened, at the start of our vacation. For me, clearing the paths felt like participating in an epic battle, complete with hard labor and dangerous monsters, even though I knew the "enemy" would be no more formidable than a hairy spider or an infrequent snake. I worked hard, helping to heap the twigs and branches oozing pitch to the side, out of the way.

The paths often led to natural clearings where *boldos*, native medicinal trees, and eucalyptus grew; we called these our parlors. Here we sat, played, talked, snacked, read, and fantasized. I folded and crushed the leaves of the boldos and squeezed the Chinese hats of the eucalyptus seeds to extract their fragrance. Flat on our tummies, we scratched under the pine needles and examined the dark earth, soft and powdery, where life pulsated richly and busily in its private seclusion. Early on in those halls we pledged our allegiance to Mother Earth.

Past the woods, on either side of the road, stood an olive grove and the orchard where Juan Crisóstomo and Margarita, the gardeners, oversaw several acres of fruit, vegetables, table grapes, and flowers. Their young crew of gardeners would judiciously direct the irrigation water from the basin, careful not to waste any of the precious resource that flowed irregularly from the spring up on the hill.

One sharp short acceleration took us up the steep incline in front of the house, and then with two deft turns we arrived. Israel had hardly stopped the car under the maples flanking the house before we scrambled out. Yes, my family was all there waiting for us. Like the arms that welcomed us, the house was built in the shape of an H, with two sets of arms to embrace us. It had been built in 1850 with thick adobe walls that were covered with eggshell-colored stucco and brownish trim. Covered porches surrounded it, bordered by ditches into which gutters emptied the rainwater; nine chimneys studded the roofs. The doors were all alike, indistinguishable from interior doors—they locked with a turn of a key—and the sash windows were protected with slender bars. The house stood serene, unafraid of intrusion.

The terrace was stark, as no water could be diverted from the orchards to water a lawn or irrigate flower beds. Instead, we relied on seasonal wildflowers, whose lushness attracted birds and bees but only for a short time in the spring and fall. A solitary vine in one corner of the back patio, a *multiflor*, had been trained as a shade umbrella. An esplanade in front of the house below the terrace was used as a soccer field. Juan Crisóstomo had organized teams, and each evening after work, before retiring to their homes, the laborers played while my brothers and I enviously watched. Some distance away from the side of the house and toward the north rose the barns, chicken coop, stables, wine cellars, and mess room.

On special occasions, such as the morning of our arrival, the large table in the living room was cleared to make room for breakfast. We did not sit down, as we had sat long enough on our travels. Rather, in the delight of our arrival, my parents paced up and down, discussing family issues and current news, holding their cups of tea or coffee while we children stopped at the table to serve ourselves Honorina the cook's "filed" bread, already dripping butter, with heaps of fresh *natas*.[6] My aunts and uncles sat and listened, their laps available for us children. I played musical chairs evenly among Tiíta, Tata, and Tío Manual. Mama Aurora had retired for some rest to recover from the travails of the journey.

In Coroney, where the business of life and its sustenance were always in plain view, I developed a profound understanding of how many people it took to make the farm and the household run smoothly. These people, connected to the land and its slow-changing traditions, had ancient-sounding, old-fashioned names that seemed to hail back to a much earlier time. Also hearkening back to a previous time was their dependence on one another to get the work done. Margarita and Juan Crisóstomo supplied Honorina with the provisions she needed from the farm to make our meals. Irineo kept the woodshed stocked with fuel, perfectly cut to fit into the stove. Francisca, Lydia, and Rosa tidied and cleaned and relayed food from the distant kitchen to the table. Cirilo fetched the water from whichever source happened to be most plentiful on an oxcart fitted with a barrel, and his brother, Eliécer, distributed it, but not before filtering it through porous stones into huge ceramic vessels. The water they brought for our baths smelled herbaceous and earthy, depending on the weather, and had to be heated and then carried to the tubs. Also, large pitchers were placed next to the "thrones" in the bathrooms to speed the "tokens of our gratitude," as Tiíta would say, on to their organic decomposition. Natalia, the laundress, who dressed all in white and spoke like a poet, also needed plenty of water to do her work. She relied on her water-bearing sons for the precious resource. There was also the herdsman, Leandro, who doubled as postman and messenger and wore tinkling spurs that announced his presence; Euscarpio, the stable boy, who readied our horses; Apolinario, the winery supervisor; and the retired patriarch of Coroney, Narciso, who checked on everything, still concerned with all the goings on of the busy farm.

After breakfast we sought out all these people so integral to the smooth functioning of our farm. They cared for us in an intimate way because their work was done by hand. The very physicality of their duties attracted me: there was beauty in the repetitive choreography of their daily chores, acted out with elegance and ease. Indeed, the staff seemed superior to us in a certain way, for as they performed their work

with grace—chores such as kneading the laundry to get the dirt out, chopping the firewood just the right size for the stoves, or mincing the parsley as fine as sand—I recognized that we could not do any of it with equal ability or authority. I suspected an age-old wisdom behind their methods, so I liked to watch them work, and I would often join them in the kitchen, listening to conversations that made me see things differently.

And then we scattered to our assigned quarters. I went to Tiíta's bedroom where the divan in the corner by the window was my bed, always.

An ESTABLISHED VARIETY of activities ordered my days. Tiíta and I would wake up early, but we did not speak until she finished her silent prayers. In her grandmother's wide bed, framed within the striped hangings of the baldachin, she would hold her head in the crook of her arm and sigh. As soon as she moved to adjust her pillows the conversation would begin. It was mostly I who talked, spilling out my enthusiasm and joy at being there, letting her know what I expected to do, where I wanted to go. She would smile, amused, happy to feel my love for the place and offering suggestions to add to my enjoyment: maybe I should go visit the white rose bush by the well or try the new bench under the oaks. Perhaps I should investigate and tell her whether the Italia grapes were turning amber. Tiíta was not talkative. She commented frugally, enunciating thoughts related to the moment. She had much to attend to in the household. She knew so many things and what it took to do them well—not just technique but also how the chore would affect the person assigned to the task. She understood the rhythms and intricacies of life at Coroney, allowing her to guide but also sometimes scold, with a stern and sometimes harsh rebuke, those in her charge. She served incomparable meals, tailored Tío Manuel's summer jackets, pleated his linen shirts, and shared with Juan Crisóstomo her scientific knowledge of gardening. She was the competent guardian, the expert nurse available to all. Gently and patiently she eased our pain and healed our wounds. If she judged the injury not serious, she would dismiss the whiner with a look.

Tata was her opposite—timing and rhythm made her lean. She lived in the here and now—impatient, romantic, quick-tempered, demanding, irreverent, charming, a flirt. Tata was one for surprise and mystery. She preferred one-to-one relationships, and every now and then she would steal away in great secrecy to the Pataguita—provided the pond was not dry—for a midmorning picnic of cold chicken necks and innards followed by some French poetry. I used to seek her out to rub my feet and tell me stories of olden times. Her descriptions were so vivid that for a time I was convinced I had known my grandmother, even though she had died when my father was a little boy.

Every day, Tío Manuel would retire to the library after lunch. Sometimes, decked out in robes and shawls to play the wife of a man who lived naked in a barrel, I would break into his sanctum sanctorum to tell him the latest gossip of my imaginary friends.[7] My uncle would sit up, put down his book, and adjust his monocle, greeting me most graciously and indulging me with a feigned credulity for my make-believe stories. Following my ramblings with interest, he would then show me out when I was ready to leave. On occasion, we would ride home from Collipeumo, the rosiness fading from the night sky, Venus shining brightly overhead and the south wind rising. Tío Manuel whistled *Aida*'s march confidently, leaving a trail in my ear.

A certain virtue in the stillness and moderation characterized life in Coroney: a highly prized self-sufficiency kept any possible hunger for excess at bay. Always aware of the presence of the earth, the inhabitants would reflect on its gifts and return thanks for the modest but life-sustaining yields won through hard and persistent labor. Cherished were the oak and rose, the olive and almond, the grape and peach; caressed was the fleshy muzzle of the pet white stallion who stopped every evening to claim his sugar cube on his way back to the stable. Tío Manuel performed this ritual, and I watched for the cupping of his hand as it extended the offering and lingered with affection.

Then there were the things that were spoken and passed on, person to person, generation after generation. Stories, events, anecdotes, and meaningful moments—all were told and retold and tilled into our

memories, shaping and enriching our lives just as the richest compost built up the soil. These were no fairy tales but stories about real people that I wanted to hear again and again. Some were good, some not so good, and others were quirky, funny, or scary, depending on the subject's idiosyncrasies and, of course, the storyteller's fancy. To supplement the oral sources, a library was at our disposal, and we were often guided to make use of its resources: "Go look it up in the dictionary, make sure what it means. Read that sentence aloud, savor what it says, how it is said. Don't miss it, it's somewhere there." There, too, was my grandmother's gold-inscribed, thick blue volume with colored illustrations of native costumes from all over the world. It was here that I first spotted a lavish use of embroidery, and together with the variety of elaborately ornamented costumes, the book cast a spell on me. Compared to these, our sober native costumes seemed plain, decidedly lacking panache. Summer after summer I would return to this book, setting it on the table to "study it," as Tata would say.

It was Tiíta, however, who could read where no words were written. She would draw me to her to stand in awe of the beauty around us. Under the clear night sky, she would introduce the stars to me by their names, mention black holes and nothingness. One night, sensing that fear rather than awe lurked inside me, she decided she would transform it. It was not the faraway darkness that disturbed me; it was the dark that enveloped us every night like a thick mantle. It was a darkness that could not be readily switched off but only minimally pushed aside by a quivering candle. In those years the darkness of the countryside was organic, unadulterated; it poured out every evening, soft, velvety, dense, submerging everything. Tiíta sensed that I feared it. She commanded me to pierce it, traverse it, and make friends with it. Watching from the porch, she made me walk through the pines, clear to the road and back. I was choked with fear as I trod obediently forward, and when I thought there was no more breath left in me, a pride from deep down rose up in me, pumping new breath into my lungs. I marched home triumphantly, and although angry with Tiíta for making me do that, her lesson that night remained with me always. Whenever I am faced with difficult or scary

circumstances, I remember that they can be conquered by penetrating and transforming them.

And so it was that who I am was molded by Coroney.

As Federico and I left Ninhue and started to climb the hill on that beloved road that brought back so many memories, fear gripped me once again. But this fear was one I had never experienced before—it was the fear of an animal being hunted down. Hunched over, hardly daring to lift my head, I scanned the growing darkness outside, not for the familiar niches and hollows that had suggested dreams when I was a child, but for dark recesses where danger might be lurking.

Suddenly the openness of Coroney—its remote and unsheltered expanse defined only by earth and sky—narrowed and stood out distinctly. We entered the pine forest. This sanctuary of conifers had shaped my hopeful outlook on life but not on this particular evening. This time, all sense of protection vanished from the forest as I realized my brother was more exposed to danger here than at any other place. This was just the spot for an ambush. I noticed how he maneuvered the car deftly, crossing the darkness in a flash and stopping the vehicle a few seconds later near the side entrance of the house. Flor María, my sister-in-law, and the children greeted us with relief.

That night, sleepless and aware of every sound outdoors, I reflected with profound sadness on what inevitably happens when social and economic inequalities are not addressed—they fester and ultimately explode. I was also afraid, for although there had been no physical violence when the farms had been besieged, the present situation might lead to a very different showdown. Unsure of what to do, I felt powerless in the face of the hateful situation. In this feverish state, I sought a path that would cut through the problems and bypass politics. Suddenly, out of the blue, I thought of something so absurd, so utterly ridiculous that I immediately waved it from my mind; yet it returned, insistently demanding my attention. The idea that something meaningful, healing, and creative could be done through stitchery had taken a firm hold on me.

Threading the Needle

My thoughts shot in every direction that fateful night in Coroney as I lay awake pestered by the outlandish idea that I might bring calm to the people in Ninhue through embroidery. I had been immersed in stitchery for almost ten years by then—reading about it, working with people, and taking such pleasure from the craft that as I write today, it seems entirely natural that I would turn to the nearest source of calm at my disposal in that moment of despair. But it did not feel that way then. The idea scared me, yet I couldn't let it go.

My flight of fancy got the best of me. I saw myself working with a large group of women turning out beautifully embroidered pieces, and it was these reveries that assuaged my doubts and apprehensions. The night sharpened my vision: this place I was about to lose was exactly the right place to establish the kind of workshop I had been contemplating. The size and relative isolation of Ninhue, the traditional makeup of its population, its deep roots—all were characteristics that suited my hopes. Plus, I had the added advantage of working in my own country sporadically while living abroad. I was both part of the community and yet in some ways foreign to it, a condition that confers one with a certain authority. Knowing this, the special relationship I had had with the people there and the leverage I could exert gave me confidence.

There was no doubt in my mind that the threat of losing these places that were so much a part of me had inspired these thoughts, but that didn't compromise their validity. The circumstances could not have

been more adverse, and some would be suspicious of my motives, but I had reached the conviction that this place was where I had to start my work. I would defy expropriation with my love for the region. Realizing I could do *something*, I felt reassured and somewhat relieved, but I still slept fitfully that night, waking often, feeling afraid, obsessed, and frantic.

The following days I spent listening to my family and the workers discuss the situation. My friend, Douglas Wilson, an American journalist, visited Coroney and Ninhue during that time. He wanted to see both sides of the land reform issue for himself. I translated for him. In Ninhue, he met with Nino Andrade, the local advocate for land reform and a fierce opponent of my brother. In spite of my presence, the meeting was most cordial.

At the end of the interview, I said to Nino, "I understand my brother's life is in danger."

"Don't worry, Señora, they're only threats." His tired voice was surprisingly soothing.

"But don't you think after a rally and a little wine somebody might just pull the trigger?"

"Yes, that could just happen," he answered in a trailing voice.

"So the threat might just end in tragedy," I insisted.

Extremely discouraged, he looked down, shrugged his shoulders, and said very softly, "What do you want? This is the only way we have to attract attention over there in Santiago."

Faced with imminent sweeping changes, workers at Coroney performed their tasks mechanically, without the urgency that typically characterizes farming. There was an atmosphere of finality, despondency, expectation, weariness, irritation. The conversation with my family spun around uncertainty, for nothing could yet be decided. I talked to some workers in the mess kitchen; others I visited at their homes, and I listened to what their families had to say. Clearly, much of the loyalty they showed my brother was conditioned by the apprehension of having to strike out on their own. Some workers were frank and outspoken, ready to assume responsibility for the future management of the land even

before attaining full ownership of it. Others were ambivalent and cautious. They feared the consequences of land reform and felt they were better off working under my brother. They doubted the state's ability to subsidize them once the land was divided and feared the diminished yield of the land would put them in a state of mounting debts. These were not unfounded concerns, for the dream of great success was improbable on dry-farmed land subdivided into smaller plots, even if those plots were owned outright by those who would work the land.

Among the workers, there was a palpable if tenuous yearning to become owners, a wish that extended into dreams of self-sufficiency for their wives and children. Still, the actual means by which they might bring about this transformation seemed beyond their reach. When people have worked for generations on land they do not own, their lives become defined by a certain dependence that is often difficult to shed. They work just enough to meet their basic needs, which deters them from wanting to own land and manage it independently. Outside indoctrination befuddled the workers of Coroney; it attracted them, but they also distrusted it. They had no real desire for violence or, ultimately, change. A number of them even petitioned President Allende to spare my brother from total expropriation. These people, attuned to the soil, trusted the wisdom of gradual change and knew that their frugality would ensure that change would proceed in a natural manner. What must have been most frustrating to them was the realization that any imminent change in land ownership would not necessarily be accompanied by a change in the power structure.

The situation was therefore quite delicate, and when I mentioned to my family the idea of starting a stitchery workshop, they reacted with stunned disbelief. They told me such a gesture would be misinterpreted by the villagers and would add to the turmoil. The proposal was impractical, they said, and I would be acting irresponsibly. How could a non-resident, who would be unable to sustain such a program, initiate it? I tried to explain the concept. After the first workshops, the program would be self-supporting. Each woman would carry out her work as she

saw fit, and her progress would depend solely on her initiative, creativity, and time. I would simply be offering the prospective stitchers a technique, a tool, and assistance in finding a market for their work. My family insisted that I was naive. They could not conceive of success in such a venture, especially at this time. But I argued with determination that it was precisely because we were in a highly explosive moment in history that my outlandish idea might take hold. The idea became an obsession, and I a pain to my hosts.

A week went by. Sunday came, and it was time for me to return to Santiago. The family attended Sunday Mass each week in Ninhue, and I accompanied them. The little church of Our Lady of the Rosary was packed. I recognized very few people. Even the priest was new to me. He was unlike Father Arritola, the parish priest of my youth. Father Arritola was a Basque man who, it was said, had once been chaplain to Queen Eugenia of Spain. Despite his many years in Chile, he never lost his thick accent and worse still, he never addressed the congregation in anything but lofty, imperious tones. Clearly, this new priest ministered to his parishioners in a simple, caring, and understanding manner.

By God knows what strange designs, the priest had chosen this particular Sunday to urge the congregation to work together to build a deeper sense of community in the parish through church-sponsored activity groups. He suggested sewing, knitting, and cooking groups; he distributed information and sign-up sheets and pressed people to voice their needs and suggest other kinds of interest groups. He called upon everybody to volunteer their talents to integrate and serve the community.

I could hardly believe my ears: the refreshing message the Church had been spreading in other parts of the world had finally reached Ninhue. True, it was possible, as I had been told, that the Church mainly wanted an alternative to the Centros de Madres, which had been instituted by past administrations with political agendas. These community interest groups focused on the parish were to counteract the political influence of the Centros by offering similar assistance through Church-sponsored social groups. To me, though, none of this really mattered; whatever the motivation, the proposal was positive.

My eyes scanned the sign-up sheet: cooking, stressing nutrition; sewing and knitting, based on accurate patterns and construction techniques. At that moment I wished with all my heart I didn't live abroad and could participate. As I watched, I realized that a number of the women could not read or write, so I approached them. The women continued to discuss the priest's proposal. They wanted very much to join, they said, but they worried that these new activities might interfere with their responsibilities at home. As they confided in each other, they seemed to gather courage, and they offered each other help with their problems. One was worried about being gone in the middle of the day. "*Comadre*," suggested another, "if you start lunch early I will see to it that the *compadre* and the kids get fed when you're away."[8] Still another said she feared opposition from her husband, and a friend promised she would get *her* husband to convince him this was the right thing to do. I offered to fill out the registration form for one woman, and when I was finished and handed it back to her she smiled, full of confidence, and thanked me.

The contact with the women increased my desire to be part of it all; we got up to leave, stopped at the fountain by the door, dipped our fingers in the holy water, and made the sign of the cross. Outside, the hills of Ninhue and Coroney rose deep green and dense against the gray sky. I was overwhelmed by the feeling that if I were to do anything in Chile, it would have to be then and there or never. On the spot, I chose to do it, refusing to give up on my dream. And once the decision was made, I caught myself smiling, relieved, like the women who had been so uncertain. Both the women and I had wanted to do something, and we found the help to do it.

Returning to Coroney for lunch, I was full of joy and apprehension. A terrible and yet delicious feeling surged in me from the commitment I had made under seemingly the most inauspicious circumstances.

Nor did the excitement abandon me that night in Santiago. I slept very little. Instead, I found myself fantasizing about how I would actually be teaching the women. Of course, all I had at that point was my desire. I had no idea where I would get the funding for this project. But as I

quickly learned, the first step in realizing any dream is to hold to the idea passionately, committing to carry it out as an act of faith.

As it turned out, this practical question was answered the very next day at my father-in-law's house during a luncheon in honor of Douglas Wilson. I sat next to my friend, María Teresa González, who asked me if I was still teaching embroidery at home and whether I'd be interested in doing it in Santiago. I seized the opportunity in a most mercenary fashion and informed her there was nothing I'd rather do, but that I would have to charge a fee in order to support a project I wanted to start with the women of Ninhue. The idea of combining efforts appealed to María Teresa and by that evening she had recruited twenty pupils for my class. We started the following Monday, three sessions a week, each two hours long at the house of one of the participants.

Meanwhile, I scoured the city for yarns, fabrics, needles, and hoops, acquainting myself with vendors and their stock. I planned the classes for both Santiago and for Ninhue, adapting my presentations for a less educated group, for I wished no student in Ninhue to feel discouraged. Lessons that had originally combined demonstrations with written instructional materials were transformed into demonstrations with new stitches learned through repetition and memorization. Last but not least, I translated into Spanish what I had previously taught only in English.

In the meantime, my husband, Juan, home alone with our youngest, Matias, did his best to understand the details and locations of my wild projects, even as they increased week by week. Because telephones were unreliable in those days and our letters took many days to arrive, it was difficult for him to keep up with it all. I, however, knowing him well, had no doubt of his support—I knew that once I carried out what I intended to do, he would be most pleased with the results. I missed them both, but the greatest sadness for me at this time was not being at my daughter's side when she gave birth to our granddaughter, Magdalena. She was born just a few days after I left Bloomington for Santiago. This absence has remained with me always.

In a letter to Federico, Juan described this period: "My life as father, mother, and grandfather, added to the many parallel lives that my work imposes, is difficult, but I confess it has its compensations. The grand-daughter that Francisca and Julio have produced is one of them." He also added: "I have you constantly in mind with the hope of finding some way to help." I was not mistaken in counting on Juan's uncondi-tional support, which he has maintained and reinforced throughout all these years because of the great admiration he has for the ever-evolving work of the embroiderers.

When I returned to my family at Coroney at the end of the week, I was resolute and self-assured; my fear had dissipated. I had decided I would walk to Ninhue the next day and stop at every house. I would invite the women and girls to meet during the weekends so I might show them how to stitch with wool. My brother looked at me sadly, as did the rest of the family. I was sorry to disappoint them, but I had made up my mind, and there was no turning back.

First Steps

Saturday afternoon I set off with a determined stride toward the village, climbing the hilly, winding road, anticipating meeting people I had not talked to in many years. Under other circumstances, I might have daydreamed as I walked along, but not this time, for I felt I was walking toward the fulfillment of my dreams. I knew when I began asking women to participate that they would naturally wonder what was prompting my invitation; yet at the same time I was certain they would accept it. Indeed, their acceptance of the invitation, I told myself, would be proof that the timing was right and that the project would eventually succeed.

As I walked, I once more took delight in the place and felt comforted by the stretch of valleys and soft hills toward the east and from the snug folds and crannies encircling the foot of the mountains. It made me happy to be inventing a job for myself at the place I loved most in the whole world. Finally I would be able to thank the people who, in so many unsuspecting ways, had contributed to my upbringing. I felt a rightness about this project. For the first time in my life, this walk to the village was not a promenade but rather a pilgrimage. With poignant tenderness, I contemplated the dichotomy in my position: to one side was my allegiance to my roots; to the other, my detachment. A curious freedom lay before me—that of choice: I was choosing to become responsible for something here that was entirely my own.

As I walked toward the village, Ninhue's unique location and layout

came to mind. Sporting not one but two plazas, life in Ninhue is oriented around two centers, the older plaza near the schools to the south and the new plaza, four blocks away to the north. In earlier times, the southern plaza would pulsate with youthful vigor as the children played soccer every day on the empty open ground. Now, having been landscaped, it serves as a gathering place where excited youngsters watch the drills taking place at the imposing new firehouse. The new plaza lies at the foot of the church between two triangular flower beds shaded by palms and linden trees. Here, friends seeking a bench for a visit and others going about their business will stop for a friendly chat.

As if to complement the two plazas, two parallel streets form the main arteries of Ninhue. Calle Arturo Prat stems from the new plaza and is lined with orange trees. Along this street is the Church of Our Lady of the Rosary, the post office, the municipal buildings, various shops, some taverns, and the old, long-standing houses. Beyond these, to the south, is the new high school along with the *internado* (the boarding house for students who live far from town). A well-staffed clinic with an ambulance service that serves the county is situated close to the school. The other main thoroughfare, Calle O'Higgins, edges the old plaza. Near this street, the village is expanding—here separate dwellings spring up and new housing developments arise. Short streets crisscross each other forming grids enclosing sizable plots that are hidden behind old buildings.

I walked a little farther and arrived at the first house by the road opposite the cemetery, where I stopped. A man was working in a nearby field, chickens were pecking in the yard, and a poster of Che Guevara was emblazoned high on the adobe wall. I stood at the gate and called, "Hello, hello, anybody home?" A woman I did not know came out to greet me, and I introduced myself, telling her where I lived, what I did, and why I had stopped to see her. She gave me her full attention, and when I asked her what she thought of my plan, she said it sounded like a good idea and that she would very much like to participate as long as her husband would permit her. As she said this, she looked toward the field where the man was working. He had stopped and was watching us.

She gave me a list of names of other women in the village and assured me that she would meet me at three o'clock the next Saturday afternoon, if her husband gave her permission.

One of the names on this list was Emerita Valverde, the president of the Centro de Madres. Emerita owned a tiny food store, licensed to sell liquor, adjoining her house at the opposite end of the village, and I chose to cross the village and interview her first. I found her, an energetic and lively person, behind the counter of the store, busy at work. With growing interest she listened to my proposal between customers and then suddenly shouted toward the house for someone to mind the store so she could devote her full attention to the plan I was presenting. The community should unite, she told me, and work together, not only to provide needed services and bring about improvements but also to channel the many untapped skills of the villagers. She assured me we would meet in a week; she would talk to other women and urge them to attend. My visit with Emerita was very open and friendly, reassuring me that the idea would be well received.

As I retraced my steps, I started to run into people I had known in the past. Maestro Unda, a gifted carpenter who had helped restore Coroney after the 1939 earthquake, was a staunch Allendista. He told me he was proud that the voice of the workers was finally being heard. He, too, approved of a stitchery project in Ninhue. Farther up the street I stopped to see Maruca Bustos, whom I had known all my life. Tío David and Tía Elvira had raised her, and she lived in the house she had inherited from them. She had turned the house into a pension that offered food and lodging. It was getting late, and she made me come in for a cup of coffee with "malicia." I told her about my idea, and she responded with some caution, recognizing the potential for formidable obstacles due to my familial affiliation and the political divisions among the people. She shared my family's perspective that people might question my motives. Although this response contrasted sharply with the reaction I had gotten from those I had been talking to, it was definitely something to watch for as I interacted with the villagers. As I rose to take my leave, Maruca encouraged me as she bid me farewell: "What the heck, *m'hijita*,

you lose nothing in trying!"[9] I laughed aloud, for I realized how Maruca had an appreciation for a little trouble and excitement under the veneer of caution.

I made one last stop at a house I did not recognize before leaving the village. I knocked at the door, and when a young woman greeted me warmly and let me in, I started to tell her who I was without realizing that I not only knew her but everybody else in the room as well. They laughed at me kindly and ushered me in. This was the Vergara family: Filomena and Vicente and their two daughters, Filomena and Ema. Vicente was now retired from Collipeumo, where he had worked both in the vineyards and as a shepherd. They had moved to Ninhue, where they owned a house and some land. As we engaged in conversation, I learned they were pained by the political division in the village and by the animosity against my family. They believed nothing good would come of it. Daughters Filomena and Ema assured me I could count on them for my project. Filomena offered to look for an appropriate meeting place. I laughed at her unforgettable parting words: "At last, something fun to do in this boring village."[10]

It was getting dark when I left Ninhue and started the climb back to Coroney. As I passed the Che Guevara house, the woman I had spoken to earlier waved to me. Farther up the hill, I stopped at two houses owned by the Manríquez families. Here I recruited several pupils, old and young, all of whom had the unmistakable Manríquez look: high red cheekbones and engaging smiles.

I took a shortcut home, avoiding the woods, and tried to sum up my impressions of the afternoon. Instead of the tension my family had led me to expect, I had been received with openness and good will, which left me exhilarated. I knew everyone's warmth and receptivity was genuine, for people cannot fake such qualities without betraying their duplicity. In the end, I think curiosity may have gotten the best of them. I suspect too that they probably shared Maruca's attitude about the whole project, that there's nothing lost in trying.

During supper, I started to report the results of the trip to my family. I had hardly begun to relate my story when I was abruptly interrupted.

The owner of the Che Guevara house, they told me, was my brother's bitterest enemy. I was suddenly stung by the same hurt that had wounded my family, and I realized the danger in my efforts. In a week I would know how my actions would be ultimately interpreted and whether the women's immediate trust and assent would endure after a period of reflection in an environment where some were ill-disposed toward my family. Nevertheless, I strived to keep my spirits on an even keel, hoping that both the village and my family would not doubt my sincerity.

The Sustaining Warp

All the while I was making contacts new and old in Ninhue, I was also teaching embroidery classes in Santiago three times a week to women who could pay to learn the craft. After that first day of rustling up interest for embroidery in Ninhue, I returned to Santiago to meet my first embroidery class. The time appeared right not only for the villagers but also for the more affluent Chileans to start this activity. Once the Santiaguinas finished the course, they continued together under the able direction of María Elvira Reyes, adopting the name of La Hebra for their group.[11] Soon they would begin to work on large-scale tapestries depicting family estates that were being expropriated under the socialist regime, which contrasts interestingly with the intention of the Ninhue pieces. The work produced by the members of La Hebra took on the format and muted palette of old European tapestries, with which they were acquainted. The emphasis is on subtle shading and a very imaginative combination of stitches, which creates textures that are gradually integrated and well suited to depict the typical architecture and landscape of these old country houses. They are worked in panels using Paternayan yarns. The borders framing these tapestries repeat pictorial motifs related to the main subject matter. Both technically and conceptually, La Hebra has come closest to upholding traditional crewel embroi-

dery and adapting it to a local theme. The tapestries of La Hebra stand out for their originality and high craftsmanship, but most important, they constitute historical documents in terms of their content, the impetus behind their creation, and the time period in which they were created. La Hebra became the most prestigious group to learn embroidery and distinguished itself through the creation of several well-planned pieces. In addition, some of its members have become volunteer instructors, organizing workshops for low-income women in the suburbs of Santiago, such as the one in Barnechea. They have also been instrumental in helping their protégées sell their work.

Between May and September of 1971, I led six more workshops in Santiago and one in Concepción, thus easily ensuring the continuation of the Ninhue project through the monies I raised from these paying students. As with La Hebra, these city groups produced many volunteers who helped others learn the craft. Probably one of the most important workshops in achieving visibility and commercial success was Taller Macul, brought together by Mónica Aguirre. The lively pictorial tapestries first designed by one of Mónica's daughters represented the activities of working people in the large metropolis of Santiago. Mónica was instrumental in securing commissions from corporations for larger works. Later, printed reproductions on cards and calendars would add income to the stitchers' efforts.

First Stitches

On Friday in Santiago, after getting paid, I rushed out to buy the materials for Ninhue. I headed for the station to catch the late afternoon train for Chillán, loaded down with yarns, fabrics, needles, hoops, paper, and crayons. In those days there was a shortage of wool, and some weights and colors were hard to come by, so I had to shop around quite a bit to find what I wanted. The unusual quantity and variety of my order roused the curiosity of the merchants, who would invariably offer me a

discount on the materials as soon as I explained their purpose. They saw this as their contribution to the project, which they continued to make for the duration of the workshops.

Friday night in Chillán, Federico met me at the train and smiled at my cargo. The next morning in Coroney, Flor María and the children helped me arrange the yarns and the rest of the material in round, shallow harvest baskets. It was a rich display that we proudly loaded into the Jeep. I was moved that my family was willing after all to help me materialize my dream, with ease and good will. But would my dream really come true? How many women, if any, would show up?

The early afternoon was gray, cold, and dry when we arrived in Ninhue, but as we approached my doubts vanished. A large group of women was waiting at the plaza in front of the church. The women huddled together, talking softly, and held themselves as they usually do when they need to conserve heat—feet close together, knees slightly bent, arms crossed over the chest, and hands tucked under the armpits. We greeted each other, curious to see what this encounter would bring. They informed me that the priest had offered to let us use an empty house that belonged to the parish for our workshops. It was an old adobe structure that stood just opposite the church. The women helped unload the Jeep and carried the baskets into the house. More women kept arriving and children too. A group of men stood by and watched, silently. Our meeting room was large and dark. Just two windows faced the street, and when we opened the shutters, we noticed that some of the panes were missing. But the earthen floor had just been swept, and a table, chest, and some benches neatly lined the walls. We placed the yarn on the chest and the roll of paper and crayons on the table. We all sat in a circle around the room, the women stiffly against the wall and I facing them but also next to them. I knew a few women from the past and recognized those I had met the week before and those with whom I had talked after church. I looked for one woman in particular, but she had not been given permission to come. I missed her.

I counted some thirty women in the room; others joined us later. Our

first moments together were filled with an awkward shyness, but I gathered my courage and began to talk. For those I had not approached personally, I repeated the invitation and explanations I had previously offered the others. To help them understand why I wanted to launch this project in Ninhue, I began to explain why this village of theirs was so important to me. Ninhue had been very good to me, I explained. I had been the recipient, indeed the beneficiary, of the beautiful work of their mothers and grandmothers, their fathers and grandfathers. I described the little embroidered shirts I had worn at birth, my first shoes made of hand-rubbed goatskin, and the fleece for my crib mattress that had been whipped and teethed by two women from the village. The pull cart my mother used to take me on outings through the forest or to the orchard and vineyards had been built by a Ninhue carpenter.

I told them how the laundresses, Romilia and Gregoria, would rush out of their house to greet us as soon as they heard our car approaching in the early summer, headed to Coroney for our vacation. Flapping their arms and drying their hands on their white aprons, they would stop the car and make me get out to see how much I had grown. I told how they would hug me tightly and each year invariably pronounce me scrawny. A couple days later, dressed in their Sunday best, they would arrive in Coroney with baskets of fresh eggs and chickens to "put some meat on my bones." Filomena and Vicente, walking tall and calm and surrounded by their daughters, would appear carrying fat delicious fowl carefully wrapped in towels so they would not be harmed by the roughness of the baskets. Once, my playmate Leonor even brought me a tiny basketful of partridge eggs.

I continued remembering other people, telling what they had done and where they had lived, and then asking what had become of them. I was sorry I could not recall many names, and especially sorry to have forgotten those of people who had made the many fine things I had just described, some items of which I had carefully kept. After all, they were examples of excellent craftsmanship from long ago, and it was only right that I honor the work of somebody's hands by preserving these things.

Then from across the room, a woman smiled, raised her hand, and said proudly, "The lady who embroidered your shirts was my godmother. She herself told me she had made them. Everything she stitched was lovely." Then somebody else spoke up and told me it was her grandfather who had rubbed the goatskin for my shoes. "He had infinite patience when he sat with a little skin," she said softly.

The comments flowed back and forth as we discussed the care with which such work had been performed by older generations. I mentioned the tweeds that had been woven with locally spun and naturally dyed yarn, some of which I still had. They said the old weavers were all gone, just like Tía Elvira, who had taught them. The younger generation, they added, was not interested in weaving anymore. Embroidery was still done to decorate bed and table linens and maybe a blouse or apron.

I explained how I had discovered wool embroidery, learned about it, and mastered it well enough to teach it. Teaching embroidery techniques had developed into a desire to bring it to Chile. I went on to relate that the most meaningful place to introduce this kind of embroidery in Chile was Ninhue. I mentioned how the recent workshops in Santiago had made this project financially feasible and that I was confident it might result in something worthwhile and important for all of us. They would develop and strengthen the community and possibly augment their incomes; I would be able to express my gratitude to those who had given so much to me in the past.

I stopped talking and a warm silence filled the pause. Encouraged, I went on to explain that the most important aspect of this project was that they themselves would be making the designs for their embroidered work. There would be no patterns to follow. That jolted them. A chorus of alarmed voices rose up in protest—they did not know how to draw. I assured them that if they represented what they knew, they would render it well. There was a sudden, tight silence. I insisted they should not think they had to make pictures like the pretty ones they saw in books and magazines. Rather, I reassured them, they would be turning out valuable, unique, and authentic documents if they embroidered tapestries representing their experience; that is, their surroundings, the peo-

ple they knew, the animals, landscape, and activities that constituted
their daily life, and their feelings about them. Some laughed and others
started to talk excitedly—what could possibly be so interesting and spe-
cial about life in Ninhue?

I told them that at home in America I often thought of Coroney, Col-
lipeumo, and Ninhue: the land and the people and the unique setting of
the little village against the hills of the coastal range and opposite the
towering Andes and the chain of volcanoes, the tiny plaza with a few
flowers and palm trees, flanked by the church, and old adobe houses,
the orange trees lining the streets that demanded constant protection
from the vandalism of idle and bored children. I reminded them of their
fields at different times of the year: blond and parched in the summer,
verdant in winter, burnished amber with touches of crimson in the
autumn as the vineyards neared the time of harvest, and decorated in
shades of pink and yellow for the spring when the pears, almonds, and
mimosas would bloom in the hollows, marking the presence of houses. I
told them how I also thought of the chalk-white cemetery halfway up the
hill and of the steep climb of the stone-paved path of Los Calladitos, the
silent ones. It was as if I could see Ninhue in my mind, I told them.
Their houses, their patios with flowers and grape arbors, their orchards,
and even their animals—chickens, pigs, sheep, maybe even a cow, close
at hand. Equally alive to me was the character of village life, the proxim-
ity to relatives, friends, and acquaintances, and the gentle quality of their
existence.

Stitchery could bring them a worthwhile and enjoyable occupation, I
explained, adding that I, too, liked living in the country, and they agreed
it had many advantages, provided work was available for everyone.
Maruca Bustos dismissed my idealized view of village life by declaring in
no uncertain terms that I liked it because I did not have to live there.

"Maybe," I replied, "but if I had to, I'd want to make it better for
myself. Wouldn't you?"

"Why not—there's an idea," she answered gamely, and I saw others
nodding in approval, as if energized by the possibility of bringing about
a change for the better in their condition.

It was all very new, very tenuous and tentative, and yet inside that room while the darkness and evening chill fell outside, I sensed a unity, a developing willingness to do, a playful lightness and abandon, so new and fresh, that it made it all the more concentrated and active. I got up, went to the table, pulled out a roll of paper, and taking pencils and crayons, suggested they begin drawing something they might like to turn into a tapestry. After some joking and nervous laughter they sat down to work. Houses, trees, flowers, animals, and hills began to appear. They showed each other their work and laughed at the results. Úrzula Manríquez had difficulty making her house stand firmly on the ground; it looked as if it were about to take flight. "Don't worry," a woman told her. "That's your house up on the hill. You're windswept!" Morelia Herrera squatted in front of the ledge of a nearby casement window and began drawing the church that stood across the street. She sketched what she could see as well as what she could not, for she worked at the parish and was familiar with what was inside the church as well as the priest's house next to it. Encarnación Fuentes, a young girl, drew the church too but altogether differently. She did not draw what she saw but rather her own idea of what the church was. Rosa Montecinos designed an orange tree loaded with fruit, with the Andes and the morning sun in the background. These were some of the many drawings that were produced that afternoon; some were destroyed, not in discouragement, but with the will to try again. I looked at each delightful image and assured the women that once they were stitched in yarn they would surely meet their approval.

It was now late, and we decided it was time to go home; we would meet again the next day. Before they left I urged them to take whatever yarns they liked and found appropriate for their pieces. They reached into the baskets of yarn, turning them about, delighting in the colors, and then, ever so delicately, they chose two or three, rolling them into light little balls and putting them in their bags or pockets. Then they each cut two pieces of fabric, one for practice, the other for their project. They also took two needles, one dull and one sharp.

Before parting, I gathered them around me outside in the corridor, making the best of the faint light to show them one stitch. I made a bright yellow, fat spider web. They were amazed. They had never seen such a stitch. They all wanted to touch it and promptly gave it the name *el cototito*, the "little bump." I knew for sure I was going to see them the next day. The spider web had trapped them the same way it had trapped me.

The next morning at Mass, newly familiar and smiling faces lit up the church, but no one lingered to chat after the service. We scurried away for lunch before our two-thirty meeting. When the appointed hour came, a large gathering greeted me on the plaza between the church and the meetinghouse. I was introduced to new family members and friends who were eager to join the class, and to my delight my sister-in-law and nieces had come. A few men gathered as well, hanging back at a distance but curious, leaning against the walls of the surrounding houses, watching as they talked.

The slanted sun of late fall had warmed the afternoon enough that we decided to sit outside. The men fetched the benches, and the women arranged them while I made a list of my students' names. Forty-three students in all, all females, ranged in age, I discovered, from eight to sixty-seven. They had all heard about el cototito and wanted to see it for themselves, so I sat down and demonstrated. As I worked, some six or seven women stood behind me murmuring softly to themselves, committing each step of the stitch to memory. Nobody took notes. When I was done, each of them examined the stitch on both sides of the cloth and asked questions. Then they tried it on their own, and it was my turn to observe. They grasped the woven and wrapped principle of the stitch with no difficulty, and those who got it right the first time taught others. I took a group, and then each of those who mastered the stitch took a group, and soon everyone had learned el cototito.

As the stitch was repeated more and more successfully, the excitement mounted. Laughter resounded across the plaza, and even bystanders came to share in the merrymaking. I then showed them more textured

stitches, such as needle weaving and Turkey work, which became known as *punto tendido* ("stretched stitch") and *el peludo* ("the hairy one"). Together these stitches done in wool presented the women with a totally new concept of embroidery. The dramatic texture of the stitches, the ease of their execution, and their suggestive power were all appropriate for their capacity to evoke and represent a rich range of scenery, from the physical environment to the emotional landscape of the people who inhabited it.

Next we tried stitches they had done before using cotton floss for their household embroidered work, such as stem, buttonhole, chain, French knot, and bullion. These too were transformed by the coarser textures and heavier weights of the wool. Finally, I showed them one more stitch I suspected they did not know—Palestrina. The purpose was to dazzle them with the delight and ease of wool embroidery. As the women began to experiment using the colors of their choice to try each stitch, the resistance to making their own designs gradually diminished. Oranges, grapes, cherries, tomatoes, rocks, suns, moons, and stars began to appear on the canvases. In no time, the women were discussing the various ways they might use the stitches and marveling at the different possibilities each one offered. Already during these first days, this kind of exchange and mutual encouragement fueled their enthusiasm and established a generous ethos of sharing that would help to define the Ninhue style, both individually and collectively. As the repertoire of stitches was expanded and grouped according to procedure, the women began to better understand the potential for how each stitch might be used.

Before ending our first full meeting, I urged the women to start stitching right away whatever interested them. They took markers to draw on the fabric, chose more yarn, and departed.

T HE NEXT WEEK I followed the same plan. I taught in Santiago— new classes were starting—and on Friday afternoon I repeated my foray for yarn before boarding the train to Chillán. This time, Federico was unable to meet me and sent a taxi instead. The driver helped me with

the bags of wool and piled them on the back seat next to me. They made soft pillows, and I soon dozed off. About a quarter mile before entering Ninhue, the driver woke me and, slowing down, gestured to the road in front of us. It was dark, but in the headlight's beam I could discern a small figure planted in the middle of the road signaling us to stop. It scared me. The driver tensed, and I could see him checking the mirror and calculating his retreat in case of an ambush. Then, in a voice not totally devoid of concern, he exclaimed, "It is a child!"

As we got closer I recognized eleven-year-old María Cristina Silva, whom I had noticed the previous week during the class. She was an intense, curious little girl with round, rosy cheeks and intelligent eyes. In class, she had inspected what each woman was doing. She had missed nothing. "Please stop," I urged the driver. "It is all right." The man pulled up and María Cristina ran toward us, opened the door on my side and climbed in. "Did you bring any green?" she burst out. "I need it for here," she said, trying to show me something she was holding. The sympathetic driver turned on the light, and I saw she had a small piece of cloth on which she had embroidered a boy flying a kite. "I need it for the corners," she explained as she pointed to the pink kite. I realized the kite would not fly without the green, so we rummaged through the bags in search of all the greens I had been able to find. Taking her time, she tried them all and finally chose a bright kelly green. She quickly wound a small ball that she thrust into her pocket, and then, folding her work carefully, she settled against the bags, and we resumed our trip. I put my arm around her, but we did not say much. A little way into Ninhue, she asked the driver to stop. "'Til tomorrow," she said and jumped out and ran home.

The following day María Cristina was waiting outside the door of Maruca's house, where the women had now decided to meet because there was better natural light. The child's face was beaming as she held up her finished piece for everyone to see. I saw the pink kite soaring with the help of three beautifully made fat green puntos tendidos placed strategically at each corner (fig. 4.1).

That week I found the women eager to learn more new stitches—

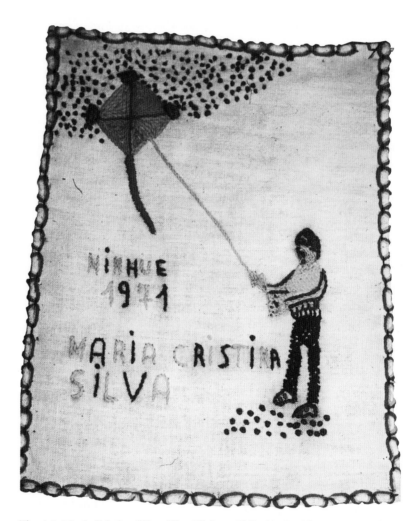

Fig. 4.1. María Cristina Silva, *Kite*. Ninhue, Chile. Embroidery. 10½ x 13 in., ca. 1971. Her only piece of stitching, *Kite* holds a special place in María Cristina's heart today. Throughout her life, the kite, soaring above, has symbolized her constant attempt to reach higher.

FA. 72.67.26. Reproduced by permission of the International Folk Art Foundation Collection, Museum of International Folk Art (New Mexico Department of Cultural Affairs [DCA]), Santa Fe, New Mexico.

those they had already used had whetted their appetite for more. I showed them variations of the chain stitch and fishbone, Cretan, Vandyke, and Basque. They grasped them immediately and understood their spatial and directional potential, and they proceeded to combine them with the stitches they had learned earlier for contrast and variety. In subsequent meetings, certain stitches such as buttonhole became such popular fillers that they became a distinct feature in the tapestries of Ninhue. The detached buttonhole was also adopted as the principal stitch for fashioning the human body in the three-dimensional figures that were developed years later. On the other hand, couching stitches never became favorites in Ninhue, possibly because they required hoops or frames, which the women did not like to use from the very beginning. For the same reason, I did not insist on their using long and short stitches or satin ones. A stitch that did become a great favorite, however, was the Romanian stitch that Maruca Bustos picked up from a friend in Cobquecura and later introduced to her colleagues in Ninhue. When done in short, winding curves and worked in glossy acrylic yarns, it gives a moiré finish to the piece. This style was applied mostly to the background of the embroidered slippers that were first made by the Vergara sisters.

During the next few meetings, we took up the running, back, and laced stitches and repeated the buttonhole and the chain. By now, I was comfortable discussing some of the technical points of these stitches, and the women had come to understand how the movement of the stitches related to the look and feel of their designs. They quickly absorbed cause and effect relationships: how the simple details of the stitches relate to the weights of the fabric and thread and how the manner of holding the cloth and the direction of the needle as it enters the fabric and is pulled through can distort the shape of the stitch. Almost instinctively they realized the importance of stitching with an economy of movement and at the same time accepted and became aware of their own physical and personal conditions, those idiosyncrasies that make each stitcher go about her craft differently.

They continued to find inventive ways to use the stitches I taught: the Eskimo stitch, for example, which is traditionally used to join together furs, was used ingeniously by the women to edge their tapestries. Thus, in addition to the use of nontraditional crewel materials (yarns and fabrics), the choice of subject matter, and the overall composition, this innovative edging was one more element distinguishing the emerging embroidery of Ninhue from the spirit and execution of traditional crewel.

Lives Emerge on Canvas

Choosing Their Stitches

As the women learned their stitches, I learned about them, their families, their extended relatives, where they lived, and what their interests were. Warmth, happiness, and much laughter accompanied us as we worked together, and I loved to watch them stitch: the way they eased into their work, slowly, gingerly at times, trying this way or that until their hands told them which way was best; their contemplative stares; and the appreciative strokes they gave their work when completed that would briefly interrupt their concentration. When I pored over their finished pieces, I discovered more. The little tapestries seemed identified by name to me, for as I looked at them, the women and their work became one.

Very early on I could see which stitches the women liked to do best. These favorites and the textures they produced would often determine the motifs the embroiderer would choose to stitch. Next came the selection of color in very precise hues to complement the stitch. Sometimes the repetition of a stitch in various shades of the same color or in a very restricted palette could produce beautiful results.

The first stitches introduced in embroidery classes in Chilean schools are the stem stitch, chain stitch, and buttonhole stitch. Not surprisingly, these were the most common stitches used in home embroidery. When I first began to meet with the women in Ninhue, I thought that some of them used stem stitch so much because it came easy to them. Yet when I looked a little closer, I realized a definite purpose in its

choice. Stem stitch is a very satisfying stitch, especially for a beginner. Depending on its direction and the material being used, it can produce a wide variety of effects that are particularly useful in creating textured, pictorial embroidery. When used as a filler, stem stitch can achieve a smooth, compact glossiness or a marked ribbed surface. As an outline stitch, it can be used to delineate an area either with a fine line or wider one, a flat line or more corded one. In addition to its remarkable versatility, stem stitch also allows the stitcher to fall into a cadence that both accelerates the rate of the work and makes it a soothing pleasure to do. The very simple repetition with the needle of in and out through the fabric is not unlike the spreading of paint with a brush, an effect sought by many embroiderers.[12]

I suspect it was this painted effect and not necessarily the ease of making the stem stitch that prompted María Herrera to use it to achieve the density of color she was looking for in *Copihue* (fig. 5.1). Similarly, Jaqueline Espinoza used it in a concentric fashion in *Fruit Bowl* (fig. 5.2), and Adela Parra created a certain texture for *Duck* (fig. 5.3) by using this elementary but effective stitch. The beautiful results prove the stitch was the right choice, but it was probably also satisfying for them to do the work in that stitch too. Over the week the women had worked hard on their pieces, and they shyly presented them for inspection. Most of them had done their own designs and a few had enlisted the help of relatives and friends.

The Women and Their Work

I was lucky that I got to watch as Morelia Herrera designed her embroidery of the church during our first meeting. She looked across the street at the church, and although she seemed to be copying it, the domed structure that she sketched bore no resemblance to the two-part building with its square bell tower to the side. She drew bouquets of flowers on the walls, similar to those set on the altar inside the church. Later, when she transferred her design onto the cloth she introduced the figure

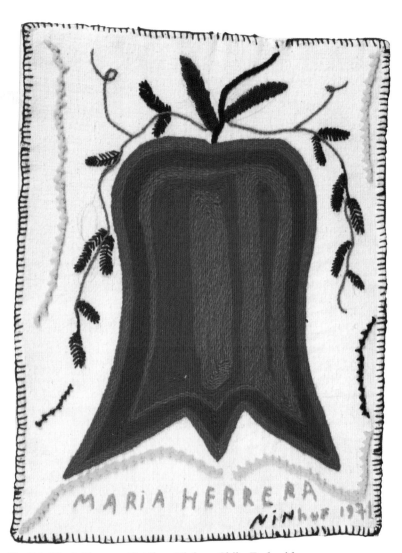

Fig. 5.1. María Herrera, *Copihue*. Ninhue, Chile. Embroidery.
In a simple yet serious manner, María Herrera recreated the shading and
smooth texture of the *copihue* (*Lapijeria rosea*), the national flower of Chile.
Reproduced by permission of Kent State University Museum.

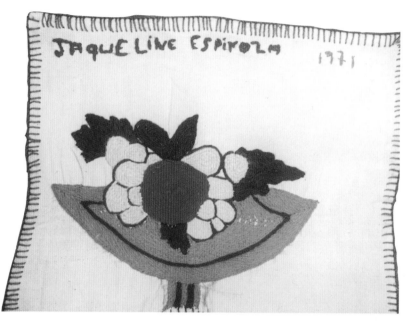

Fig. 5.2. Jaqueline Espinoza, *Fruit Bowl.* **Ninhue, Chile. Embroidery.**
The use of clear, unshaded colors helps to both define the shapes in the piece and enhance the terseness of the design.
Reproduced by permission of Kent State University Museum.

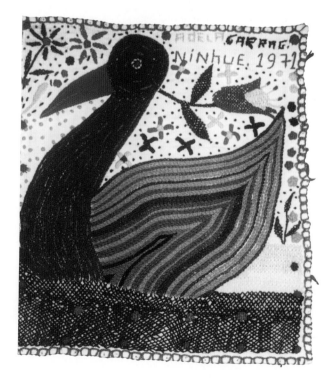

Fig. 5.3. Adela Parra, *Duck.* **Ninhue, Chile. Embroidery.**
Adela conveys pride and movement in her densely stitched duck by placing it on a background marked by sharp textural contrasts-—sparsely placed dots on the one hand and transparent netted stitches depicting water on the other. Her signature bell-shaped flower facing to the rear adds to the forward thrust of the piece.
Courtesy of the Museum of International Folk Art (DCA), Santa Fe, New Mexico.

of the Virgin, which stands in a grotto around the corner of the building. She decided to omit the flowers and instead add a garden. The multicolored patch shape in the upper left corner stands for the priest's house; it roughly represents its floor plan, which Morelia knew well since she had been employed at the parish (figs. 5.4 and 5.5).

In working the piece, Morelia did not concern herself with fine workmanship but rather focused on realizing the spontaneity of her vision. This was the first embroidered tapestry in Ninhue I saw that used bits of leftover yarn to finish its edges.

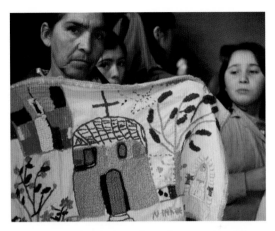

Fig. 5.4. Morelia Herrera shows her completed (but unstretched) church tapestry while María Cristina Silva looks on.
Photo by Mónica Bravo for Eva.

Morelia is a tall, slender woman, and in the tapestries she did after completing the church she depicted several elongated human figures—resembling her own—flanked by similar shapes to emphasize their linearity. *Lumberjack* is her best example (fig. 5.6). Similarly in *Flowers*,

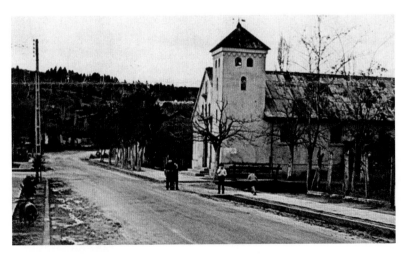

Fig. 5.5. Church of Our Lady of the Rosary, Ninhue, Chile. After the devastating earthquake of 1939, the church was rebuilt facing the new plaza. Its color is changed periodically; today, it is painted red.
Photo by Mónica Bravo for Eva.

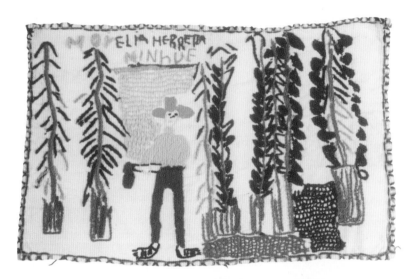

Fig. 5.6. Morelia Herrera, *Lumberjack*. Ninhue, Chile. Embroidery.
Perhaps Morelia intended to fill the background with a detached buttonhole
net but decided against it to accentuate the verticality of the piece.
Courtesy of the Museum of International Folk Art (DCA), Santa Fe, New Mexico.

blossoms are set upright side by side, as in a meadow, against a transparent background achieved by the use of wide-set buttonhole stitch (fig. 5.7). This technique conveys a dreamy, ethereal mood.

At the beginning of the workshop, Blanca Estela Fuentes showed me a basic sketch for a projected tapestry with flowers in each of the four corners and a heart-shaped object in the center. After only two meetings, however, Blanca Estela unfortunately suffered a heart attack. She survived, and her time in the hospital allowed her to work on *Flower, Snake, and Hummingbird* (fig. 5.8). Later, when she showed us her rich, dramatic piece done in vibrant colors, we could not help but feel she had translated her scary experience into an embroidered picture. The two flowers resembled breasts and the snake looked ominous to us. But Blanca Estela quickly corrected our misinterpretation, saying, "I love the snake. It looks so beautiful, whether it is up on a tree or just eating a

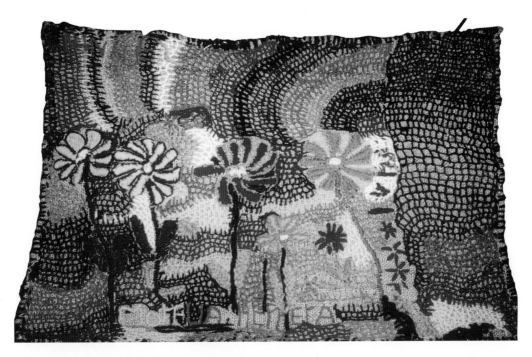

Fig. 5.7. Morelia Herrera, *Flowers*. Ninhue, Chile. Embroidery.
Morelia chose to stitch four tall vertical flowers and one close to the ground. To tie the composition together, she devised a light, variegated background that runs horizontally behind the flowers and vertically above them. The subtle checkered effect achieved by open rows of buttonhole stitch intensify the magic of the piece. *Photo by author.*

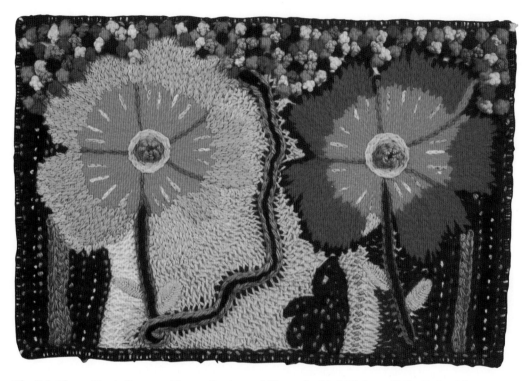

Fig. 5.8. Blanca Estela Fuentes, *Flower, Snake, and Hummingbird.* **Ninhue, Chile. Embroidery.**
Blanca Estela worked passionately on this piece during her illness and came up with her own version
of clustered spider webs, rather than waiting to return to the workshop to learn the way they had been
taught. *Reproduced by permission of Kent State University Museum.*

little bird." Such is the peril of interpreting another's work! And she
never did explain why she had not followed her original plan.

With few exceptions, the size of the tapestries corresponded to the
size of flour sacks cut in half, approximately 27 x 18 inches. For the
most part, the women would cut the fabric I provided to correspond to
these measurements. The flour sacks were made of *tocuyo*, an excellent
cotton muslin the right weight for embroidery. The sacks were com-
monly turned into napkins or dish towels. From the start, women
thought of the sacks as an appropriate and inexpensive material to use in
the future for their tapestries.

From the start, the spacing, texture, and color reflected the individual preferences of the stitchers. Some women drew the entire design on the fabric, centering it, and composing the whole; others—less assured perhaps—started at the edges or the corners as if they were just trying out the figures and the stitches. For the most part they planned their work with an unstitched background, creating a drawn and detached appearance for the figures. In addition to its aesthetic effects, this approach also had a practical aspect to it, for it offered those who had a minimum of time to devote to their stitchery the opportunity to complete their work without devoting hours to the time-consuming and demanding work of stitching in the background.

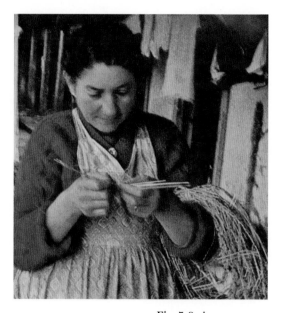

This practical aspect was especially important to María Ortiz, who had ten children and the responsibility of attending to the pressing demands of a large household with a variety of work. To increase her earnings, she braided *cuelchas*, did farm work at harvest time, and worked in the kitchen of a large shelter for boys that had recently opened in Curahuén, the house Tío David built up on the hill after the earthquake of 1939 (fig. 5.9).[13] Hence, the scarcity of time led her to design traditional farm activities as simply outlines, such as we see in *Mud Crab Diggers* (fig. 5.10). She then worked her pieces with great economy, using primarily stem and buttonhole stitches in carefully chosen colors. To maintain weight and balance, she added light touches of knots, bullions, and webs as sparse fillings.

Fig. 5.9. A woman braiding *cuelchas* from straw. In the Chilean countryside, it is common to see women walking up and down the street casually braiding *cuelchas*, which they sell or use later to make straw hats. *Photo by Mónica Bravo for Eva.*

Some women traced motifs to start their work and added various samples of stitches as fillers to complete it. Adela Parra's first piece, for example, was a sampler. She placed various rectangular and triangular shapes massed together at the base of the cloth and then stitched a dove

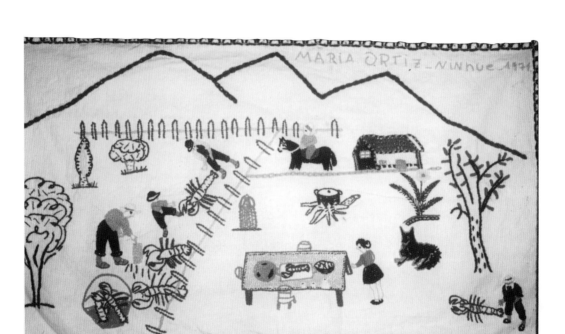

Fig. 5.10. María Ortiz, *Mud Crab Diggers*. Ninhue, Chile. Embroidery. 19 x 32 in.
In the wintertime, mud crabs are dug from the fields, sold, and consumed as a delicacy. Digging them is a messy job. The owner, sitting astride a horse, oversees the procedure that will damage his field. The silhouette of the hills is a carbon copy of the hills of Ninhue.
FA. 72.67.21. Reproduced by permission of the International Folk Art Foundation Collection, Museum of International Folk Art (DCA), Santa Fe, New Mexico.

over them. She placed a tulip-like flower—perhaps a *copihue*—on one side, and opposite it a symmetrically subdivided rectangle. The rest of the space is filled with tendrils, floral shapes, and dottings. Adela continued to develop her compositions with essentially these same elements, so the dove, which she had traced from a cement sack, became her trademark (fig. 5.11). In more elaborate designs, Adela juxtaposed horizontal planes to create depth and maintained the lower triangle as the axis of her composition. In *House* she introduced a sequence of triangles at the top to extend the horizontality of the design and to tie the same elements together (fig. 5.12).

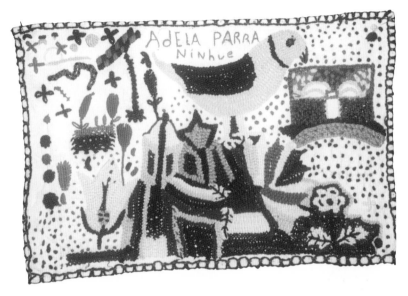

Fig. 5.11. Adela Parra, *Dove Sampler.* Ninhue, Chile. Embroidery. Because the dove became another of Adela's trademarks, I asked her if it was a symbol of love or peace. "No," she said, "since the sampler sold so quickly, I adopted it for good luck."
Courtesy of the Museum of International Folk Art (DCA), Santa Fe, New Mexico.

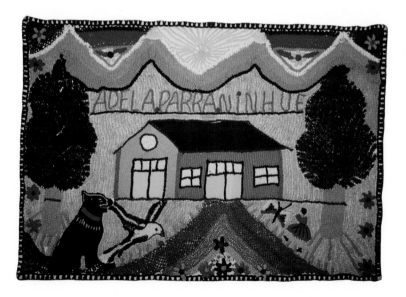

Fig. 5.12. Adela Parra, *House.* Ninhue, Chile. Embroidery. This piece is one of a long series of houses embroidered by Adela. Adela's penchant for houses is understandable, as she owns a spacious house with an orchard and flower garden.
Courtesy of the Museum of International Folk Art (DCA), Santa Fe, New Mexico.

Another important embroidered motif was developed by Patricia Medina, who traced the figure of a Pan Am plane from a poster and subdivided its shape into sections (fig. 5.13). These she outlined and stitched in various colors, producing a patchwork effect that was later adopted by several other embroiderers. Years later, I learned that Willem de Kooning, the painter, owned this particular piece, having received it as a gift from a giver who had acquired it at an exhibit.

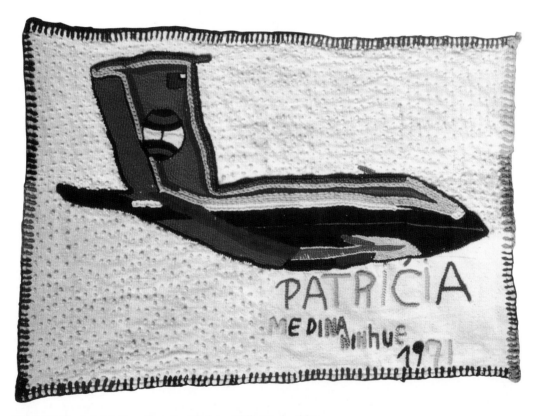

Fig. 5.13. Patricia Medina, *Pan Am*. Ninhue, Chile. Embroidery.
Patricia was fourteen years old when she traced the plane from a newspaper and embroidered it. When asked why she had chosen it, she explained that she wanted to leave the village. Today, Patricia lives in her own house in Coroney. *Photo by Mónica Bravo for* Eva.

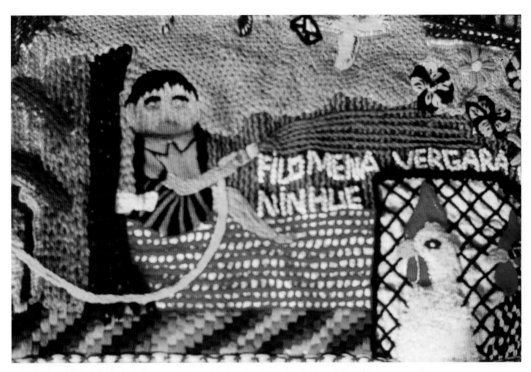

Fig. 5.14. Filomena Vergara, *Girl with a Hose*. Ninhue, Chile. Embroidery.
From her very first piece, Filomena showed her intuition for the potential of stitches. She used the Turkey stitch to represent the fluffiness of the white chicken feathers, black and white yarn in a magic chain to achieve a spattered effect (see the second chicken in the bottom right corner), and a combination of square chains, detached buttonholes, and couched stitches to simulate various transparencies. *Photo by author.*

Girl with a Hose was designed by a neighbor for Filomena Vergara to stitch (fig. 5.14). To this day, Filomena has not felt confident doing her own designs and has relied on family members to do them for her. When the piece was designed, the idea of stitching a girl sitting down to water her flowers with a hose was regarded as a joke, for at that time water was so scarce that watering was done only with a watering can, and very selectively at that. Yet *Girl with a Hose* has proved to be prophetic, for over the years Ninhue increased its water supply and now

people do in fact have hoses to care for more flower beds than in earlier years. Right away on this first piece Filomena concerned herself with what would become her signature style: the application of stitches that render her subject as realistic as possible. Striving for this realism, she establishes particular ways of creating special effects and characterizations when she needs them. On *Girl with a Hose*, Filomena used practically all the stitches she had learned, assigning each one a distinct purpose.

Unlike Filomena, many of the other women were not intimidated when it came to designing their work. Úrzula Manríquez, for example, who eventually became one of the most original and prolific stitchers, designed *Sad Donkey* as her first piece (fig. 5.15). Here, a small, blurry family portrait in the shape of a medallion appears off-center with the figure of a sad donkey under it, which gives the tapestry its name. The tired, forlorn little animal is positioned in the midst of a riot of flowers done in clear colors and textured stitches, highlighting its dejected aspect. Úrzula's next piece was a strange two-headed animal for which she offered no explanation and which intrigued all who saw it (fig. 5.16). Recently, Siri Montecino, who owns a Manríquez tapestry and is very attuned to her imagery, suggested it must be a depiction of a birthing goat, like the three-dimensional piece by Teresa Torres done many years later. Lina Andrade, on the other hand, created a more robust donkey, showing her tactile knowledge of the subject. The soft shading of grays and browns portraying the donkey indicates her dexterity in braiding cuelchas of natural and dyed straw (fig. 5.17).

The first works of Victoria Durán were designed to be simple and sparse. For example, a few of her compositions feature doves and flowers symmetrically arranged, using stem stitch in subdued colors that convey a tranquil mood. *Dovecote* is one of the most charming (fig. 5.18). Victoria went on to depict home and village life, which reflects her deep concern for Ninhue.

Edilia Medina's work, in contrast, uses many colors and distinguishes itself through the precision of its stitching. As a young girl, Edilia had

Fig. 5.15. Úrzula Manríquez, *Sad Donkey*. Ninhue, Chile. Embroidery.
Úrzula's work always seems to represent a life philosophy that joy and sadness are inextricably joined.
Courtesy of the Museum of International Folk Art (DCA), Santa Fe, New Mexico.

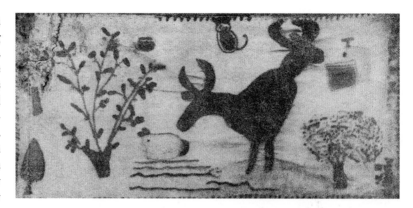

Fig. 5.16. Úrzula Manríquez, *Birthing Goat.* **Ninhue, Chile. Embroidery.** Before this puzzling piece was identified, it was called "The Monster," unbeknownst to Úrzula. Because this was such an early work, Úrzula may have felt too shy to tell what it actually represented.
Photo courtesy of Clarín.

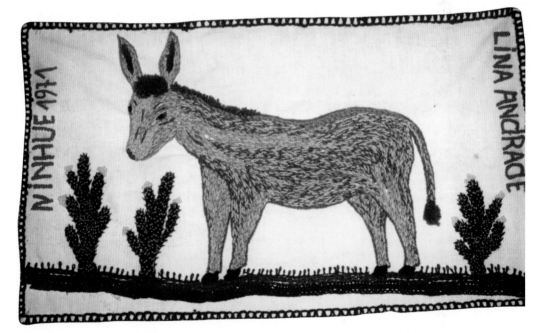

Fig. 5.17. Lina Andrade, *Burro.* **Ninhue, Chile. Embroidery.**
This piece is a great favorite of the public. When first exhibited at El Callejón de las Artesanías, many people wanted to buy it because they were impressed with the texture of the piece and the burro's gentle aspect. *Collection of Maria Marchant de Gonzales-Vera. Courtesy of the Museum of International Folk Art (DCA), Santa Fe, New Mexico.*

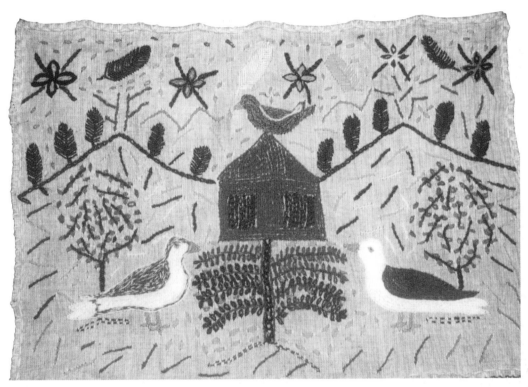

Fig. 5.18. Victoria Durán, *Dovecote.* **Ninhue, Chile. Embroidery. 15 x 22 in., ca. 1972.**
The dovecote at the center of the tapestry flanked by the outline of two identical hills that replicate the triangular shape of its roof, divides the space in half horizontally. Figures of doves, foliage, and trees and floral motifs mirror one another, creating a symmetrical effect of simplicity typical of Victoria's work.
FA. 72.67.6. Reproduced by permission of the International Folk Art Foundation Collection, Museum of International Folk Art (DCA), Santa Fe, New Mexico. Photo by author.

attended the *escuela técnica* (technical school) in Chillán and received a
degree in dressmaking and needlework. In Ninhue she worked as a
seamstress, and she promptly joined the embroidery workshop as soon
as she heard about it. Later, she told me what attracted her to wool
embroidery was the wide use of color and "the stitch variations in rela-
tion to the design." Although Edilia was experienced, several of the
stitches nevertheless turned out to be new to her. Her first tapestry was a
whimsical house with a *choroy*, a native parrot (fig. 5.19). This piece was
much admired because of its excellent workmanship.

 Orange Tree was created by Rosa Montecinos, who lived in the neigh-
boring town of Quirihue and was drawn to the orange trees lining Nin-
hue's streets when she designed her first work (fig. 5.20). The tree fills
the entire space of the square cloth with shimmering vitality. It bears
flowers and fruit, a bird sits at its top, and a girl with a watering can cares
for it. Yet it is embroidered with delicacy, which accounts for its trans-
parency. The sun and the hills of Ninhue convey energy and perma-
nence. Perhaps because she was not a native, she especially appreciated
cuelchas, and she picked a finely braided colored one to finish the edges
of her piece. The unusual choice suits the delicacy of her work.

Fig. 5.19.
Edilia Medina,
House with Choroy.
Ninhue, Chile.
Embroidery.
Unfortunately, a color
photograph of this
piece was never made;
one would have done
justice to Edilia's imag-
inative and expert use
of stitches.
Photo courtesy of Clarín.

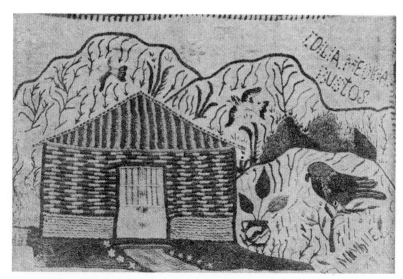

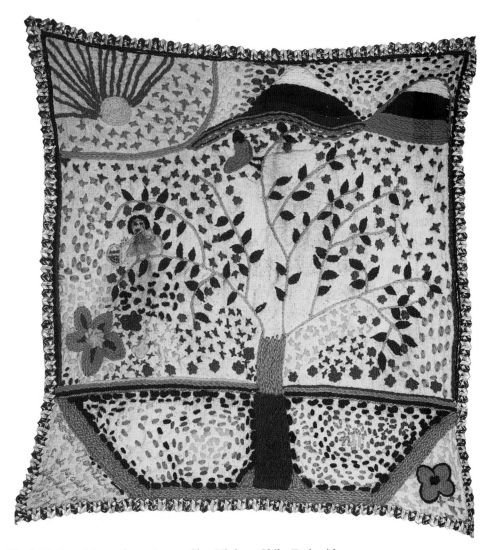

Fig. 5.20. Rosa Montecinos, *Orange Tree*. **Ninhue, Chile. Embroidery.**
Rosa calls on humans, animals, and nature to participate harmoniously in the depiction of the life force as she makes her orange tree a new emblem of the Tree of Life. *Photo by author.*

First Fruits

For six weeks I continued to split my time between Santiago and Nin-hue, making the trip from the city to the village every weekend to teach the women stitches and techniques and to bring them materials to work with. The women's spontaneous expressions amazed me, and their inge-nuity—which appeared so readily in their recently acquired craft— delighted me. The women were enjoying themselves thoroughly; at the same time they were taking their work seriously, and their families were pleased with and proud of the results. In many instances husbands and children contributed with suggestions and designs. It was almost becoming a community enterprise.

I marveled at the ease with which all this was taking place. At first I naively told myself that this was the typical reaction of people newly enthralled by stitchery. Later, I would concede that people—no matter what their circumstances—would not pass up the opportunity to receive free instruction if there was any probability for gain. But I did not really dwell on these alternatives because I was won over by the obvious results and by everyone's friendliness. What was actually happening was what I had wished for: the women were enthusiastically responding to and becoming captivated by an activity that would reveal to them some-thing they had no idea they could do. And what's more, they were doing it in the midst of disturbing times, which showed how the creativity, concentration, and devotion of embroidery could bring solace and respite to a worried mind. In fact, both the playful and calming aspect of the project even drew in some of the men of the village, which I found especially encouraging. Politically, the die had been cast—the sweeping land expropriation for the region seemed to be moving on inexorably, yet at the same time, the government was running into grave difficulties as it attempted to bring about those changes. People throughout Chile were experiencing an ever-increasing deterioration in the quality of goods and services. The supporters of the new administration could not help but sense the precariousness of the situation and were coming to

realize that mere simple adjustments would not effect the future changes they had envisioned. For my family and me, it could only result in loss.

Time after time I walked up and down the village, and in so doing, I could not avoid seeing that hateful sign in front of the post office. I took it in and allowed myself to be reminded of its implied danger, but thankfully the panic was gone, and shame did not make me lower my eyes. The embroidery project had begun to work its subtle changes; I could not ignore the happiness the work of the embroiderers brought me, nor could I overlook the extraordinary unspoken understanding that had been forged among them and between their families and me. Politics had no place in the embroidery workshops.

As the days went by, their strong commitment convinced me that something lasting would come from this work. What they were depicting was truly theirs: they were distilling their experience into symbolic representations in both personal and communal terms. Their self-awareness was gradually developing and with it a sense of identity felt not only by the stitchers themselves but also by those outside the village. This is not to say that there was not a good deal of skepticism and shyness mixed with their pride and growing confidence. The women felt great ambivalence when faced with the possibility of presenting their work to a public audience. Comparing their work to the pictures they admired in magazines, they worried their images were too coarse and not realistic enough. And although I tried to encourage them, telling them a literal rendition of their world would be less interesting and therefore less desirable, they were not soothed.

By the time the first tapestries were completed, winter had set in and the mayor of Ninhue invited the women to hold their meetings at the *municipalidad* (town hall) where they would have better light and heat. This new public and centrally located place allowed them to develop a following of sorts. As they stitched, people from the village and the surrounding areas would stop and visit. The women relished the attention and exchange. Soon they were answering all kinds of questions and offering explanations about their work.

When the first completed tapestries were ready to be blocked, they asked some of the men who happened to be present to help. The municipalidad provided large boards that had been used as political posters, which the men hoisted and covered with brown paper. It so happened two boards were available, one that had been used by the followers of Allende and another by the followers of Jorge Alessandri. I chose the latter, as it was the one Father had provided for the earlier political race.

Armed with rulers, tacks, and hammers, they stretched and blocked the tapestries. As the pieces were blocked everyone could see the stitches surface and stand out in all their beauty. The women marveled at what lay before them. We gathered around the boards in silence to look at the blocked tapestries, which were standing side by side, forming a still larger tapestry, one that was totally unexpected: here, in all their diversity, the tapestries formed a new whole that displayed the cohesion of the group. It was a deeply moving moment for all involved.

At the blocking, I watched as each woman searched for her own piece and looked at it for a long time, and then gradually noticed the others and studied them in detail. Suddenly the women all began talking, pointing out what delighted them, what made them laugh, what struck their hearts. The women praised each other's work generously; they confidently offered educated comments about the craftsmanship and appreciated the humor and ingenuity reflected in how certain details were done. They showed their familiarity with each other's pieces by noticing the changes and improvements that were introduced before completion.

After the initial excitement subsided and the women again turned to fix their eyes on their own tapestries, a reverent silence set in. They had plenty to say about each other's work but nothing about their own. As their whole production lay before their eyes, they focused on the piece they knew best, standing still before it, mystified, their faces full of questions. They seemed to wonder how they had accomplished this work. Some extended a finger to touch, rearrange, or just fondle a particular stitch as if this element of their pictorial representation held the clue to

the transformation that had taken place in their souls. Too modest and too innocent to give creativity a name, they seemed not to even recognize its presence. In time, as they continued to practice their craft, they came to trust it as a constant and dependable companion.

Even after all these years, recalling that day evokes silent smiles, for its power seems to exceed words. And it is good that silence guards that sacred moment.

"We Can Get Our Own"

Publicity and Recognition

Less than a month after initiating the classes in Ninhue, I met Hernán Edwards in Santiago, who was looking for unusual material for the first exhibit of his new folk art gallery that was to open in August. I showed him some unfinished pieces, and he decided they were just the right thing for the show. When I broke the news to the women, they could hardly believe their good luck. The gallery promptly contacted the media, and *Eva*, a woman's magazine, responded by sending a writer and photographer to do a story on the stitchers. Soon after, other periodicals and newspapers followed suit with the result that the public was well aware of the new artisan group when the gallery show opened in Santiago on August 6, exactly two months after the women had started their work.

During the weeks that preceded the exhibit, the women worked at a rapid pace to meet their first deadline, but they remained cool and skeptical. Although they worked diligently, every so often they would pause, turn to one another and ask, "Who would ever want to buy these *monos*; would you, *comadre*?"[14] The response was invariably, "Are you crazy? Not I!" Then they would laugh and continue.

When it was time to price the tapestries, their self-deprecating humor shifted to obstinate refusal: "We can't charge for materials because they didn't cost us a thing."

"Never mind that," I countered, "you know what the materials cost. Now tell me how many hours you worked on each piece." They hadn't kept track of their time, even though I had begged them to do so.

"How can we do that? It's a bit here and a bit there, between feeding the chickens, working in the garden, setting the pot on the fire, and looking after the kids."

"At night, then?" I insisted.

Then there was a big laugh. Those who were married did not touch their work at night. "Our husbands would think we don't want them anymore!" they protested.

I found little support. They were expecting me to price their pieces, but I tossed the responsibility back to them. The work was theirs. Yet they resisted with an attitude that verged on sullenness.

We were stalemated until finally, in desperation, I took up a piece that lay in front of me and said, "Suppose somebody were to come in here and ask you to do something like this—this size, a similar subject matter, with the same treatment of color and stitches. What would you charge?"

Without missing a beat the author of the tapestry declared in a convincing business tone, "Ah! In that case if someone wanted me to work for her and she wanted me to do a special piece, then I would do it for three hundred to three hundred fifty pesos." [15] It was a moment of revelation to me and to them. As far as their embroidery was concerned, they would have to start thinking of themselves differently, and they had just taken the first step in doing so. Eventually we settled on a pricing method based on the size and amount of stitchery covering the cloth. [16]

The next step for them was to participate in setting up the show, attend the opening, experience the reaction of the public, and bask in the attention they would receive. But this time all my plotting and prodding failed. In the end only one of the forty-three, Filomena Vergara, was able to go to Santiago.

The name of the new gallery was El Callejón de las Artesanías, which translates as "craftwork alley," but it was more like a courtyard. It was paved with cobblestones around an old fig tree, and a profusion of

plants and flowers softened the stark light of the display cases set around the enclosure. The debut of these first embroidered tapestries was especially beautiful in the festive atmosphere created for the late winter opening of El Callejón. The turnout was large and included dignitaries and even Chile's first lady, Hortencia Bussi de Allende. Filomena became the star of the evening. She guided the first lady through the show and was interviewed repeatedly about her work, Ninhue, and the rest of her colleagues. The exhibit was practically sold out in the first twenty minutes, and the reviews that appeared in the following weeks ranged from complimentary to ecstatic.

The following is a sampling of the press the Ninhue project received:

El Mercurio: "These country women from the area of Chillán have become part of the popular art form that Violeta Parra initiated in Chile and which the embroiderers of Isla Negra picked up."[17] (August 8, 1971)

El Mercurio: "The embroiderers of Ninhue are a revelation in terms of the quality and authenticity of their works." (Date unavailable)

El Clarín: "Candor, emotion and bold coloring are the principal characteristics [of these tapestries]. This embroidered work will very soon become conversation pieces." (August 29, 1971)

El Siglo: "These extraordinary embroidered cloths are a magnificent testimony of the possibilities and qualities of Chilean popular art." (August 7, 1971)

Eva: "There are the parish flowers abundantly watered, trees, landscapes, the plans of trips long dreamed of. Everything is a shout of life, full of strength and color. Each embroiderer has put her soul in her work. The impatient one cannot finish her piece in her eagerness to start another; the perfectionist fills each space with a new motif or filling. Most of the women portray their families, their village or whatever they most appreciate of their surroundings. The art of the embroiderers

from Ninhue cannot leave anybody indifferent!" ("Nin-
hue, a New Artisan Encounter," Sept. 17, 1971)

Paula: "The first thing that hits the eye is their joy. But their
 sorrows and problems also appear." (August 19, 1971)

El Sur: "The name of the stitcher also performs as a decorative
 element and it revives an ancient Spanish artisan tradi-
 tion." (Roberto Escobar, August 13, 1971)

In Ninhue, the women could not fully grasp this enthusiastic out-
burst. As time went by and they continued reading what was being writ-
ten about them and as we discussed it together, it began to dawn on
them that they had made an important contribution to folk art in Chile.
To be singled out as followers of Violeta Parra was astounding. The
public recognition of various elements in their tapestries as representa-
tions or suggestions of their lives gradually helped them to see their vil-
lage and the lives they had stitched differently. They began to hear their
own voices and respect them. Slowly, almost cautiously, they started to
discuss new projects as they committed themselves to this craft.

They took their work seriously. When I returned with the money
from the gallery sales, they were quiet and restrained. They received the
money and thanked me with great dignity and solemnity. They smiled as
if, at last, they were coming to terms with what had been developing
during the last twelve weeks. Trying to sum it all up and weighing each
word carefully, one woman told me, "From now on there is no more
need for you to give us yarn. We can get our own with what we have
made and we will stitch on the flour sacks we have." The others mur-
mured their agreement, but that was all that was said. They were now
professionals.

Tapestries from Daily Life in Ninhue

The tapestries done after the exhibition showed a growing confidence in
the thematic choices the women made. Some of them began to portray

more complex scenes involving daily activities or exciting events, such as the arrival of television in Ninhue in June 1971.

The first TV set was installed in the entrance hall of the municipalidad. It created a great commotion in the village, and people stopped in awe, watching as if in a trance and saying very little. María Parra, who was ten years old at the time, left us an invaluable document of the event. She modestly named the piece *Watching TV while Waiting for the Bus*, as if to minimize the exciting event, instead focusing on a more ordinary activity (fig. 6.1).

In her piece we see a bus whose driver barely seems to occupy his seat. To the left, a man wearing a cap is captivated by the TV set. Since the bus stop was in front of the municipalidad, both drivers and passengers lingered to watch TV from outside the building before departing. María Parra had little concern for turning out well-finished stitches; she was in a hurry to record an important event in her community. Especially touching is the representation of the TV set itself, for she had no prototype on which to base her design; it is all her own. It is interesting to note that she shows no image on the screen.

Some time later, her sister, Gladys Parra, also recorded the arrival of television in Ninhue on a nine-by-ten-inch piece of cloth. Gladys's tapestry shows a young girl—probably copied from a magazine—standing close to the set, which is drawn simply as a box. It sits on the table and includes an image on its screen (fig. 6.2). The proximity of the girl to the set suggests a familiarity with this new appliance and its adoption into the home. The piece is beautifully balanced and well distributed within its small format. A vertical red stripe to the right balances the standing figure, and the background is divided at the top by horizontal blocks. The bottom of the background is filled with the stitcher's name, date, and place. This compact piece in rich warm colors, densely stitched to cover most of the background, conveys more enjoyment than excitement.

Luisa Quijada and her husband lived on inherited land up the hill behind the village. She kept a garden and tended her sheep while her husband took care of a herd of goats. Interested in relationships and in the cyclical aspects of life, Luisa translated the subjects that inspired her

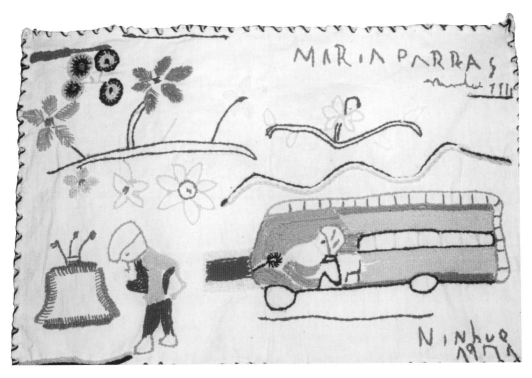

Fig. 6.1. María Parra, *Watching TV while Waiting for the Bus.* Ninhue, Chile. Embroidery. 14½ x 22½ in., ca. 1972. The bus stopped in front of the *municipalidad*, but it is interesting that María identifies the place by outlining the hills of Ninhue (shown here above the bus) rather than stitching the building itself. *FA. 72.67.23. Reproduced by permission of the International Folk Art Foundation Collection, Museum of International Folk Art (DCA), Santa Fe, New Mexico.*

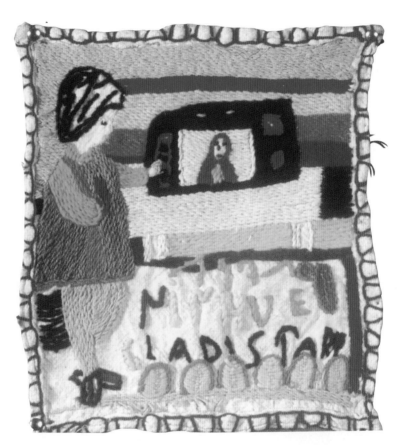

Fig. 6.2. Gladys Parra, *Girl and TV Set*. Ninhue, Chile. Embroidery.
The image Gladys recorded in this piece is that of an already established reality in village life; therefore, it seems appropriate that she used a carefully planned and masterfully executed style to convey acceptance and institutionalization of the television. *Photo by author.*

with great feeling and directness. She had lost two small children and
depicted life with faith in the promise of renewal that nature offered her.
Spring (fig. 6.3) represents a woman tending her sheep and swine
against the background of the inside of her house. On the right stands a
cherry tree in full bloom with smaller ones scattered below it. To the left
stands a dead tree. In Puebla—a very dramatic and powerful piece—four
houses surrounded by fences are linked by well-defined roads (fig.
6.4).[18] A netlike sky frames it above. The colors are dark and intense,
and the use of empty space is striking. Animals—mostly birds—are
coarsely represented with little detail. To the right, in a narrow space
between two trees, two birds fly vertically toward each other.

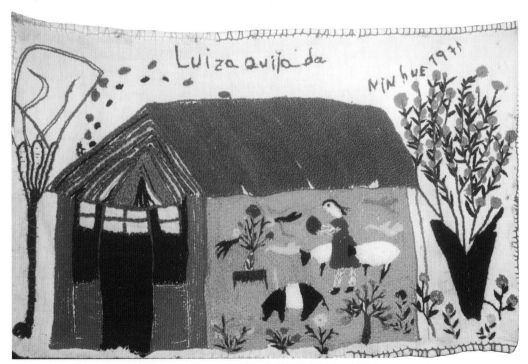

Fig. 6.3. Luisa Quijada, *Spring*. Ninhue, Chile. Embroidery. This is Luisa's second tapestry. She cele-
brates life as she practices it. The massive colorful house centrally positioned exudes strength while the
trees on either side—one dead and one in full bloom—suggest the cycle of life. *Photo by author.*

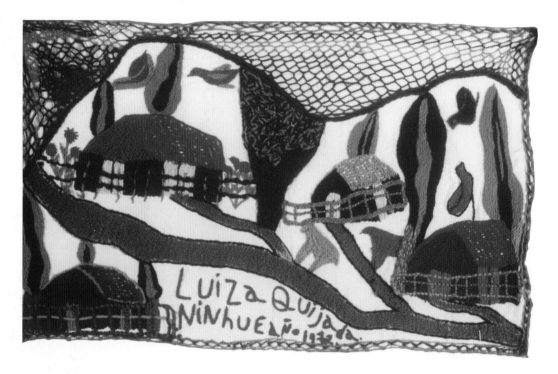

Fig. 6.4. Luisa Quijada, *Puebla*. **Ninhue, Chile. Embroidery.**
Long ago, Luisa mentioned that stitchery made her more connected with the affairs of the village, especially with the school at the time her children were in attendance there. *Photo by the author.*

Gladys Contreras lived in a house near a stream with her father, Filidor, the majordomo of Coroney. The location of their home near a barely adequate supply of water enabled Gladys to take in laundry for income, but her days were long and arduous, judging from the many large baskets of freshly washed and perfectly pressed laundry she sent back each week to our farm and to other clients. Hence, I was pleasantly surprised to see Gladys had found the time to attend the workshops in spite of the demands on her time to finish the laundry.

It did not take Gladys long to turn in *Lumberjacking Scene*, in which a man with an ax fells a tree while a woman piles firewood onto a cart (fig. 6.5). The scene conveys a happy energy, featuring shapes done in

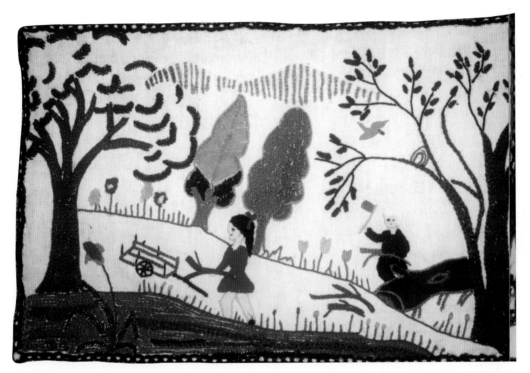

Fig. 6.5. Gladys Contreras, *Lumberjacking Scene.* **Ninhue, Chile. Embroidery. 15 x 22 in., ca. 1972.**
The densely stitched green poplars behind the red figure of the woman gathering firewood focus our
attention on the effort exerted, while the two sparsely stitched larger trees framing the scene contribute
to a tone of lightness and happiness.
*FA. 72.67.2. Reproduced by permission of the International Folk Art Foundation Collection, Museum of International Folk Art
(DCA), Santa Fe, New Mexico.*

bright clear colors that suggest a hilly environment. Four trees distinctly
characterized by Cretan and buttonhole stitches frame the action. In the
upper background, the Andes are defined by light blue vertical lines
done in the thick Palestrina stitch, a device that suggests depth and dis-
tance, complementing the thickly filled foreground where the woman
stands.

Edilia Medina embroidered with great aplomb, and her pieces offer a
feast to the eye. In *Country Landscape* (fig. 6.6), the cloth is completely
filled in. On the lower left side a pond offers refuge to some geese, which

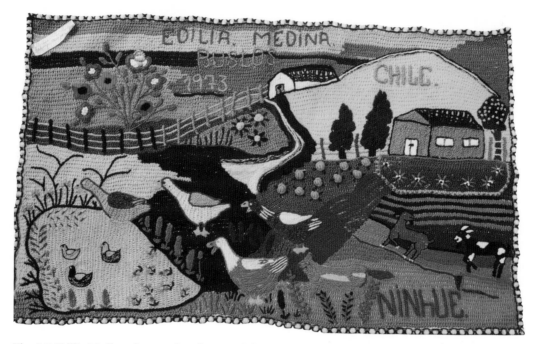

Fig. 6.6. Edilia Medina, *Country Landscape*. Ninhue, Chile. Embroidery. Winding roads define curved areas that contain the elements of a typical country scene and whose action is both sustained and distracted by line and color. *Photo by author.*

are fleeing a fast-pursuing fox. Three ducks are already on the pond, and some flowers and grass border it. Colorful patches define different planes of the piece and also help to integrate the various elements of the composition. A road stops abruptly with great color effect, and the quiet houses lend stability to the rolling landscape. Here, however, Edilia did not choose colors to convey any sense of realism. To add to the gaiety, the fresh, clean colors of a bouquet of flowers behind a fence takes the place of a tree. Meanwhile, two romping goats follow each other playfully, contrasting with the aggressive fox. The horizontal patches at the

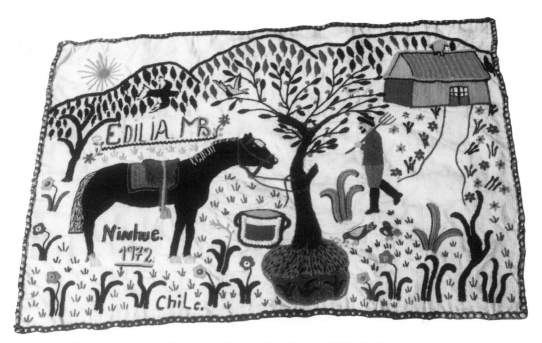

Fig. 6.7. Edilia Medina, *Man, Horse, and Orange Tree*. Ninhue, Chile. Embroidery.
Upon closer inspection, two sets of allied images seem to be at work in this tapestry: one, the man walking toward his horse; the other, the house and tree of life, whose branches point toward the house as if drawn to it. *Photo by author.*

top of the piece give it a sense of depth and distance, while slanting lines in the foreground accentuate action, movement, and perhaps even anxiety.

Edilia Medina, limited by poor eyesight, produced few pieces, but *Man, Horse, and Orange Tree*, a very rich piece even if the stitches do not cover the entire fabric, is an outstanding example of her ability as a stitcher (fig. 6.7). It also highlights her acumen in portraying the interaction between human beings and nature. The tree is the central focus in the tapestry. It is bearing fruit, and its root system is purposely exposed,

which Edilia emphasized by overstitching the row of plants at the bottom of the tapestry right onto the roots. The tree projects its life force, and the man coming from his house, the horse tied to the tree's trunk, and the birds in the piece are all drawn in by it. Fertility is further accentuated by eggs in a nest harbored in the crook of the middle branches of the tree.

For Emelina Ramírez stitchery became the platform for a spiritual unfolding that is traceable in her art. She joined the group after the first exhibit in Santiago at El Callejón de las Artesanías. Though she had mastered an excellent embroidery technique in school using cotton and silk floss, she was intimidated by having to come up with her own designs. After trying her hand at wool yarn on copied embroidery designs, she produced her first original piece, *Andean Landscape*, which still relied on a postcard-like depiction of the Andes for its design (fig. 6.8).

Soon after she started working on this piece, Emelina discovered the therapeutic effect of embroidery. For example, she chose split stitch to fill the mountain area of her piece. Because of its flatness, split stitch is slow going and time consuming, attributes Emelina was well aware of when she chose the stitch for her work. When she needed to calm down or work out a problem, she would work the split stitch in a light shade of mauve; once calmed, she would turn to other sections of her work and do more textured stitches in brighter colors. For Emelina, this piece ended up representing an important emotional breakthrough, and she confided that she fell in love with it. Once finished, she hung it up and looked at it again and again. Although her daughter wanted to keep it at home, Emelina knew the work would enable her to keep sending her daughter to boarding school in Chillán. From then on she created her own designs using a bolder palette and coarser textures.

Inés Castillo and Nino Andrade were the first husband-and-wife team to design and stitch together, and two of their six children, Sara and Elisabeth, joined them soon after they had begun. In spite of her large family and the work she had to do at home, Inés did knitting for sale and

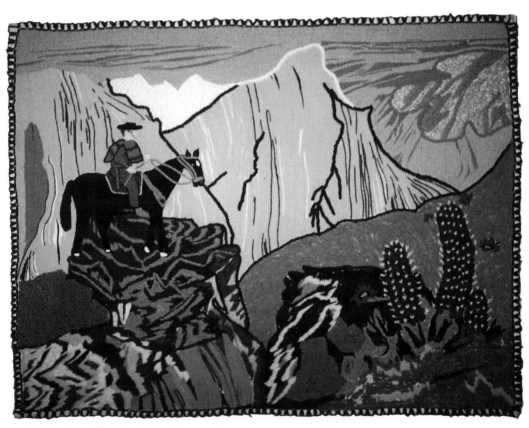

Fig. 6.8. Emelina Ramírez, *Andean Landscape*. Ninhue, Chile. Embroidery.
Emelina chose her early subjects not from close personal experience but rather from something more remote, which she considered more admirable and grandiose. Still, the actual elaboration of the work, evidenced here especially by the use of split stitch, brought her in close contact with her inner self.
Photo by author.

also worked in the fields during the grape harvest. She liked to embroider and was intent on good workmanship but felt she had no talent for combining colors. Nino was a carpenter who also did a variety of farm work. He enjoyed drawing classes at school and especially appreciated how his designs improved once they were stitched. He also believed that a person could better himself by using his imagination, which explains his faith in embroidery as a good source of income and a business in which the whole family could take part. Inés agreed, going on to point out that making more money by stitching than her husband could by doing carpentry or farm work would not affect their relationship, for "it does not matter who brings the money home."

He designed *The Killing of the Hog* for his wife (fig. 6.9). To embroider the piece, Inés used flat stitches both for outlining the figures and for filling them in so they would have the right weight and volume. The bare background makes it especially easy to follow the entire process of this typical farm activity, here represented by cartoonlike figures. Inés ingeniously used cross-stitch, which had not been taught in the workshops, to represent the diced *chicharrones* (pork cracklings).

Inés also interpreted the design of *San Agustín*, a representation of the house (and now a national landmark) of the revered naval hero Arturo Prat, whose memory is honored annually in Ninhue on May 21, the anniversary of his death (fig. 6.10). Originally designed by Iris Rodríguez, a school teacher and wife of the mayor at the time, the representation captures the simplicity of the traditional Chilean farmhouse: a tile-roofed, one-story, L-shaped building opening onto a long *corredor*, a pillared, covered porch. An ancient eucalyptus tree towers behind the roof, and the Chilean flag indicates the patriotic significance of the place. Inés Castillo was the first to interpret this design with stark, precise lines.

Ester Garrido chose to represent the *cueca*, the national dance of Chile, in her tapestry (fig. 6.11). To do so, she copied the design from a print and used mostly outline stitches and very little filling to embroider a couple that stands freely against an unstitched background. Interestingly,

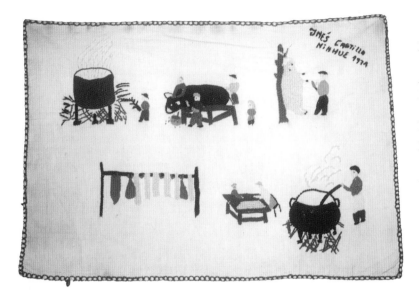

Fig. 6.9. Inés Castillo, *The Killing of the Hog*. Ninhue, Chile. Embroidery. Inés strove to interpret her husband's design with precision, using simple flat stitches to make the process of slaughtering a hog as clear as possible to the viewer. *Photo by author.*

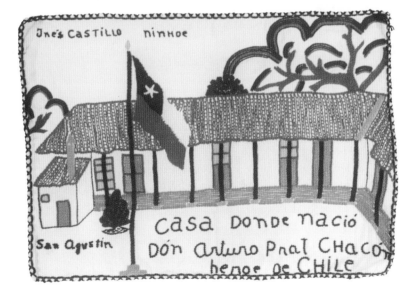

Fig. 6.10. Inés Castillo, *San Agustín*. Ninhue, Chile. Embroidery. 28 x 20 in., ca. 1972. Inés aims to acquaint the viewer directly and respectfully with a national shrine that is located in an old traditional Chilean country house.
FA. 72.67.5. Reproduced by permission of the International Folk Art Foundation Collection, Museum of International Folk Art (DCA), Santa Fe, New Mexico.

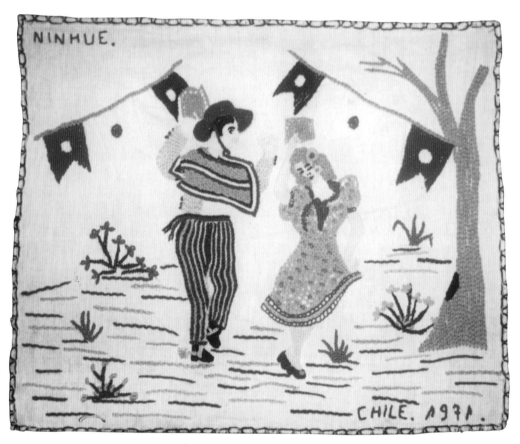

Fig. 6.11. Ester Garrido, *Cueca*. Ninhue, Chile. Embroidery.
As an accomplished dancer of the *cueca*, Ester shows her enthusiasm for the dance in this piece.
Courtesy of the Museum of International Folk Art (DCA), Santa Fe, New Mexico.

Ester's rendition of the dance shows a looseness and abandon on the part of the woman that is not altogether traditional, even though when she herself danced the cueca, she did so in the traditional style, keeping her movements confined to suggest a tinge of indifference at the relentlessly circling man, which parodies the coupling of a rooster and hen. The restrained control on the part of the woman is meant to show the tricky balance between her independence and her acceptance of her partner's advances.

As the women stitched, they were entertained by the charming play-fulness of Teresa Torres and Ruth and Alicia Cortés, who were insepara-ble friends (fig. 6.12). The girls would help each other with their work and carry on with youthful shenanigans. For example, while Teresa designed for Alicia, the latter would write love letters to her brother on Teresa's behalf. I guess the strategy worked, for later Teresa and the Cortés brother married. Ruth was interested in depicting her home, and she was one of the few stitchers who portrayed rooms. She first designed and embroidered her bedroom using only outline stitches, and then she added the dining room in the same way (fig. 6.13). She did not, however, maintain this technique when she embroidered a rodeo designed by her godmother, Iris Rodríguez, in bold colors covering the entire cloth (fig. 6.14). Years later she depicted a cozy and whimsical liv-ing and dining room scene (fig. 6.15). She showed in great detail a well-furnished room and stitched it densely. A man sits reading a newspaper while another person gestures toward the dining room. On the wall is a tapestry of a landscape and a calendar issued in Ninhue, and through a window the viewer sees a garden and the snow-covered peaks of the Andes in the distance.

Fig. 6.12. *Left to right*: **Teresa Torres and Ruth and Alicia Cortés.** Theirs is a friendship that has endured to this day. *Photo by Mónica Bravo for* Eva.

Fig. 6.13. Ruth Cortés, *Bedroom Scene.* **Ninhue, Chile. Emroidery. 16½ x 22 in., ca. 1972.** By embroidering her bedroom, Ruth seems to want to share the intimacy of her home. *FA. 72.67.5. Reproduced by permission of the International Folk Art Foundation Collection, Museum of International Folk Art (DCA), Santa Fe, New Mexico.*

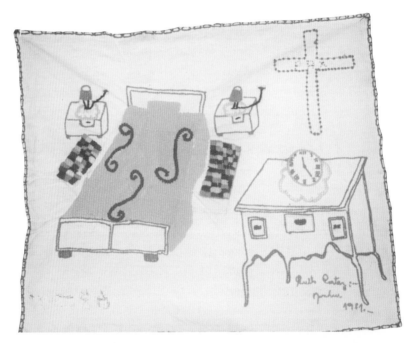

Fig. 6.14. Ruth Cortés, *Rodeo.* **Ninhue, Chile. Embroidery.** This is an uncharacteristic piece in which, I suspect, Ruth followed suggestions for color and texture from Iris Rodríguez, the designer of the piece. *Photo by author.*

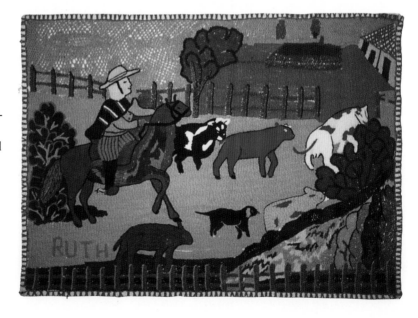

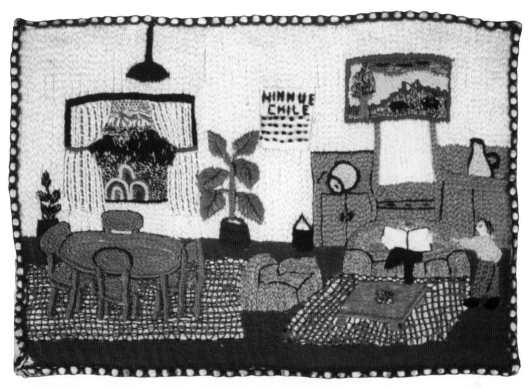

Fig. 6.15. Ruth Cortés, *Living Room*. Ninhue, Chile. Embroidery.
This tapestry invites the viewer to examine every detail in the room to learn more about the way Ruth lives, much as we examine a home's décor when we visit someone for the first time.
Reproduced by permission of Kent State University Museum.

Alicia Cortés designed *House and Eucalyptus Tree*, a powerful piece that took her a long time to produce. The tree, shown in figure 6.16, represents a eucalyptus, filled and shaded with rows of stem stitch, close to a house. This is one of the most dramatic characterizations of trees among the tapestries of Ninhue.

Teresa Torres represented the totality of actions by interrelating the elements that defined them. She left nothing out that was necessary for making her point, but she also added nothing that would detract from it. Several years after she had started embroidering, I showed her slides of her first works and asked her to comment on them. This is what she said referring to *The Hunt*, her first work done in outline stitches (fig. 6.17)

> Here, I told myself, are autumn days in the country when the leaves begin to fall. The hunter goes out on a hunting day, as it is a sport for him. Here, I imagine, he finds something interesting, perhaps some kind of bird. [When I designed the piece,] I imagined a rabbit escaping when he heard the shot, just as the birds did. After the hunter and the dog have walked a long stretch, I imagined the dog lying in front of a pond to quench his thirst. I painted the colors so they would coincide with nature, and I chose the stitches I liked best that would make what I was embroidering real.

In *The Orchard*, Teresa expressed the proud determination of a woman who crosses a garden that she has carefully tended to pick some ripe fruit (fig. 6.18). The awkward, broken lines of the branches of the fig tree are repeated in the line of the fence and in the separation of the different plots. Teresa again left the background open and filled only the elements she considered important. The figure of the woman seen from the back is especially dynamic and compelling, for it invites the viewer to identify with the action by being drawn into it. This is what Teresa had to say about the piece:

> In *The Orchard* what I imagine is going to the orchard to see how my plants are doing—if some plot was in need of water—that's why I made the well in the middle [of the piece]. After examining the plants, I picked vegetables for dinner. Then, upon leaving the

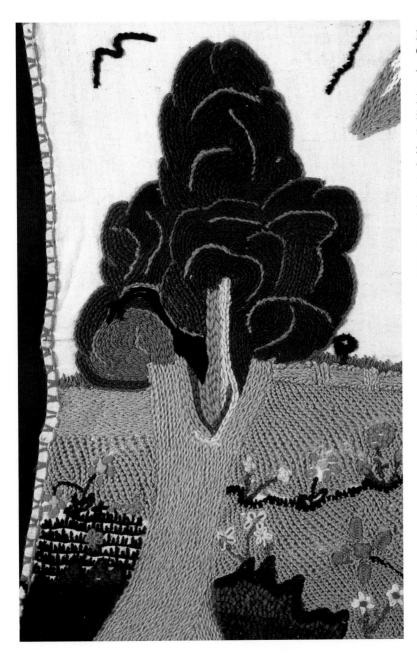

Fig. 6.16. Alicia Cortés, detail from *House and Eucalyptus Tree.* Ninhue, Chile. Embroidery. Because it took Alicia a long time to do the tree, she got discouraged and did not complete the tapestry with the same dedication. Her eucalyptus stands as one of the strongest realizations of that particular tree.
Photo by author.

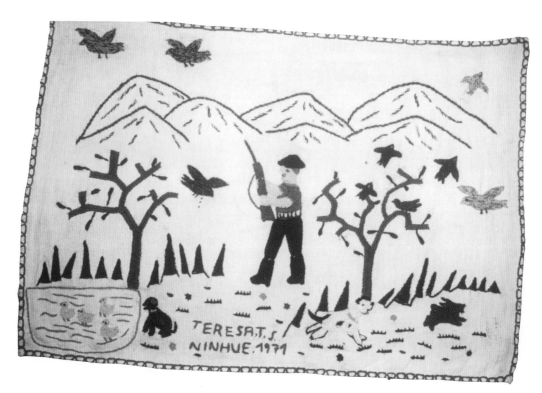

Fig. 6.17. Teresa Torres, *The Hunt*. Ninhue, Chile. Embroidery. 19 x 27 in., ca. 1972.
Teresa's sense of composition sustains her focus on narrative, shaping it and facilitating its comprehension. The three hills of Ninhue appear here behind another range, probably indicating that the hunt is taking place away from the village. *FA. 72.67.27. Reproduced by permission of the International Folk Art Foundation Collection, Museum of International Folk Art (DCA), Santa Fe, New Mexico.*

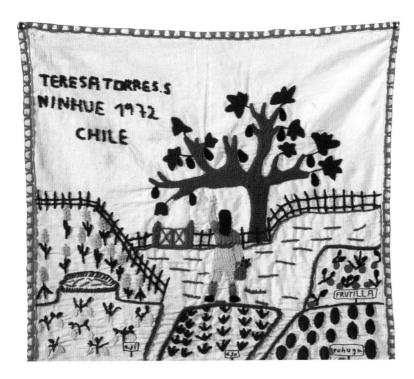

Fig. 6.18. Teresa Torres, *The Orchard.* Ninhue, Chile. Embroidery. A clear sense of purpose and determination are evident in this tapestry, coming from the well-tended orchard and the confident stance of the woman reaching for figs; it shows she is rewarded for her hard work.

FA. 72.67.27. Reproduced by permission of the International Folk Art Foundation Collection, Museum of International Folk Art (DCA), Santa Fe, New Mexico.

orchard, I am drawn to the fig tree and help myself to some figs and take some along for dessert. Also the colors: I chose them to give the real hue of the vegetables and the fruit. The stitching I did the same as in *The Hunt.*

Promotion and Marketing Outside of Chile

The stitchers and I decided that I would take their pieces with me when I returned to the United States, so I could explore the market abroad. I was fully aware of what I was about to do and of its consequences. I would be removing this newborn craft from its domestic market and eliminating the healthy competition that would result from the development of other embroidered work; I would also be depriving the artisans—at least in the beginning—the chance to offer their work directly to

the public, which meant they would not be able to learn the essential lessons of art marketing. In spite of these liabilities, I had no choice. When I began the project, I had offered to market the work if its quality warranted it, for this would be the only way to ensure the project's continuity. In Chile, there were few genuine folk art outlets apart from those that catered to tourist tastes. The few places that offered more authentic selections of popular art lacked the clientele to stay in business, as the eventual closing of El Callejón de las Artesanías attested. At the same time, CEMA, the government Centros de Madres program that sponsored centers for the distribution of folk art, sometimes made demands that interfered with the artisans' freedom to decide how to conduct their craft, and the Ninhue stitchers could not satisfy these demands. Learning from the earlier Isla Negra project, for which the promoter, Leonor Sobrino, took charge of the distribution of the embroidered pieces, I knew it would be best if an individual oversaw the promotion and marketing of the Ninhue tapestries.

Barely three months had passed since the embroiderers and I had started our happy association, but it was time for me to return to the States. To bid me farewell, the women organized a party on September 11—a date I will never forget for both the joy it gave me and the tragic resonances it has repeatedly acquired over the years. The women and their families cooked a bountiful meal of traditional Chilean dishes including *mistela*, a cinnamon-wine drink, and little sandwiches for starters; *cazuela de pavo* (turkey stew), roast pork, and salads for the entrée; and *torta de bizcochuelo* and *alfajores*, which are special cakes and pastry with blanc mange, for dessert. During those days when staples and food in general were scarce, the abundant display on the tables, the sentiment of the *tonada* (love song) composed by Edilia Medina, and the gaiety of the cueca so expertly danced by Ester Garrido and the commissioner, Carlos Sepúlveda, showed me the measure of their gratitude and affection.

To my great amazement, this festive gathering was held at the post office. Its walls had been freshly whitewashed—the ugliness had been erased. This healing gesture moved me profoundly.

Many Voices Define a Style

In the village of Ninhue, as in the rest of Chile, low-income families are typically multigenerational, with newlyweds, grandparents, and possibly other older relatives all joining the nuclear family to form a large household. While the men work away from the home, either in the village or the fields, the women—even those who hold outside jobs—share the domestic chores, which often include caring for the family's gardens and livestock. In the early afternoons, stitchers often find some quiet time to prepare *maté* (a mildly stimulating South American herbal tea), relax, pick up their embroidery, and work while watching television or listening to the radio. In some cases, other members of the household—even children and husbands—have become interested in the craft and enjoy participating as designers or embroiderers.

By the mid-1970s the embroiderers had developed distinctive personal styles by blending their own creativity with that of collaborating family members and other stitchers. The many influences feeding into each stitcher's style created the distinctive "Ninhue look" that lends a certain coherence to the work of the stitchers without compromising their individuality. The characteristics that contribute to this style are in their choice of themes, their repetitions and variations, their adoption of motifs and stitch vocabularies, their spatial definitions, their choice of colors, and the mood of their work. The main stitchers to develop these characteristic traits of Ninhue embroidery were Lina Andrade, Victoria Durán, Adela Parra, Úrzula Manríquez, and the Vergara sisters, Filomena and Ema.

However, before describing their work, one other person's contribution must first be shared.

Fig. 7.1. Maruca Bustos (*left*) and Carmen Benavente. One of many friendly chats held in the street before going home after an embroidery meeting. Here, Maruca has been explaining how she has started to embroider using fewer markings on the cloth. *Photo by Judit Hausner.*

Maruca Bustos

Maruca Bustos is an exception (fig. 7.1). A single woman, she invested her strong personality—which was distinctly passionate, dramatic, and charged with emotion—in her work. Her choice of color was carefully considered for each subject and used precisely in specific areas. Heavily stitched bright colors form the focal points of her designs and contrast with the unstitched spaces on the cloth, which enhance the motion and irregular lines of the piece. These bold techniques exerted a significant influence among some of the embroiderers who imitated her. They borrowed modes of representation that expressed the dramatic and colorful extremes of nature around them. We can see these expressions of nature in the rugged mountains and turbulent skies, her powerful interpretations of springs with water cascading down the *cordillera*, her depiction of flaming *arreboles* (the red clouds at sunrise or sunset), her tortuous trees symbolizing difficult times, and in contrast, the tender positioning of a nest in the crook of a branch.

Another hallmark of Maruca's work was her acquaintance with and appreciation of painting. Because she had been raised by

Tío David, who collected works of Pedro Lira, Sergio González Tornero, Benito Rebolledo Correa, and the French-born painter Fernando LaRoche, she was exposed to fine art at an early age. From the very beginning, Maruca deliberately related stitchery to painting. She would remember details of the paintings she knew and associate them with the stitches that best reproduced the brush strokes she recalled as she depicted mountains, water, fields, trees, and skies (fig. 7.2).

Embroidering gave her great satisfaction, as she pointed out that "the pleasure one feels in it is like music." When she learned that the style and technique she used to portray the Andes were being imitated, she proudly said that her work provoked "admiration and envy." She wished to "transmit the beauty of everything—be it a tree, an animal, a house—to make you feel it is alive—that it actually *is* alive" (fig. 7.3).

At the beginning, Maruca picked up the Romanian stitch from a friend in Cobquecura and readily adopted it, passing it on to her colleagues in Ninhue. "It goes fast and comes out perfectly," she said convincingly; "it can be turned any way I want it to go, much more so than others." Maruca distinctively used this stitch in a flamelike pattern for shading and for filling in large areas. Others were inspired by these techniques and imitated them. Toño Sánchez, a boy who worked for her, helped her with some of the horse figures, and an ad for a farm fair served him as the prototype for *Lamb* (fig. 7.4). Later, she would mold the figures as she stitched them without even needing to trace them onto the fabric, as in *Geese* (fig. 7.5). As she became more adept, this was the way she did most of her backgrounds and filling.

Despite the popularity and influence of Maruca's work among the embroiderers of Ninhue, she recognized that her work did not sell well in Chile. Consequently, she devoted more time to knitting sweaters because of their greater market demand. The fickleness of the market did not concern her, though. On the contrary, she would later confidently quote a client who told her, "after you die, your art will be recognized." Those who own her tapestries today have no quarrel with this statement; they only regret that she could not produce more because of her long illness and eventual death in 1998.

Fig. 7.2. Maruca Bustos, *Willow Tree*. Ninhue, Chile. Embroidery.
Unlike the actual tree, Maruca's willow is made heavy and dramatic through its
lines and texture in keeping with her style. *Photo by author.*

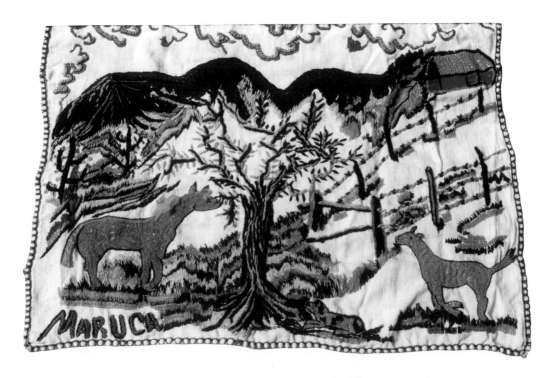

Fig. 7.3. Maruca Bustos, *Horse and Espino*. **Ninhue, Chile. Embroidery.**
In this predominantly blue and yellow tapestry, suggesting summer, the steepness of the terrain and a downhill barbed wire fence lead the eye to the lower center, where a horse and its colt try to nibble on the meager branches of an *espino* tree. The dark hills of the coastal range and a red house at the top of the hill accentuate the steep dip where the action takes place. *Photo by author.*

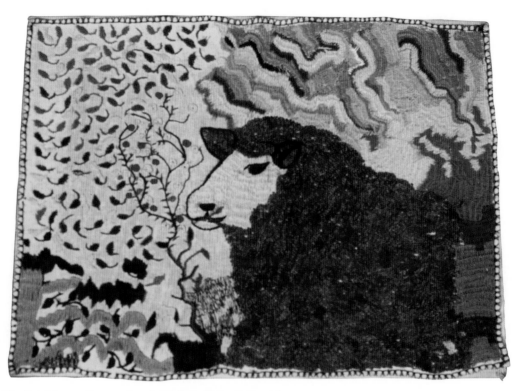

Fig. 7.4. Maruca Bustos, *Lamb*. Ninhue, Chile. Embroidery.
Unlike the earlier stitchers, who used stem stitch widely on their tapestries, Maruca elected to use French knots repeatedly in her last tapestry. Given the coarsely spun, undyed, natural wool she used, this was a very laborious process, but it gave her the desired texture for the lamb. This work is one of the most impressive pieces produced by the embroiderers of Ninhue. *Photo by author.*

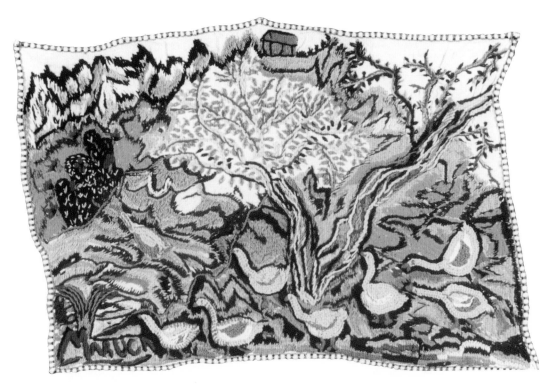

Fig. 7.5. Maruca Bustos, *Geese*. Ninhue, Chile. Embroidery.
I suspect that this entire piece--not just the geese--was done without tracings. This is another version of Maruca's usual downwardly swept compositions, this time with the Andes and the house on the horizon.
Photo by author.

Lina Andrade

When Lina Andrade joined the embroidery workshop in 1971 she told me how much she had enjoyed drawing and painting at school, which gave her confidence in creating designs for her work. She planned the designs slowly and liked to repeat them with slight variations, focusing foremost on the movement of the action she wished to portray. "I do the designs myself," she said, and added that she wanted to do "imagined embroideries." After completing *Burro* (fig. 5.17), Lina concentrated on designing farm scenes that detailed the various steps of sowing and harvesting wheat, focusing on the various social aspects of these activities. Lina created prototypes with distinct figures that recurred in her work, for example, the tillers and the sower, the man leading the oxcart, the woman preparing food, and the lying-down dog. Some of these elements were later adopted by both her daughter, Margarita Ortiz, and her sister-in-law, María Ortiz, and incorporated into their own designs. In *Mud Crab Diggers*, for example, María uses the woman standing by the table, the cauldron, and the lying-down dog (fig. 5.10). Similarly, in *Hunting Rabbits* (fig. 7.6), she adopts the tree done in buttonhole stitch in the round from Lina's *Sheep Taken Away by Condors* (fig. 7.7). The detail and repetition of these figures in Lina's work show her involvement with the subject and allow the viewer to become acquainted with the characters as they are encountered in succeeding tapestries. This continuity among the tapestries created a stock set of characters that lent credibility and realism to her work, so that they actually served as documentation of the farming practices she was recording in her embroidery.

In *Sowing*, she establishes the flowing horizontal rhythm of seeding a field by juxtaposing the back and forth motion of the laborers on three parallel planes (fig. 7.8). In *Wheat Harvest* (fig. 7.9), her favorite piece, she places the division of work in clusters, reproducing the separate stages of work that define reaping. In the first iteration of this theme, Lina uses red cotton fabric instead of the usual flour sack to emphasize the pale coloring of the wheat.

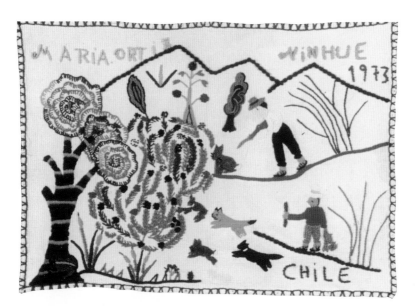

Fig. 7.6. María Ortiz, *Hunting Rabbits*. Ninhue, Chile. Embroidery.
The scene is in early fall: the trees are beginning to turn and the blackberries are mostly ripe. This hunt may be close to the village because the three hills of Ninhue are unobtrusively depicted.
Courtesy of the Museum of International Folk Art (DCA), Santa Fe, New Mexico.

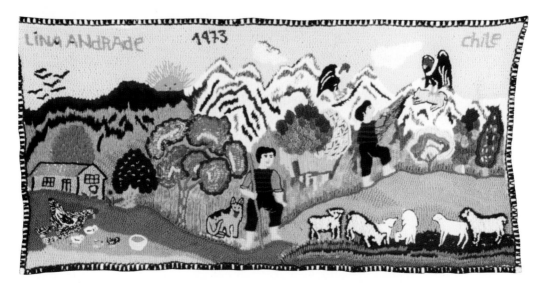

Fig. 7.7. Lina Andrade, *Sheep Taken Away by Condors*. Ninhue, Chile. Embroidery.
The boy in the foreground tending his sheep in the company of his dog seems to be remembering a past experience when he had lost an animal in a different place. The figures of the boy correspond to the same person. Two distinct mountain ranges are shown: the coastal and Andean. The drama is complex and faithfully rendered, even though not personally experienced by Lina.
Courtesy of the Museum of International Folk Art (DCA), Santa Fe, New Mexico.

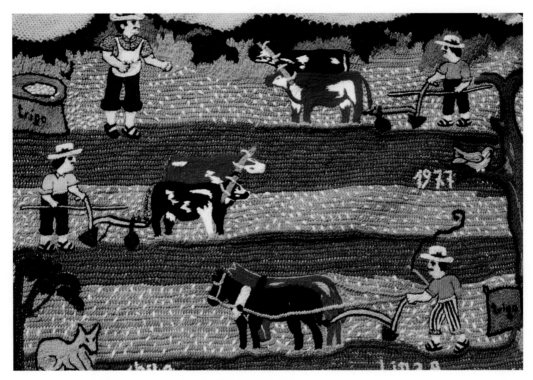

Fig. 7.8. Lina Andrade, *Sowing*. Ninhue, Chile. Embroidery.
This late piece of Lina's exhibits maturity in design and execution as well as elegance in coloring. It communicates the rhythm of sowing, inviting the viewer to imagine participating in the actual work.
Photo by author.

Lina created few designs over the years, and her output was small because she felt the market was too slow and uneven for this type of work. Nevertheless, she was quick to point out that "it [embroidery] meant a great deal to me because I liked it and because it was useful economically. I bought myself dentures, a dining room set with six chairs, a bed, kitchen appliances, and so on." She added that she was satisfied with what she had accomplished, "although at times I caught details that I corrected, I find I stitch better than I did in 1971. I still don't know all of the stitches and have continued to stitch without them."

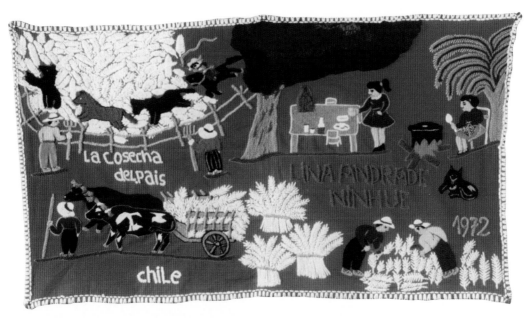

Fig. 7.9. Lina Andrade, *Wheat Harvest*. Ninhue, Chile. Embroidery.
Lina presents the progression of the work involved in the wheat harvest from the lower right corner of the tapestry up to the opposite corner, where the *trilla* (threshing by horses) takes place. This event is always celebrated with a feast, which we see the women preparing under the shade of a large, dense tree, whose dark shape, like a cloud overhead, brings together all the other dark colors in the work. *Photo by author.*

Margarita Ortiz

Margarita Ortiz, Lina's daughter, embroidered to afford new clothes for herself. She stitched several small pieces, borrowing her mother's proto- types and following her use of stitches. Margarita, however, favored a denser texture and a brighter palette to portray simple, less-detailed activities within an encircled space. A work titled *Milk Cow* (no illustra- tion) is one of her most expressive works.

María Ortiz

Lina's sister-in-law, María Ortiz, worked mainly in a linear fashion, both because it suited her design style and because it saved her precious time. Mother to a large family, María could embroider only after all the domes- tic chores were accomplished. While her daughters were living at home, she had more time to embroider because they helped her do much of the work around the house. Once the girls were married and left home, María found she had less time to stitch. This is not to say that her hus- band and sons were unwilling to help, only that they were unable, for they worked away from home—sometimes at quite a distance. Her hus- band and sons actually deeply appreciated María's work, as evidenced by her oldest son's request that she embroider a tapestry for his wed- ding present. María was proud of what she turned out, remarking, "So beautiful! The colors! Three herons by a pond: two were looking down, searching for worms, and the other with its head up looking for mosqui- toes." María was only sorry she could not afford to keep or give away more of her tapestries instead of having to sell them for much-needed cash.

In a later piece, *Resting*, María took more time, as if to align the theme of her work with the circumstances under which it was produced (fig. 7.10). This tapestry is more densely stitched, expressing the tranquil activity of repose in soft quiet hues. Here, both people and animals find a moment of rest and tranquility by the banks of the stream. The calm

Fig. 7.10. María Ortiz, *Resting*. Ninhue, Chile. Embroidery.
The mood of this piece is so tranquil that all seems to be at rest, not only the people and animals but the setting as well. Several trees, among them a native maiten and a boldo along with a poplar and pine, stand tall like sentinels guarding the peace. *Photo by author.*

and peaceful mood of the piece takes on heightened significance when contrasted with the busy realities of María's hardworking life.

Victoria Durán

Victoria Durán was proud of knowing how to stitch because it allowed her to show others what her life was like. She derived her subject matter principally from her rural surroundings, celebrating the work of farmers—"the only things I know because I do not know other practices." Victoria used fillings sparingly to emphasize the liveliness and lightness

of her pictorial information that over the years evolved into more crowded compositions.

Her light-colored pieces were followed by works done in dark hues, possibly because of the difficulty of finding yarn at the time. Yet this stage of her work was brief, for ensuing depictions of active village life and farm activities were again colorfully represented. For example, in *Feeding the Hog* (fig. 7.11) and *Chimilto*, Victoria presents us with a mosaic of country life, including hunting, harvesting fruit, peddling, cutting wood, laundering, raising chickens, and so on—each encapsulated in areas loosely defined by natural or constructed boundaries. The variety of details in these tapestries seems to have kindled an added interest in the use of more textured stitches and a greater density of flat stitches as well. Victoria adopted detached stitches to create a web effect for the sun and sky and a vertical scratchy look for the mountains; detached stitches were gaining popularity among other embroiderers at the time. These newly acquired influences were successfully incorporated in some of her later designs, such as *Doña Toya's Cow* (fig. 7.12), and came to their fruition in *Termas de Chillán*, a tapestry that recorded one of Victoria's rare opportunities to travel. Victoria included a whimsical trademark throughout her work: a beelike figure done in needle weaving that she scattered all over the sky. These, she said, were *jotes* (buzzards).

Victoria's children played an important role in her work. Since she could not draw figures in profile, she turned to Willi, her ten-year-old son, to do them for her. These were then used by her daughters, who chose subject matter and coloring that viewers would easily recognize as having been done by the Durán family. When it came to passing on her knowledge, Victoria believed that "one has to teach those who don't know, but one must not be vain of what one teaches," and her closest students were her daughter, María Tapia, and her daughter-in-law, Luisa Toro.

When I visited the family, Luisa and Willi told me how Victoria's children had quarreled over a photograph of their mother prominently displayed in one of the Chilean magazines. This altercation showed how

Fig. 7.11. Victoria Durán, *Feeding the Hog*. Ninhue, Chile. Embroidery.
Viewers could wonder if on this large property only one person is around to perform the task of feeding the hog—until they discover a face in the window of the outhouse.
Courtesy of the Museum of International Folk Art (DCA), Santa Fe, New Mexico.

proud they were about Victoria and their work in general, especially when they went on to describe the emotional difficulty of working so hard on a piece only to have to ultimately trade it for money.

"What happens, Señora Carmen," Victoria said, discussing the family's work in general, "is that it breaks one's heart to send the tapestries on, once they have been stitched and look so beautiful."

So I asked, "Why don't you make some for yourselves?"

"*Para hacer platita*" (to make a little dough), exclaimed Victoria and Luisa in unison.

María's first tapestries were similar to her mother's work until she

Fig. 7.12. Victoria Durán, *Doña Toya's Cow.* **Ninhue, Chile. Embroidery.**
As Victoria became more confident in her ability to stitch, she began to design tapestries that tell a story.
Here, she shows her gratefulness toward the pet animal that provides for her family. *Photo by author.*

began to fill the cloth with heavy stitching and dark saturated colors.
Her designs usually portrayed domestic aspects of rural life. Her family
was very supportive of her work, as evidenced by the pleasant work
space she was encouraged to set up on the family's dining room table in
front of a window. Her husband often held jobs in other parts of the
country, and because he admired his wife's work, he would take it with
him and show it to others. This exposure generated valuable contacts
for María, for example, in Temuco, where she was invited to show her
work at the yearly crafts fair.

Luisa Toro, who moved in with Victoria after her marriage, began

learning embroidery from her mother-in-law early on. Since Luisa had
recently given birth when the workshops began, she could not attend
the first meetings, but she most enjoyed stitchery, especially when the
women got together to do it. She creates her own designs but also asks
her young brother-in-law Willi for help from time to time. The same
quiet and contained feeling that is present in Victora Durán's work
seems to pervade Luisa's.

Adela Parra

For Adela Parra, mother of eight, life was busy. In addition to the obliga-
tions of child rearing, much of Adela's time was devoted to cultivating a
variety of produce on the rather large piece of property on which she
and her husband lived. She also busied herself with sewing, knitting,
braiding cuelchas, making ceramics, and painting fabric. When the
embroidery workshop was started in Ninhue, she undertook stitchery
with enthusiasm and dedication, and her work has always been
extremely personal and original. She used a wide range of stitches—flat,
textured, and detached—but when stitching the same motif she returned
to the same stitch, yielding a very consistent product. As for the compo-
sition of her work, she stuck with essentially the same elements that she
used on her first sampler—mainly a triangle, which establishes an axis of
symmetry and an upward motion that creates a sense of distance and
perspective when juxtaposed with the horizontal planes of the piece.
This central triangle is usually elaborated upon. However, it also serves
as the base image that is often mirrored at the top, either as a single
shape or as a concatenation of triangles representing a mountain chain.

Later Adela would design massive rectangular houses flanked by
doves, trees, or plants that took the place of trees. One example of her
tree/plant exchange is the grapevine in *House with* Parras (fig. 7.13).[19]
This design style developed into images of houses that dominated the
canvas, squeezing the figures on the sides further toward the edges.
Human figures began to appear when her son-in-law, Danilo Navarrete,

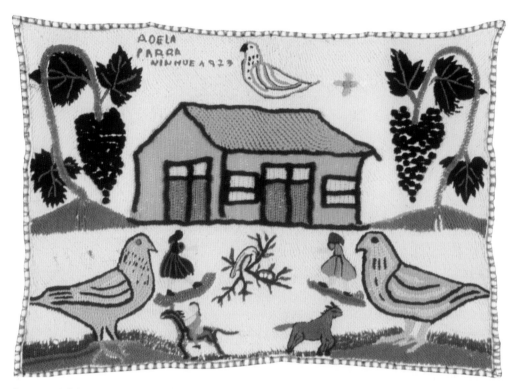

Fig. 7.13. Adela Parra, *House with Parras.* **Ninhue, Chile. Embroidery.**
In this version of a house, Adela plays with the word *parra*, which means "grapevine." She flanks the house with two stylized grapevines, which indicate the house is hers. In the lower half of the piece, between the two doves, are the figures of three young women who are perhaps her own three daughters.
Reproduced by permission of Kent State University Museum.

designed large houses flanked by trees with one or two persons standing in front of the structure, thus doing away with her usual compositional style. In *Dream of Africa* (fig. 7.14), a more sophisticated design, Adela repeats her signature central triangular axis with stratified planes.

Adela repeatedly uses the dove as a motif. When asked whether it symbolizes love or home she laughed and explained that it is a symbol of luck. As part of her sampler she had traced the dove from a cement bag because she lacked the confidence to draw. Then, since the piece readily sold, she adopted the dove as her symbol. The dog that also appears repeatedly—and seems quite threatening in *Police Station*—turns out to be a popular figure taken from a school text.

Fig. 7.14. Adela Parra, *Dream of Africa*. Ninhue, Chile. Embroidery.
The advent of television acquainted the embroiderers with foreign lands, and they began to represent exotic animals in their tapestries and as three-dimensional figures. Following her usual format, Adela juxtaposed her own quiet world with an image of Africa culled from some publication in which the emphasis is on violence and cruelty. Adela's rejection of that cruelty is implied in the way the Chilean farmer attempts to distance himself from it. *Photo by author.*

Adela introduced embroidery techniques to her daughters—Rosa, Mireya, and Carmen—who did a few tapestries and later took a leading role in designing the three-dimensional embroidered figures that would become so popular in the marketplace. Adela, however, was less interested in producing these figures, and the doves proved to be less successful commercially than her tapestries.

Juana Parra

Fig. 7.15. Juana Parra. A world of fantasy lies behind Juana's placid smile as she leaves one of our meetings. *Photo by Judit Hausner.*

Adela also introduced embroidery to her sister, Juana (fig. 7.15), whose work was initially quite similar to hers until Juana's son, Oscar, started to help his mother with her designs, establishing an unusual mother-son collaboration. Oscar brought an awareness of technology and social issues to his mother's rural world. As they combined their visions for compositions, they introduced a variety of design styles to their pieces. The trees in *Helicopter*, for example, take on an East Asian character (fig. 7.16), and we see the influence of feminism in *Headache*, as the female figure makes her suffering and annoyance at her husband's abuse of alcohol evident (fig. 7.17). Oscar likely traced the human figures from a publication while Juana put them together in her usual method, starting with one element and adding another as she went.

This collaboration is most evident in two other brightly colored tapestries in which she used again the figure of the man holding a bottle in *Headache* and combined it with predominantly larger and intriguing figures of women set against richly detailed backgrounds. In *Girl with a Bonnet*, an old-fashioned-looking girl wearing a densely embroidered red dress holds a small bunch of flowers and stands in front of the small figure of the man next to a house (fig. 7.18). The composition is divided diagonally by a road occupied by a reclining cow and a passing truck. More people along with animals, trees, and flowers complete the picture against a bright blue background that serves equally for earth and sky. A

Fig. 7.16. Juana Parra, *Helicopter*. Ninhue, Chile. Embroidery.
The dwarfed cart to the right appears obsolete in the presence of the helicopter, and the native tree is less decorative than the exotic one opposite it. The uniformity of Juana's version of the Romanian stitch, spread horizontally throughout the tapestry, seems to deliver the message in a straightforward, matter-of-fact way. *Photo by author.*

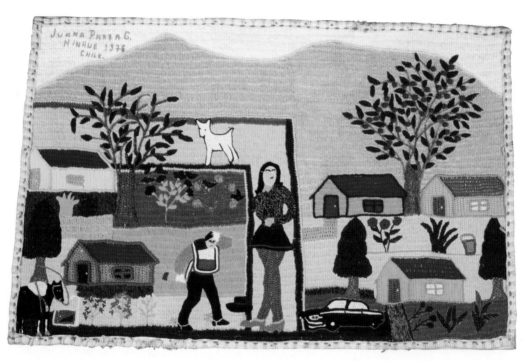

Fig. 7.17. Juana Parra, *Headache*. Ninhue, Chile. Embroidery.
Again, Juana skillfully uses Romanian stitch in a way that fixes the viewer's attention on the woman's frustration with the man's alcoholism. They both live in their own prison, defined by strong outlined spaces. Beyond lies an unattainable world, where trees bear fruit and a car stands by the door. *Photo by author.*

thin black line indicating hills establishes the boundary between the two. In *Woman Carrying a Fox*, a strange and distressing figure of a woman, who is also wearing a red embroidered dress, occupies the foreground to the right and is hurrying down a road carrying a yellow fox over her shoulder (fig. 7.19). Behind her is the man holding a bottle with one hand and his head with the other. Both figures disrupt the quiet mood of the family scene on the left of the tapestry, which depicts two children, their dog, a home, and a flock of sheep.

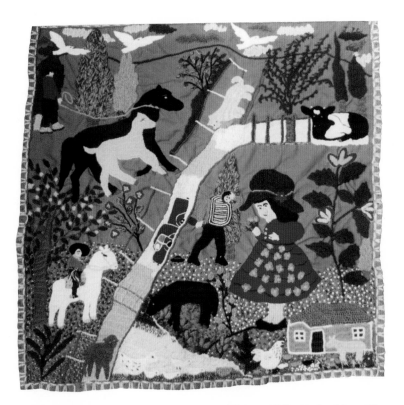

Fig. 7.18. Juana Parra, *Girl with a Bonnet*. Ninhue, Chile. Embroidery. The road that divides the tapestry diagonally is blocked at both ends by cattle, indicating a temporary nuisance. The figure of the man with a bottle in the space shared with the girl with a bonnet looks less ominous than the man in *Headache*. Yet this side is more static than the one in the opposite section, where people and animals move freely. In this piece, Juana has used a variety of stitches in addition to the Romanian stitch. *Photo by Patricia Orellana.*

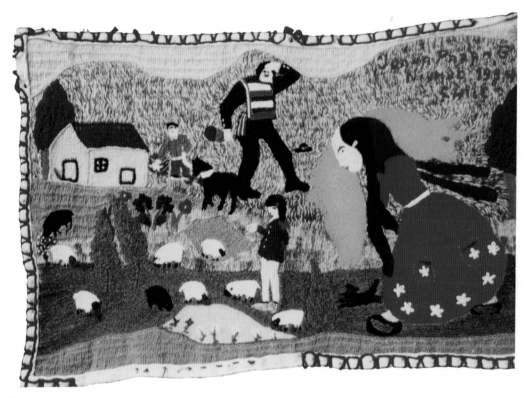

Fig. 7.19. Juana Parra, *Woman Carrying a Fox.* **Ninhue, Chile. Embroidery.**
Juana seems to have made the large figure of the woman carrying a fox first. Later she added the man with a bottle and finally the family scene at a much smaller scale. Taken as a whole, the larger figures look like apparitions that seem to surprise and frighten the boy but not the girl, perhaps because she cannot see them. Supposedly, the larger figures prevail over all others, but we do not know in what way. The overall effect is both intriguing and disturbing. Romanian stitch is used almost throughout. *Photo by author.*

Juana derived great amusement from doing her tapestries, preferring to work at night and during the winter when she said she had more time. Very candid when talking about her work, Juana said she liked her pieces, even when "they don't turn out pretty." Oscar was equally forthcoming when he told me with a twinkle in his eye that he, too, embroidered and had helped his mother with more than one tapestry.

Úrzula Manríquez

When traveling the road from Ninhue that
leads to Coroney, travelers pass the
entrance to the cemetery and opposite it
the house that once had a large poster of
Che Guevara emblazoned on its adobe
wall. Continuing along, travelers make a
sharp turn up the hill to the promontory
that overlooks Ninhue. The view is spec-
tacular, with the plain stretching out below
and the lofty Andes touching the sky
beyond. Here, Úrzula Manríquez bought a
plot of land for her home with the income
from the embroidery work she had done
(fig. 7.20).

Úrzula was a very prolific stitcher who
treated a large number of subjects. Most of
her designs were original, but now and
then she would find an intriguing picture
and "copy it just by looking at it." The
patchwork effect in *Caravel*, for example,
was derived from the back cover of the
Colón notebooks used in schools at the
time the tapestry was designed. She also
used distinct sexual symbols that recur in
pieces with gestation and reproduction

Fig. 7.20. Úrzula Manríquez. Úrzula sits content-
edly outside the house she was able to acquire with
her work, yet this picture does not include the
sweeping view that lies before her and which has
given her so much happiness. *Photo by Judit Hausner.*

themes, such as *My Garden* (fig. 7.21). Úrzula used clear bright colors
and a variety of stitches to establish textural contrasts in her work. She
gave her imagination full play in *Rabbit Puzzle* (fig. 7.22). She also scat-
tered flowers and bouquets playfully around the borders without totally
framing her pieces.

Úrzula was so successful with her embroidery that she was able to

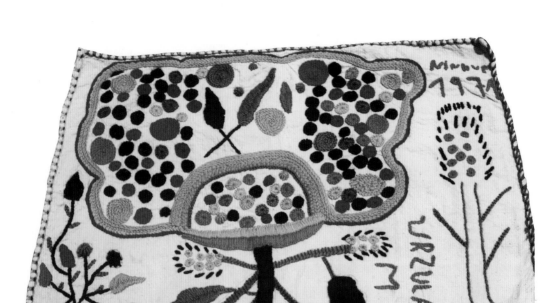

Fig. 7.21. Úrzula Manríquez, *My Garden.* **Ninhue, Chile. Embroidery.**
Úrzula represents one bloom as a womb full of seeds and calls it her garden. On one side of the tapestry
she stitches a recurrent phallic symbol, which she adds twice to the stem of the flower; on the other side
she embroiders a blooming twig that stands for the moment of fertilization. The two crossed leaves in the
center of the seeded bloom may suggest the idea of crossing species when animals or plants are coupled.
Photo by author.

buy a sizable plot of land on a choice site on the promontory. Bautista
San Martín, her husband, and the couple's ten children were enor-
mously proud of her efforts and determination. Jokingly, she said she
told the children that if she died and their father remarried, they were to
kick him out because he paid nothing for the property. To this, Bautista
responded with a laugh, saying that he would have to leave if she even
got angry with him. A carpenter by trade, he built the family's house on
the property that Úrzula bought, and this house, interestingly, became
the subject of the last pieces Úrzula embroidered. Her embroidery had
enabled her to buy the land and her husband to build the house, but

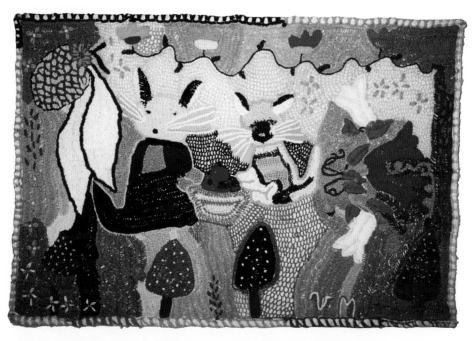

Fig. 7.22. Úrzula Manríquez, *Rabbit Puzzle*. Ninhue, Chile. Embroidery.
I believe Úrzula started to stitch the rabbits first and then continued to fill the space with trees and bell-type flowers. *Photo by author.*

with these goals accomplished, Úrzula's output diminished considerably and finally stopped. Her last pieces seem to acknowledge the very things her stitchery made possible. Structurally, these pieces are quite interesting, with some of the space divided in patchwork fashion and the surrounding space filled with figures of trees and shrubs. At the bottom, running the entire length of the piece, she left a band and on it placed a row of detached flowers. In *Cherry Tree in Bloom*, she captured simplicity itself and expresses the promise of spring next to a mysterious white and brown space in the upper right corner set apart by a clear orange line (fig. 7.23).

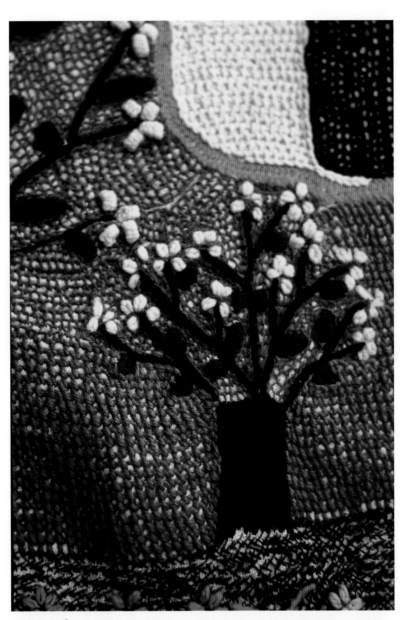

Fig. 7.23. Úrzula Manríquez, *Cherry Tree in Bloom*. Ninhue, Chile. **Embroidery.** A simple, more realistic rendition by Úrzula is equally fresh and revealing of her insight as an artist. *Photo by author.*

Patricia Medina came to the workshop with Úrzula while she was a teenager living with Úrzula's family for a time. Patricia was the first to follow my suggestion that she add texture through the use of French knots or seeding in the same color as that of the background fabric. She used this device in *Pan Am* (see fig. 5.13 again) and repeated it in other designs to tie together the interplay of horizontal, vertical, and diagonal lines. Patricia had never been to the ocean when with great patriotic fervor she embroidered the Naval Battle of Iquique. She must have added whales to further dramatize the action of the local hero, Arturo Prat, who had commanded the attack against Peru and lost his life. Patricia borrowed his effigy from the bust outside the municipalidad of Ninhue (fig. 7.24).

While Patricia lived in the San Martín-Manríquez household, there

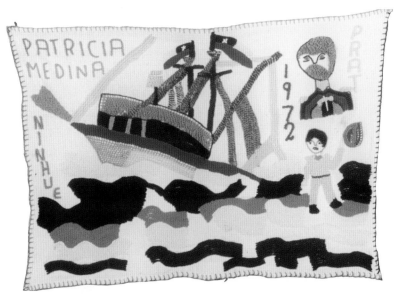

Fig. 7.24. Patricia Medina, *Naval Battle*. Ninhue, Chile. Embroidery. Arturo Prat, Ninhue's war hero, jumped on the enemy ship to continue fighting, when he was killed. Patricia, fifteen at the time, ran short of space on the cloth, so she may have deemed it equally courageous for him to drown at sea. *Photo by author.*

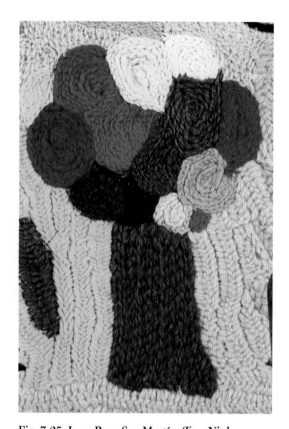

Fig. 7.25. Irma Rosa San Martín, *Tree*. Ninhue, Chile. Embroidery.
Irma Rosa derived this patchwork effect from Patricia Medina's and her mother's designs, not by any acquaintance with North American or European examples. *Photo by author.*

was much interchange among Úrzula, Patricia, and Úrzula's daughters, Irma Rosa and Rosa Elena, with respect to subject matter and embroidery techniques. Irma Rosa borrowed many of her mother's motifs, but in each figure there seems to be an exploration of stitches and color, as in a sampler. She contributed one of the most appealing representations of a tree, which has a globular shape divided into brightly colored sections in patchwork style. Her sister, Rosa Elena, readily accepted Úrzula's invitation to embroider soon after she attended the workshops. Rosa Elena helped her mother trace figures onto the cloth and collaborated in choosing the stitches and colors that would be used. She also adapted many of the symbolic motifs created by Úrzula in her own work. It is difficult to say which of the girls came up with the first patchwork trees since Patricia had done *Pan Am* and and Úrzula had done *Caravel* with this element. Although the sisters' trees were essentially the same, the way they divided space and their stitches differed noticeably. Irma Rosa's rendition in *Tree* is very dense as a result of the stem stitches made closely in the round (fig. 7.25). Rosa Elena's tree is divided less consistently with lines made lighter by the use of raised buttonhole stitches. Rosa Elena looked through magazines to choose subjects for her family's embroidery pieces. For *Cowboy* (fig. 7.26) she chose an equestrian statue by Verrocchio as her model. She transformed the majestic rider in the statue into a cowboy and completed the piece by adding four cows, two dogs, and two of her handsome trees.

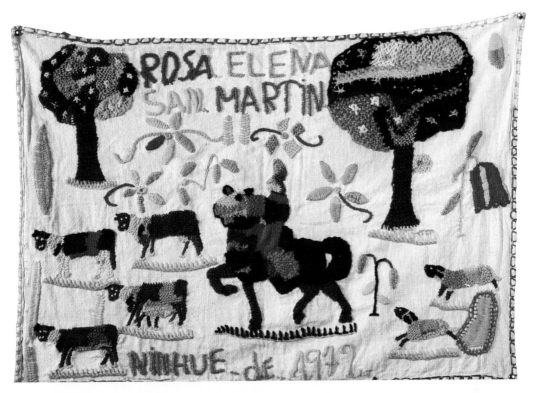

Fig. 7.26. Rosa Elena San Martín, *Cowboy*. Ninhue, Chile. Embroidery.
It is charming to encounter the innocence of a young country girl who turns an Italian Renaissance eques-
trian statue into the role of a cowboy and joins it to her own budding artistic talent. *Photo by author.*

Fig. 7.27. Luisa Quijada taught herself to spin so she could use the wool of her own sheep to embroider the sheep figures. She is demonstrating this skill outside the Centro Artesanal of Ninhue. *Photo by Roberto Contreras.*

Luisa Quijada

The subjects of Luisa Quijada (fig. 7.27) are warm and appealing, although her handiwork is rough. Her originality sprang from the sincerity with which she approached the subjects that inspired her, translating her feelings into representations. She liked texture and often overstitched surfaces already embroidered. Long ago she explained her method of composing tapestries to me:

> I want to make a horse and I draw it directly on the cloth and stitch it. Afterwards, I draw further on my imagination and continue to stitch the ideas that come to me until the picture comes out. In the *House of Doña*

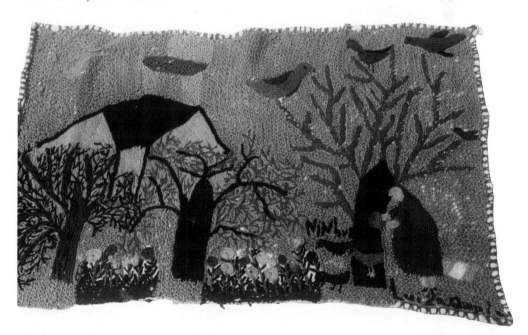

Fig. 7.28. Luisa Quijada, *House of Doña Erminda*. Ninhue, Chile. Embroidery.
The pink hue of the house, the superimposed flowers, and the hands and cheeks of Doña Erminda shine softly over the misty gray of the background as an expression of tenderness for a cherished friend. *Photo by author.*

Erminda, I made the little old lady first, then I made the little sheep and also the chicken. When I showed it to my husband, he told me it looked like Doña Erminda, so I gave it the name of Doña Erminda, just a little old lady with long skirts [fig. 7.28].

Today, Luisa still lives on the same inherited property she and her late husband had lived on together earlier. The sale of her tapestries had allowed them to add acreage to their land and also acquire more livestock and tools.

Zulema Henríquez

Zulema Henríquez (fig. 7.29) was very visible in the community, for she worked all day at her father's grocery store in Ninhue. Her long hours there slowed her work on tapestries since she could stitch only when she was not attending customers. Zulema developed her work by adopting and adapting styles and techniques from friends. She borrowed the coloring and stitch alignment from her neighbor Maruca Bustos. Similarly, she adapted a cemetery design that Edith Vergara had made for Filomena Vergara, using its main characteristics but giving the piece her own interpretation. It did not take her long, however, to acquire enough confidence to rely on herself and let her cheerful, optimistic mood surface in her work.

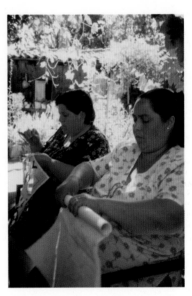

Fig. 7.29. Zulema Henríquez and Eugenia Ramírez in the Vergaras' garden. Zulema, in the background, learns how to do cross stitch while Eugenia rolls a piece of canvas left over from the first rugs. *Photo by author.*

A sense of protection is conveyed by the colorful houses and trees that surround a pet sheep and her owner in *La Pepa* (fig. 7.30). Zulema has placed the woman and the sheep on a verdant hilly site toward the bottom of the picture instead of at the top as background. The houses positioned at different levels, together with the fence that runs along the bottom, create the impression of a safe environment. In *Washday Next to a Cornfield*, half the picture portrays a busy washday next to the cornfield while the other half offers a contrast of quiet stillness as a woman surveys the maturing field (fig. 7.31).

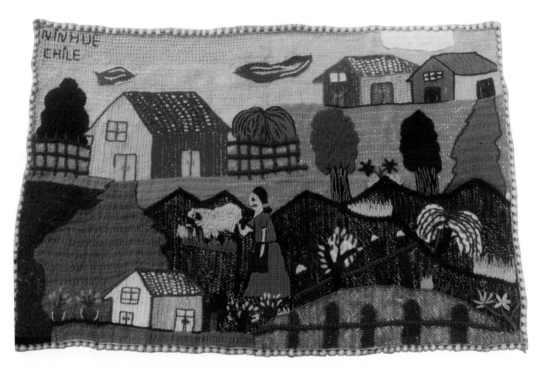

Fig. 7.30. Zulema Henríquez, *La Pepa*. Ninhue, Chile. Embroidery.
A hilly environment offers a variety of angles and perspectives that Zulema was interested in portraying from the beginning. Her first pieces were started without an overall plan; she simply clustered areas as she went along. *Photo by author.*

In her rugs, Zulema later refined this type of pictorial arrangement in which a situation or narrative emerges clearly and quickly for the viewer. The men in her family also contributed to her designs, suggesting subjects or themes from their everyday world, such as farm machinery and buildings. By incorporating these suggestions, Zulema added to the richness of her pieces as she continued to document country life pictorially in exuberant detail.

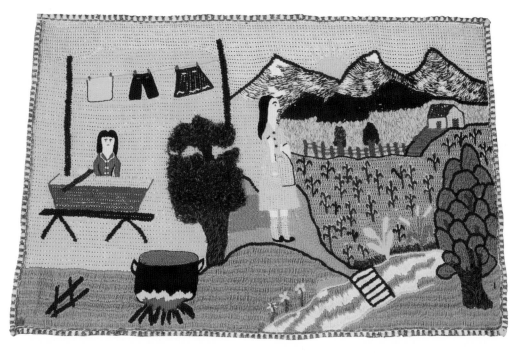

Fig. 7.31. Zulema Henríquez, *Washday Next to a Cornfield*. Ninhue, Chile. Embroidery. Zulema has avoided crowding her figures by clearly separating two distinct areas for which water is essential. At the time this tapestry was made, water was scarce in Ninhue. Was Zulema depicting an existing abundant stream or just wishing for one? *Photo by author.*

Emelina Ramírez

Emelina Ramírez had a very tactile and sensuous appreciation of the various embroidery stitches. She liked "the hanging one" (detached buttonhole stitch) because she imagined herself to be weaving like a spider. She also admired the fishbone stitch because "it is not only beautiful but also represents what its name suggests." The Palestrina she liked because "it is showy, fast, and delicious to do."

After the completion of *Andean Range*, Emelina's confidence grew, and she began to create her own designs, which lent a more personal feel to her work. In *Grape Harvest* she accurately rendered an ox struggling to climb a steep hill while pulling a cart filled with grapes. In *Lumberjack*, the entire space is taken up by a forest that surrounds a man with an axe (fig. 5.6). Emelina told me that she had done the landscape by memory, placing first one element on the cloth, and then another as she went along. This, she said, was very easy for her to do. She also explained how she designed *Cathedral of Chillán* (fig. 7.32) and *Sailboat* quickly because the twenty-first of May was drawing near and she wanted to commemorate the naval battle of the Ninhue hero Arturo Prat in time for the celebration. The tapestry was small enough that she finished it on time. Emelina surprised herself by what she was able to accomplish with embroidery during her lifetime. She produced quite a number of pieces over the years. Emelina died young, a few years after she left Ninhue and moved to Chillán.

Filomena Vergara

While each of the stitchers of Ninhue contributed her own vision and design elements to the project, one woman stands out as a leader in the movement. From the very start, Filomena Vergara embraced stitchery not only with dedication to the craft itself but with the vision of what it might signify as an added occupation in the village. With intelligence, tact, and natural leadership, she became her colleagues' representative

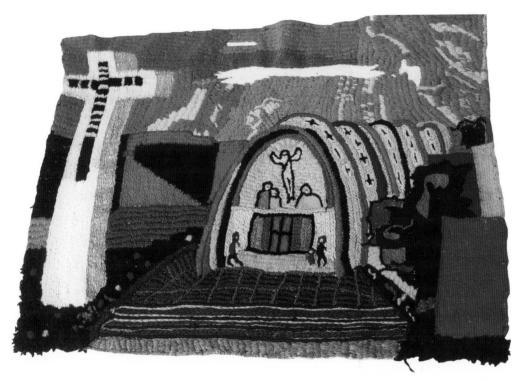

Fig. 7.32. Emelina Ramírez, *Cathedral of Chillán*. Ninhue, Chile. Embroidery. The imposing cathedral of Chillán was built after the earthquake of 1939 and is a landmark of the region. Emelina sometimes worshipped there. With this piece, Emelina came into her own through the use of bold color and texture. *Photo by author.*

and spokeswoman. During the first exhibit held in Santiago at El Calle-jón de las Artesanías, Filomena was on hand to meet with the public and Chile's first lady to explain and discuss some of the tapestries. At home, she took it upon herself to assist other stitchers with their projects and to teach embroidery not only within her circle of family and friends but to whomever requested her instruction. Her organizational skills soon led her to involvement in other community projects. She was elected to the parish council of the local church, where she set up sewing and embroidery classes for anyone who was interested. She also volunteered for a time for CEMA, the government-sponsored Centro de Madres. Today Filomena is well known regionally, participating in various agencies that promote tourism and the visibility of folk art and crafts.

Her assistance in the overseas marketing of the embroidery of Ninhue was invaluable. Since the women worked individually and not as part of a cooperative organization, each artist was paid directly for her work. When a piece was completed and ready to be shipped, the stitcher took it to Filomena, who made the arrangements to send it abroad. Work sent to me in the United States was sold directly to collectors or distributed to galleries or museum shops, where it was usually sold on consignment. Once the work sold, Filomena again handled all the arrangements to get the money back to the stitchers in Chilean currency. Filomena generously took care of all these details for no additional fee.

Filomena together with her sister, Ema, also played an important role in marketing the embroidery of Ninhue locally. They set aside a room in their house to host embroidery meetings and workshops and to display their work and that of others so village visitors could view it. None of the embroiderers advertised her work with signs outside her own house. A visitor who was interested in embroidery had to ask for a particular stitcher—and there were times the visitor had to insist and inquire again! The recently inaugurated Centro Artesanal, called Artenín, which was built strategically at Ninhue's south entrance, will hopefully remove some of the barriers to local sales. Nevertheless, the Vergara sisters are the stitchers who attained the most visibility, and it is still Filomena who

usually attends most craft fairs, gets the most media interviews, and is approached to arrange special commissions, such as the papal stole that was presented by the Archdiocese of Chillán to Pope John Paul II on his visit to Chile in 1987. Similarly, Filomena coordinated and directed the six stitchers who produced the two tapestries *Ninhue Norte* and *Ninhue Sur* that my husband and I commissioned for the municipalidad in 1986.

Filomena Vergara belongs to a family with old and strong ties to the area, and those ties played an important role in establishing the deep trust between her and the embroiderers. She inspired a confidence in them that led them to her in a natural and spontaneous way for help with their needs and problems, ranging from marketing arrangements to questions about embroidery to personal matters. She led superbly not only because of her deep sense of responsibility but also because she identified with her fellow stitchers, understanding their problems because they were also hers.

Filomena was not confident about her ability to draw, so she relied on the skill of her niece, Edith Benavides, to design for her. Edith taught art classes at a public school in Santiago and often spent her summers in Ninhue. She typically designed two or three pieces at a time, representing either public buildings or farm activities, which Filomena then repeatedly embroidered and reinterpreted with slight variations.

The plaza with the church at one corner was one of the embroiderers' most popular subjects. Filomena stitched it many times, changing the activities in the plaza, the vegetation in the garden, and the type of traffic on the streets, which all serve to indicate the seasons. The presence of the seaweed peddler, with his donkeys loaded with *cochayuyo*, for example, suggests the autumn, as seaweed is a staple of Chilean winter cuisine. These stitched views of Ninhue also include streets with the post office (fig. 7.33), the municipalidad, and up on the hill, Curahuén, which by then had been converted into a boys' home. These details combine to give a very accurate idea of the look and atmosphere of the village.

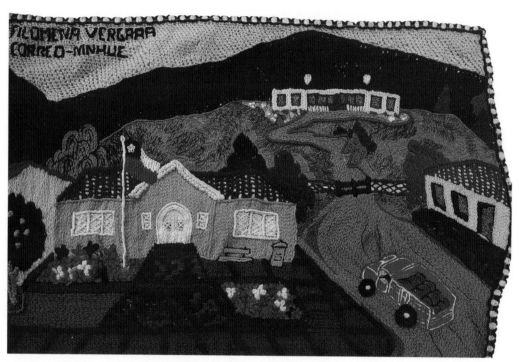

Fig. 7.33. Filomena Vergara, *Post Office*. Ninhue, Chile. Embroidery.
This is a realistic view of the corner post office on the street that leads to the house of Curahuén above the village, with the omnipresent hills of Ninhue behind. *Photo by author.*

Filomena once watched me photograph the plaza from her house, a perspective of the plaza used in her work. Recognizing the power of photography, she cried out, "Now you will show them side by side and people will see how shabby Ninhue really is!" Early on, there may have been some truth in that statement, for it is jokingly said that the fame and recognition of the embroiderers forced Ninhue to improve its image. Ninhue has had some enterprising mayors who have introduced many improvements to the village—a more abundant water supply, a new sewage system, improved lighting, and new pavement on the main streets, for example. The high school, boarding house, clinic, and fire-house have also been valuable additions to the community. Houses are

brightly painted, small garden plots edge the sidewalks, and even the orange trees that have lined the streets for years are better protected.

Filomena stitched several versions of an oxcart loaded with wheat being taken for threshing, but the first two pieces are especially interesting. In the first one, the dark red of the oxen tones down the green of the fields that would otherwise overwhelm the piece. In the second version, the terrain is more uniform, with different shades of gold that lessen the contrast between the cart loaded with pale wheat and the rest of the piece (fig. 7.34). In the first version, details stand out, adding variety and movement; in the second, the scene is more static. In these pieces, Filomena adapted the Romanian stitch from Maruca Bustos. Filomena

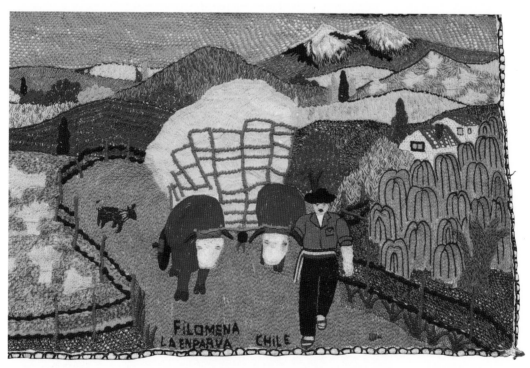

Fig. 7.34. Filomena Vergara, *Transporting Wheat*. Ninhue, Chile. Embroidery.
This piece, expertly done in a variety of stitches, conveys the feeling of the land around Ninhue during the summer. This is one of the many versions in which Filomena indulges her penchant for trying new shadings and textures. *Photo by author.*

now uses the stitch consistently, but when she talks about the various stitches, she says she has no preferences: "I use the one I find most convenient; I find them all beautiful when applied in the right place."

In spite of her appreciation of all the stitches, she has nevertheless developed some very personal and, by now, recognizable applications of stitches. For instance, to define the edges of buildings, she commonly uses a narrow, tight Vandyke stitch, taking care to orient her stitches in one direction to stress verticality. By widening, loosening, and forking out the stitch, she creates the trunks of orange trees. For dividing areas, without necessarily suggesting movement, she usually employs the Palestrina stitch, letting the rounded knot fix the shape by circumscribing it.

Filomena has also embroidered apparel. She has done skirts, children's dresses, and a poncho that is vaguely reminiscent of a Manila shawl. Her most successful items, however, are slippers that she densely embroiders with either flowers or bunches of grapes (fig. 7.35). The background stitch that she uses is Romanian, which she does with great

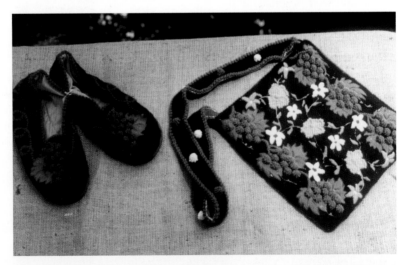

Fig. 7.35. Filomena Vergara, bag and slippers. Ninhue, Chile. Embroidery. Grapes or pansies over an all-embroidered background are the favorite decorations for bags and slippers. *Photo by author.*

skill. When it is worked with high-sheen yarn, the effect is silky. The embroidered uppers last a long time compared to the soles, which are made of padded layers of wool cloth. When these wear out, Filomena replaces them, so the embroidered portion may be used and appreciated for a long time. She has shared how to make the slippers with her colleagues, but only she and her sister Ema seem to have a real knack for them. These slippers are still popular today.

Ema Vergara

At the start of the workshops, Filomena's sister, Ema, made *The School of Ninhue* and a piece showing Mary, Joseph, and the Christ child's flight into Egypt that was based on designs provided by her neighbor, Oscar Díaz. Yet it was not until ten years later that she took up stitchery as an everyday occupation. Now, not a day goes by that she doesn't take up her embroidery for at least a little while among her many other chores, which include braiding cuelchas, making straw hats and bags, raising animals for sale, tending her garden, and cooking. Although less outgoing than Filomena, Ema supported her sister in all her endeavors related to the embroidery project. She made it possible for Filomena to represent the stitchers at their first exhibit in Santiago in 1971 by assuming all her home responsibilities. She also supported Filomena in the role she would later play as coordinator, teacher, and spokeswoman for the embroiderers.

After her ten-year hiatus, Ema started using the same designs her niece, Edith Benavides, had provided to Filomena, and borrowed Filomena's technique, which had by then become well established and successful. The sisters both strived for neat and orderly representations of scenes, typically looking to village life as encountered near public buildings for their inspiration (fig. 7.36). Ema stitched in a meticulous fashion right from the start, as is apparent in her first work, *The School of Ninhue*, whose style is clean and informative with a touch of humor added for spice (fig. 7.37). Both sisters are superb craftswomen, using

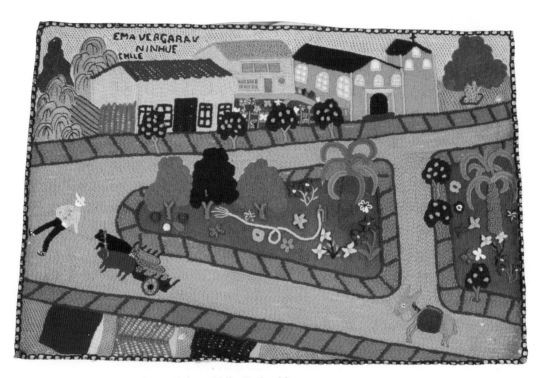

Fig. 7.36. Ema Vergara, *Plaza*. Ninhue, Chile. Embroidery.
The scenes of public buildings and the village are stitched with pride by Ema and Filomena, but those of the plaza are stitched with enormous affection. *Reproduced by permission of Kent State University Museum.*

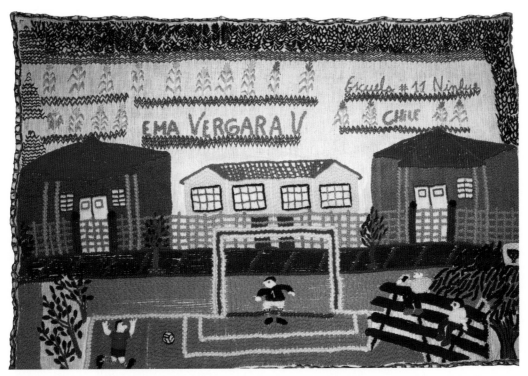

Fig. 7.37. Ema Vergara, *The School of Ninhue*. Ninhue, Chile. Embroidery.
The expression of the players and spectators at the soccer game held at the old plaza in front of the old school are vivid and funny, contrasting sharply with the plain symmetry of the buildings. Ema's first work was indeed prophetic of her abilities. *Courtesy of the Museum of International Folk Art (DCA), Santa Fe, New Mexico.*

stitches that work well for them and therefore need little variation. Consequently, the repetition of their designs is quite uniform. The only differences are in the activities they represent and the color variations they use, the latter of which depends on yarn availability.

The Vergara family style, with its common source of designs, its set vocabulary of stitches, and its rigorous workmanship, has enjoyed great public appeal. Their work possesses a romantic charm reminiscent of book illustrations that inform viewers and help them imagine village life,

yet without interference from the actual mood of the artist. Ema and Filomena keep themselves at a distance in their designs, maintaining a reserve from dramatic statements. Still, their work is very much an expression of their private, well-regulated daily routine, in which work and leisure are unhurriedly balanced. The success the Vergara sisters have attained has provided them with modest comforts, which they appreciate and generously share with their friends and colleagues.

Edith Vergara

Edith Vergara moved to Ninhue in 1972, allowing her aunts Filomena and Ema to teach her how to embroider. When she first started, Edith used the same designs from Edith Benavides that her aunts had used. Her tapestries show several influences: the tree with round foliage is derived from techniques devised by Lina Andrade and María Ortiz, and the sky, stitched compactly with detached buttonhole stitch is likewise derived from a technique developed first by Margarita Ortiz. Edith frequently divided her sky into two horizontal bands of color—one blue and one yellow—which later became her trademark. She stitched mountain ranges with snow-covered peaks in varying ways to indicate precisely which part of the winter she was representing. Her choice of stitches was always informed by the needs of her design, and this in part accounts for the refinement in her work. The viewer can see this refinement in *Sowing*, a design drawn by her husband (fig. 7.38).

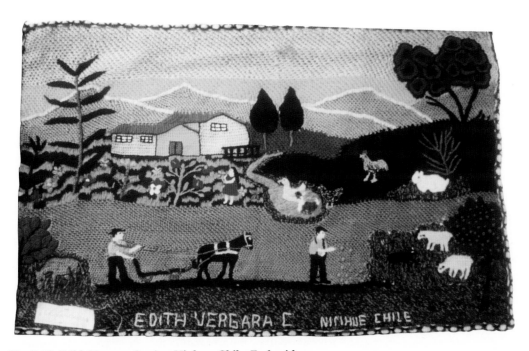

Fig. 7.38. Edith Vergara, *Sowing*. Ninhue, Chile. Embroidery.
Here, sowing is the main activity, as defined by the horizontality of the design. The superimposed bands associated with other activities invite the viewer to inspect the piece repeatedly, back and forth and up and down. *Photo by author.*

New Directions in Ninhue

In 1981, on the tenth anniversary of the embroidery project of Ninhue, I met with the women to assess the past ten years. It quickly became clear that the embroiderers had grown spiritually and made significant material gains as a result of their work. They had found contentment in plying their threads, entertained themselves with the fantasy of their *monos*, found peaceful moments for themselves when they picked up their work, and felt rewarded by the admiration they received and the pride the village had in them.[20] They were empowered by their ability to acquire land, build new houses or repair old ones, and buy modern appliances. Others used their earnings for health care or to further their children's education. In the same conversation, we also discussed changes in markets—in particular the increase in competition from Peru and Colombia, which were also selling embroidered tapestries—and the decrease in demand for the Ninhue tapestries. These changes would lead to new directions for their work (fig. 8.1).

By the end of the 1970s, the demand for pictorial tapestries from Ninhue had decreased substantially. The appearance of the *arpilleras* caught the interest of the public, both in Chile and abroad. These were highly political in their subject matter and were sold to help victims of the Pinochet regime. Pictorial political commentary was practically nonexistent in the embroidery of Ninhue for a number of reasons. Massive military reprisals took place mainly in the large cities, where they were directed primarily at private individuals and industrial locations known

to be leftist strongholds. In contrast, small villages like Ninhue were rarely hotbeds of military action. As far as I know, only one victim of the military coup came from Ninhue—Commissioner Carlos Sepúlveda, an appointed official who was shot and left to die at home. He had helped to eliminate that awful "Muera Benavente" sign on the post office wall that had so disturbed me but had also motivated me to begin the embroidery project ten years earlier. When I had learned of his death many years later, I was horrified, for to me he was a man of peace.

Fig. 8.1. At an embroidery workshop. During the mid-1980s, we would discuss stitches at the house where we first met. In the summer we would typically meet outdoors in the arcade. *Left to right, standing:* Ruth Cortés, Rosabel Gallegos, and Juana Parra; *seated and facing the camera:* Zulema Molina, Carmen Benavente, Victoria Durán, and Patricia Medina; *seated and facing the others:* Eugenia Ramírez and Filomena Vergara. *Photo by Johni Valdebenito.*

Though military reprisals were rare in small villages, it is nevertheless easy to understand how villagers and farmers who had supported the Allende regime may have felt especially exposed and vulnerable at the time the military coup ushered into power the Pinochet dictatorship. Yet if they perceived any personal danger, they must have chosen to keep it to themselves and to avoid voicing their opinions.

Another reason for the apolitical nature of the Ninhue embroidery may be that many villagers never had strident political feelings. The turmoil and unrest in Ninhue before Allende was elected and at the beginning of his administration was fomented by outsiders—young, dedicated political agitators, often students—who encouraged villagers and farmers to press for changes, especially land reform. When Allende won, the agitators and those who followed them were vindicated, so protest embroidery did not appear then but rather after 1973, when Pinochet came to power, and not in Ninhue at all.

A single piece of Ninhue embroidery could be interpreted as a protest piece, however. *Police Station*, by Adela Parra, shows a building, the

Chilean flag, and a policeman with a dog, suggesting military control
(fig. 8.2). Adela, however, attaches no political significance to the piece.
Still, in the embroidered date of 1973, the 3 is stitched in a different
color, as if to highlight the year of the coup. Another piece with slight
political content is *Headache* by Juana Parra. In this work the author
seems to incorporate some feminist ideas vis-à-vis the harm and suffer-
ing incurred by women when their husbands are affected by alcoholism.
Even these two pieces, however, had nowhere near the overt political
content that became so popular with the arpilleras.

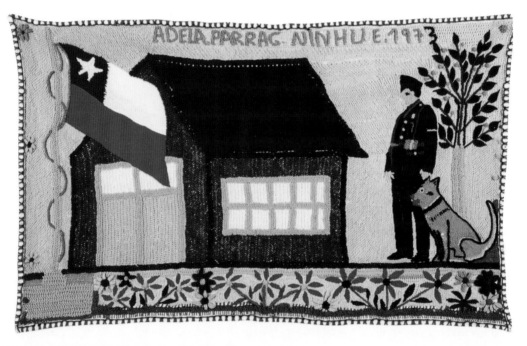

Fig. 8.2. Adela Parra, *Police Station*. Ninhue, Chile. Embroidery.
The police station is just *a* police station; it is not one of the public buildings of Ninhue. The inclusion of
the dog makes the policeman look more menacing, but the man's right foot stepping down on something
may simply have been Adela's way of correcting his boot to make it appear grounded. It is the black
numeral 3 in the date that makes people think this is a comment on the coup that took place that year.
Courtesy of the Museum of International Folk Art (DCA), Santa Fe, New Mexico.

The market was changing, and the embroiderers would have to adapt
to the changes to stay competitive. I had noticed then an interest both in
North America and Chile for soft sculpture, so I suggested the women
think of ways to make their work three-dimensional. The idea appealed
to some, who enthusiastically sat down right away to try their hand at
creating 3-D figures. They started by "lifting" the figures of animals, peo-
ple, and vegetation typical to their tapestries. Starting with sheep, they
traced the outline twice and embroidered the figure, adding a gusset for
the belly. Then they cut the pieces and sewed them together, leaving an
opening large enough to accommodate a wire frame. The frame was
meant to support and mold the figure to give it character and movement
before and after it was stuffed with wool. Sometimes extra embroidery
was required to complete the figure once it had been filled and sewn
together. As other animals—such as cows, oxen, donkeys, and horses—
began to appear, the idea for a Nativity scene soon came to their minds.
The first human figures they created represented the Holy Family, fol-
lowed by the Magi leading their camels. The wire frames permitted the
figures to assume any required posture. The stitchers refined their tech-
nique and skill at crafting frames as they shaped birds, trees, and flow-
ers, adapting the stitches to the various contours.

The use of peripheral wire frames and detached stitches contributed
to the creation of butterflies, the sun, and a rainbow above Noah's Ark.
In the beginning, the figures were small, measuring three to four inches
and sometimes even less than an inch. In the 1990s, however, some
made a few larger figures—measuring ten inches or more—that looked
like toys.

These three-dimensional figures met with great success in the North
American market because of their uniqueness. Since most of them took
less time to complete than the tapestries, their price was actually more
accessible, and customers who wanted to build collections could do so
affordably. Later the stitchers would combine the figures into particular
scenes ahead of time, selling whole tableaux. As they gained experience
with the 3-D figures, the stitchers returned to the subject matter with

which they were most familiar—farm activities such as plowing and sow-
ing, lumbering, herding, feeding flocks of fowl, spinning, and making
cuelchas. They also depicted rural leisure activities, such as playing the
guitar and going on country rides, with *huasos* and their *chinas*, for
example, saddled proudly together on a horse.[21] The results were very
attractive but expensive and therefore harder to sell.

 The components of these groupings—unless they are contained by a
larger structure, as in the case of Noah's Ark—are usually attached to an
embroidered base appropriate to the subject being represented. Viewers
can sense the importance of each stitcher's artistic vision in the way she
places the figures permanently, as if to insist on controlling the final lay-
out. In fact, most stitchers do not want buyers to tamper with their posi-
tioning. Even I was once teased when I tried to arrange a flock of sheep
with its shepherd and his dog in the presence of the stitchers. They
laughed good naturedly but did not hesitate to shift the angle and direc-
tion of the figures slightly, rearranging the space according to the vis-
ceral knowledge of their subject matter.

 Another example of the stitchers' possessiveness with regard to the
accurate layout of their work appears in two letters that one of the stitch-
ers, Teresa Torres, wrote to me in April 1989. In the first she tells me of
her plans for one of the 3-D scenes: "I'm going to send you a couple of
horses with a plow and to that I want to add a little embroidered rug
with furrows to show they're plowing and a couple of oxen yoked to a
little cart" (fig. 8.3). In the second letter, written in June, she details
exactly how her piece is to be assembled:

> The purpose of this letter is to let you know that I mailed the work
> I had mentioned to you. When this reaches you, place it thusly:
> spread the little rug, set the horses on it, place the plow so that the
> blade is just where the shaded green joins the beige; next, stand
> the man so that his hand rests behind the plow [the man is stead-
> ied by the plow and the plow is steadied by the man; they are
> upright]. Of course, before doing all this, cut all the green sewing
> threads that I stitched, letting nothing get tangled; throw the reins
> back and let them remain just as the farmer takes them. They go

behind his back and he holds them with the left hand and with the right he holds the plow. Place the cart outside the plowed field [the little rug]. This means the farmer has brought his cart with him.

The demands for creating these 3-D figures and scenes led the women to practice other crafts. The first sheep were made with French knots using commercial yarn, but very soon the women turned to natural sheep wool for a more suitable look, both in material and shading. They started buying yarn from local spinners, sometimes providing the fleece of their own sheep to the spinners. Soon they learned to spin their own yarn, which saved them money and allowed them to control the weight and twist of the threads. Next, they learned rudimentary weaving to cre-

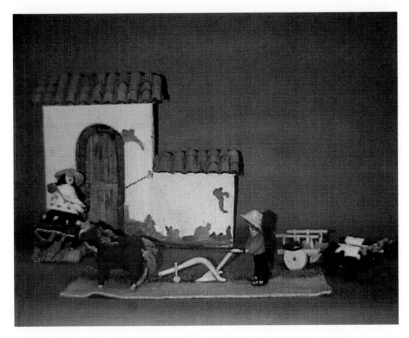

Fig. 8.3. Teresa Torres, *Plowing Scene*. Ninhue, Chile. Embroidery. Teresa's serious concern with accuracy in the presentation of her three-dimensional work went so far that she ended up having a plow and cart specially carved for this scene. María Tapia's figure of a woman spinning next to a house adds atmosphere to the scene. *Photo by Peggy Woodcock.*

ate textured surfaces, and their husbands or brothers helped them with
the carving of auxiliary pieces. Some examples are carts and wagons,
plows, and riding accoutrements, such as saddles and carved stirrups.
Tiny pieces of leather sometimes complement the riding accessories.
Traditional braided straw cuelchas were used by some to edge the tapes-
tries, to weave baskets supporting the Holy Child in crèche scenes, or
for little *chupallas* (straw hats) for the farmer figures (fig. 8.4).

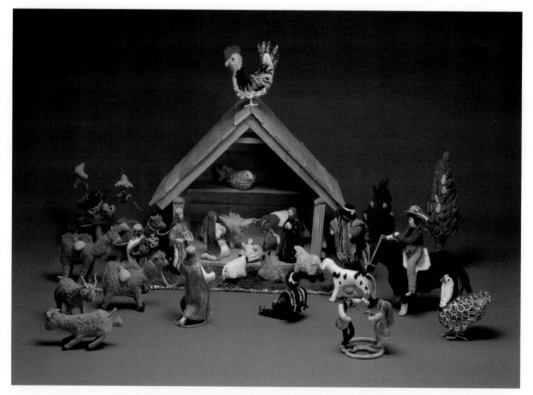

**Fig. 8.4. Edith Vergara, Ema Vergara, Filomena Vergara, Sara Parra, Julia Ramírez, Irene Eriza,
Mercedes Molina, and Teresa Torres. *Nativity Scene*. Ninhue, Chile. Embroidery.**
The typical Nativity scene in Chile also includes people and animals that come to adore the Child. Here, a
dove is on a ledge inside the manger and a rooster is on the roof. The shepherd with his sheep and dog
has come with his son, who sits on the ground. A man on horseback and a couple of guitar players have
congregated there too. The birthing goat and billy goat, a turkey, and the birds in the tree all contribute to
the festive welcome. *Photo by David M. Thum.*

Not all the embroiderers were interested in creating the three-dimensional figures, though they did attract a large number of newcomers to the project. Filomena Vergara trained most of the new people either at her home or at workshops organized by the church. She herself began with sheep, but it took her many attempts before she was satisfied with the result. Her sheep stand out as balanced and very compactly stitched and assembled. In addition to creating sheep, Filomena also devised the first tree of the project. She created an orange tree whose fruits are in spider web stitch and whose detached leaves are in needle weaving.

Edith Vergara designed the first three-dimensional human figures for a crèche scene. Her husband, Luis Ibarra, collaborated to create the figures of the Magi plus a great variety of birds and animals, both autochthonous and exotic, many of which were later adopted by other stitchers. The Ibarras attached carved pieces, such as carts and wagons, to the figures when representing farm activities. Edith and Luis with great dexterity went on to make the first *Flight into Egypt* and *Adam and Eve* figures, which proved to be enormously popular. Their guitar players are possibly their most successful rendition of the human figure. The use of very fine acrylic thread facilitated the evenness of the detached buttonhole stitch that shapes the figures. The guitars are made of wood (fig. 8.5).

The Ibarras were enterprising, and when they combined their efforts, their work on the figures picked up tremendously. Not long after they began working on 3-D figures, they moved to Concepción to provide their children with a better education. There, while holding a night watchman's job, Luis decided he could stitch the figures and let Edith do the stuffing. He didn't deny that he stitched, but he did not brag about it either. The figures sold under Edith's name. Sadly, shortly after leaving Ninhue, Edith and Luis found city life too busy, and they had no time to continue stitching.

The Ibarras' *Nativity Scene*, *Flight into Egypt*, and *Adam and Eve* were adopted by Edith's aunts, Ema and Filomena Vergara (fig. 8.6).

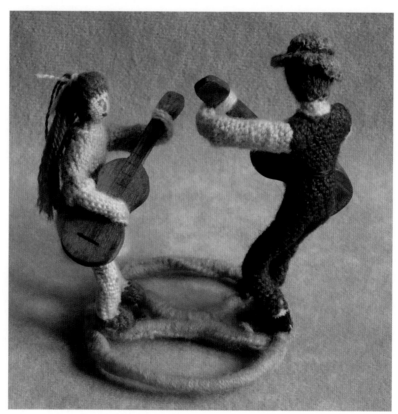

Fig. 8.5. Edith Vergara, *Guitar Players*. Ninhue, Chile. Embroidery. Edith and her husband, Luis, soon realized that the detached buttonhole stitch, because of its malleability, was the best choice for molding human figures. Here it is used practically throughout, employing a coarser yarn to do their attire, whose subdued coloring helps us better appreciate their posture and movement. *Photo by Peggy Woodcock.*

Although the patterns remain constant, their versions improve with each new figure. For example, the vestments of the crèche figures, and especially the dress and mantle of the Virgin in *Flight into Egypt* show exquisite subtle variations in the application of stitches. On the other hand, in the representations of Adam and Eve, they introduce piquant humor in their facial and body expressions, and in the appearance of the snake. The garments of the figures were done in browns, white, and light blue for several years. Bolder contrasting colors were used for the robes of the Magi, but it was not until recently, at the request of an American dealer, that the Vergaras started to experiment with bright colors when

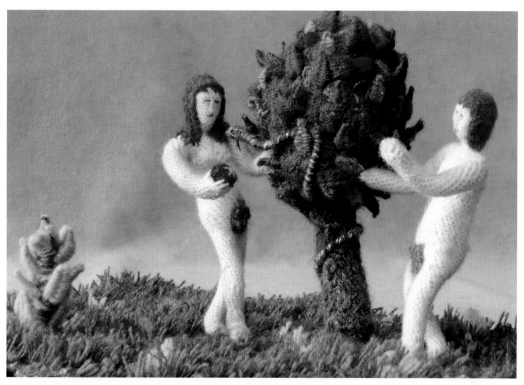

Fig. 8.6. Ema Vergara, *Adam and Eve*. Ninhue, Chile. Embroidery.
Ema lends piquancy, humor, and some measure of modesty to her interpretation of the biblical couple. To make their three-dimensional tree leaves, the Vergara sisters use the detached needle-weaving stitch (only one of the stitches is attached to the fabric). *Photo by Peggy Woodcock.*

designing the Magi's robes. Their slowness to adopt brighter colors may have been out of respect for the traditional but bland church representations familiar to the stitchers. Another possibility may have been their lack of familiarity with the richness of colonial baroque imagery. In contrast, Filomena details the *huaso* and his *china* on horseback in their Sunday best with rich, imaginative stitching. The ponchos and saddle trappings as well as the girl's apparel are especially colorful and richly decorated.

For a long time, Teresa Torres had little time to stitch tapestries. Her husband was disabled, and one of her daughters had to undergo several skin grafts for severe burns she sustained after falling into a brazier. During these trying times, Teresa provided for her family by knitting, painting fabrics, and making cheese, which she distributed weekly in Chillán. By the time the 3-D figures began to appear, her situation had somewhat eased, so she was able to join Filomena's workshop. The figures she made were popular and sold well. One of her pieces, *Birthing Goat*, was done during one of her pregnancies, showing her propensity for developing subject matter based on her own life experience (fig. 8.7). The piece is much admired, but it takes prodding to convince Teresa to reproduce it; for her it represents a unique interpretation of an intimate occurrence, and she is reluctant to make a copy.

Luisa Quijada also joined the group, and because she had sheep, she decided to take up spinning, so she could use the yarn for her embroidered sheep figures. She was the first to make sheep in the lying down position.

Victoria Durán (fig. 8.8) and her daughter, María Tapia, and daughter-in-law, Luisa Toro, specialized in making sheep and goats. María

Fig. 8.7.
Teresa Torres,
Birthing Goat.
Ninhue, Chile.
Embroidery.
Teresa transposed her own experience of giving birth into this scene. The perplexed stare of the billy goat reminds the viewer of the male's reaction at the wonder of birth.
Photo by Peggy Woodcock.

Fig. 8.8. Victoria Durán (*right*) with Luisa Toro (*left*). Doña Toya (Victoria) made herself available to show Luisa, her daughter-in-law, how to stitch. Thereafter they always consulted and helped each other with their projects. *Photo by Judit Hausner.*

experimented with the wire frames and created charming multicolor butterflies using detached buttonhole stitch. Later she joined forces with Cristina Flores to produce *Noah's Ark* with forty-eight figures. They assembled the ark by wrapping and stitching rope. The roof is woven and on it they placed the sun and a rainbow using the same technique María had used for the butterflies. The high price of this large complex piece has kept them from producing very many of them.

Adela Parra tried to replicate her signature dove in 3-D but was not very successful and consequently abandoned figure stitching. Her daughters, Rosa and Mireya Fuentes, who had not embroidered many tapestries, created numerous figures. While Mireya did mostly animals, Rosa turned out some very elaborate baskets of flowers and platters of fruit. Using a detached buttonhole stitch, she made several pieces, which she then stuffed. Among these were fruits and flowers done in clear bright colors, contrasting with their containers, which were embroidered in white and in turn placed on white-embroidered doilies. Rosa then went on to create large animals that were affixed to embroidered rugs made to imitate pasture. Among these are two flocks of geese,

one of them gathered around a girl who is feeding them. Like *Noah's Ark*, these pieces were expensive and hard to sell.

The sheep, which to this day continue to be the most popular and readily marketed figures, attracted many of the newcomers to the classes offered by Filomena Vergara. Since patterns were created and exchanged at these meetings, the design of the figures has remained quite uniform.

Soon after the sheep were well established, new figures began to appear, allowing stitchers to specialize in certain types. While the Vergara family excelled in human figures, some of the younger members involved with the project created miniature farm animals such as horses, cows, pigs, rabbits, and birds. Others branched out to design a wider variety of fauna. The mother-daughter team of Zulema and Mercedes Molina, for instance, made elegant, slender figures of camels, giraffes, and zebras. These non-native animals appeared after it was possible for people to watch nature programs on TV. María Tapia and Cristina Flores created their *Noah's Ark* at about the same time, with an abundance of animal pairs from all parts of the world. Custodia Parada designed and stitched the first tiny lambs and llamas. Then she created a narrative scene by arranging a horse, mare, and colt around a budding tree, fixing them to a stitched base. This was the first scene of its kind.

Julia Ramírez and Irene Eriza

Also most original was the work of Julia Ramírez (fig. 8.9), who learned about the figures of Ninhue while still living at Collipeumo. She did not learn any techniques formally but rather dug right in to create a series of roosters and hens. Using flat stitches, which best suited her designs, and many kinds of yarn, including metallic ones, she covered the fowls' bodies and stitched the tails with loose needle weaving. These fantastical figures in nonrealistic hues were instantly successful. Later, Julia added turkeys to her repertoire. These are majestic yet somber in black and off-white. In these too, she used flat stitches, this time following a wavy pattern for the desired effect. Julia also created some impressive human

figures in *Pregnant Woman and Husband* and *Woman Sitting by Her Christmas Tree* (fig. 8.10). Julia's remarkable talent has essentially allowed her to represent whatever she pleases, for she creates as she goes along, developing techniques as the need confronts her. Amazingly, she stitches without actually knowing the stitches and lets the needle do what is required to yield the result she is looking for.

Irene Eriza (fig. 8.11), Julia's daughter, seems to have inherited her mother's resourcefulness and spontaneity. Some of her early works include scenes of animals hitched to trees in

Fig. 8.9. Julia Ramírez outside the Vergaras' house after one of our happy sessions, during which she had shown us some of her three-dimensional figures. *Photo by Judit Hausner.*

Fig. 8.10. Julia Ramírez, *Pregnant Woman with Husband* and *Woman Sitting by Her Christmas Tree*. Ninhue, Chile. Embroidery.
The proud pregnant woman with her man wants the whole world to see them, and Julia has presented them to us and planted a cherry tree in bloom before them. Being summer in Chile, the woman has decorated her Christmas tree outside and dressed herself festively. She sits to contemplate it in the company of her hen. *Reproduced by permission of Kent State University Museum.*

Fig 8.11. María Tapia (*left*) and Irene Eriza. My 2005 meeting with the embroiderers revealed that several of them were in mourning. Here is a sad Irene shortly after Julia, her mother and close collaborator, had passed away. *Photo by author.*

which birds are perched along with flowering plants for color and variety. She also made small bouquets of flowers that are as charming as country bouquets gathered at random.

Later she developed her own designs for roosters and turkeys, using carefully calculated long stitches to create a variety of feather patterns. These feather patterns were outlined in one or two rows of stem stitch. The turkeys' tails are done in a detached buttonhole stitch that is so elaborately worked it is often mistaken for crochet work. Irene has created many turkeys, all varying in size and color combinations. One series of turkeys, worked in donated Paternayan yarns, departs from the usual palette found in Chilean folk art; the effect is more like Middle Eastern enamel or ceramic work (fig. 8.12). When Irene uses local yarns, the palette darkens, but her color sense remains intriguing. In 2003, she came up with peacock figures that are arresting in

Fig. 8.12. Irene Eriza, *Turkeys.* Ninhue, Chile. Embroidery. Departing from the usual black and white color of turkeys, Irene has given full rein to her creativity, trying new color combinations that purposely disregard reality. *Photo by Peggy Woodcock.*

their stance and coloring. The body of the bird is done in fine long stitches, and the tail, which is held together by a wire frame, is in detached buttonhole stitch overstitched in bright colors and metallics.

Irene alternates her figure production with representations of her daily life at home worked in small, richly colored tapestries. These are gaily detailed and embroidered in long stitches with a few three-dimensional details added for emphasis. The panels represent her home and its surroundings, her children and animals, and even she and her mother discussing a stitching project (fig. 8.13).

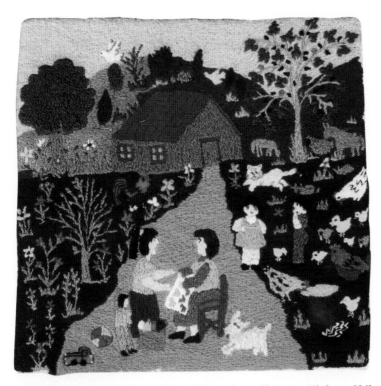

Fig. 8.13. Irene Eriza, *Julia and Irene Discussing a Tapestry*. Ninhue, Chile. **Embroidery.** Irene's world, as depicted in her small tapestries, is richly detailed but never crowded. She translates an organic, emotional order in which people and creatures develop naturally, as expressed by this harmonious collaboration between mother and daughter surrounded by their family. *Reproduced by permission of Kent State University Museum.*

Ninhue Norte and *Ninhue Sur*

In March 1988, my husband and I made the journey to Ninhue to present the municipalidad with the two tapestries we had commissioned. Originally these were destined for the post office but given the poor insulation in its walls we opted for a safer building. The tapestries represent the main access roads to the village and the area around them. Since one road approaches from the north and one from the south, the tapestries are aptly named *Ninhue Norte* and *Ninhue Sur*. These were designed by the embroiderers using an aerial viewpoint in order to include as vast a panorama as possible. The stitchers participating in this project were Lina Andrade, Victoria Durán, María Tapia, and Filomena Vergara for *Ninhue Norte* and Ruth Cortés, Ema Vergara, and Filomena Vergara for *Ninhue Sur*. Both were done under the guidance and supervision of Filomena Vergara.

Ninhue Sur is a long, narrow tapestry that shows the Ninhue road at its junction with the Chillán-Cobquecura road. The scene is in summer, showing a *trilla* with the bright yellows of straw splashed in the lower left corner of the tapestry.[22] The grays of the winding road contrast with the lighter tones of the straw, an effect that helps define the fields that extend upward on either side of the snaking path. An oxcart loaded with wheat and a bus occupy the road, and a scattering of houses and people anticipate the vicinity of a village (fig. 8.14).

Ninhue Norte shows village life as it takes place around the new plaza (figs. 8.15, 8.16, and 8.17). Men, women, and children busy themselves in their daily activities. The village priest is out for a stroll. The church, the willow trees skirting the canal, and the surrounding houses frame the lower half of the tapestry. The background hills are depicted in great detail, illustrating the richness of their various crops, and the cemetery is represented in great detail, granting it all due respect. The liveliness of the scene and the absence of monotony in the landscape invite the viewer to explore the picture in every direction. Its almost square shape stresses its containment and prevents the viewer from recognizing the

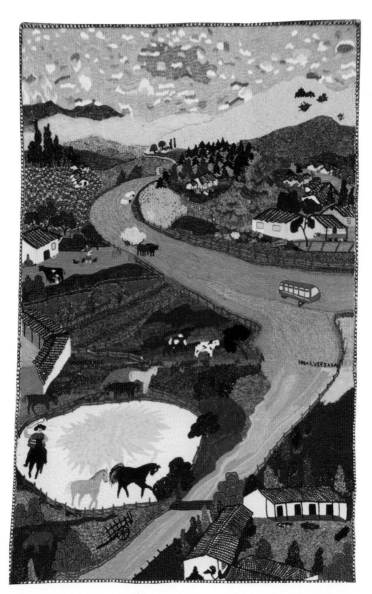

Fig. 8.14. Ruth Cortés, Ema Vergara, and Filomena Vergara, *Ninhue Sur***. Ninhue, Chile. Embroidery.** This tapestry is already a document of how times change. It was completed before the Centro Artesanal was built at the corner of the road where the cattle are grazing and before many other buildings were eventually erected. The village proper lies beyond this southern entrance, which explains the relatively empty look of the scene. *Photo by Judit Hausner.*

Fig. 8.15. The new plaza (the triangle in the middle of the photograph), which the *Ninhue Norte* tapestry shows to far better advantage, is located at the north end of the village.
Photo by Roberto Contreras.

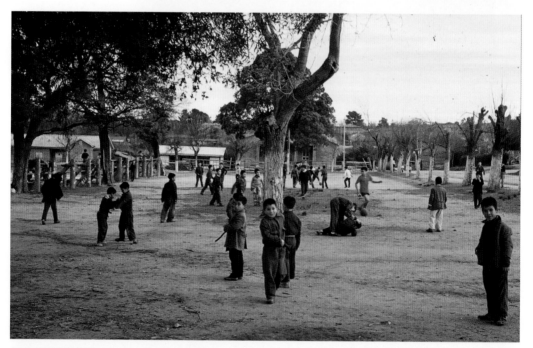

Fig. 8.16. Children at play on the old plaza. Years ago, before the old plaza was reinstated and the gardens planted, children would gather for a "short *pichanga*," an informal soccer game. The old plaza lies in the center of the village near the municipalidad.
Photo by Judit Hausner.

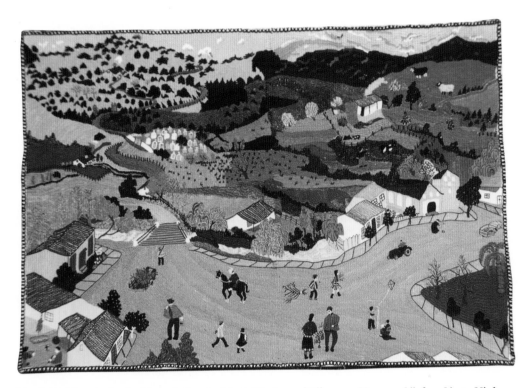

Fig. 8.17. Lina Andrade, Victoria Durán, María Tapia, and Filomena Vergara, *Ninhue Norte*. Ninhue, Chile. Embroidery.
This aerial view shows the northern entrance to Ninhue as part of the village with its buildings and daily activity. The bridge connects it to the road to the cemetery and the cultivated fields beyond.
Photo by Judit Hausner.

exit past the bridge leading to a country road. These design specifics and the tapestry's placid mood tempt the viewer to linger and explore the piece further.

Juan and I saw the tapestries for the first time outside the Vergaras' home, practically in the middle of the road. Judit Hausner, our friend, had made a special trip from the United States to photograph them. Passersby were curious, and people stopped, getting out of their cars and trucks to look at what we were doing and ask questions. As I looked around, it seemed to me that we were replicating, or perhaps even living, the spirit and meaning of *Ninhue* Norte (fig. 8.18). Later that morning,

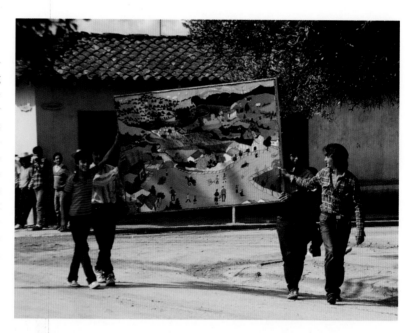

Fig. 8.18. The tapestry *Ninhue Norte* being taken to the municipalidad. On the way there, the tapestries were escorted by curious people who wanted to see them up close as they were transported two short blocks from the Vergaras' house to the destination. *Photo by Judit Hausner.*

the stitchers involved in creating the tapestries presented them to the mayor, Gonzalo Torres. *Ninhue Sur* is now beautifully displayed in the community center, built in 2007 and located behind the post office, while *Ninhue Norte* hangs prominently in the hall of the municipalidad.

For a long time, I had been concerned about finding new directions for the women, both in terms of marketing their work for higher remuneration and expanding their embroidery experience. Once again, I found what I was seeking in a most fortuitous way. One day in 1999, while leafing through an old American magazine, I caught sight of a tapestry that looked as if it had been done by Victoria Durán. It turned out to be an Azzari advertisement for Turkish pictorial rugs. Interested in the potential these rugs might hold for the embroiderers of Ninhue, I contacted the company to request a book with color reproductions describing how these rugs are woven. It turns out they are produced in several villages of Anatolia in workshops organized by a Turkish entrepreneur living in the United States. The rugs are beautiful, with themes and motifs commonly found in today's rural folk art.

The Turkish rugs, with their even stitches and folk motifs, set my
mind to work imagining possibilities for the embroiderers of Ninhue.
They also reminded me of the fine needlepoint work of my late friend
Milly Johnstone, whose work captured her own surroundings splen-
didly. Milly had lived in Bethlehem, Pennsylvania, home to the Bethle-
hem Steel mill. Appropriately, she documented the various processes of
fabricating steel, which constituted *her* life's experience, as she was the
wife of a steel executive. These unique and powerful works belong to the
art museum in Bethlehem, Pennsylvania. My fond memories of Milly
and her work reinforced my belief that *any* topic could serve as a subject
as long as it sprang authentically from the person's life.

Meanwhile in Chile, cross-stitched rugs on canvas using traditional
patterns from Middle Eastern and European carpets had become popu-
lar. This interest had given rise to many specialty shops that sold
stamped canvases and excellent hand-dyed wools in a rich gamut of col-
ors appropriate for this type of work. This, then, was the opportunity for
the embroiderers of Ninhue to use these materials in a truly creative way,
making their own designs and imprinting their craft with a distinctive
seal. On the other hand, I knew that the sinuous rural landscape sur-
rounding Ninhue would present challenges to render onto a counted
thread—and therefore by necessity geometrical—background. Neverthe-
less, I believed in the capabilities of the embroiderers, trusting that they
would adapt their designs to preserve the quaint attention to detail and
the fluid integration of human activities and landscape that were appar-
ent in *Ninhue Norte* and *Ninhue Sur*.

I expected the women would also be interested in the cross-stitched
rugs, for the craft would afford them the chance to continue working
pictorially. My expectations proved accurate, as the women readily
embarked on this new project when we met in December of that year. To
introduce them to the craft, I showed them the stamped kit I was work-
ing on. They loved the yarns but were not impressed with the design. I
then showed them the book on Turkish rugs, but again, they were not
particularly appreciative or interested. I pointed out the rural themes,

the pictures of the weavers, and the villages and rural landscapes, which, in many ways, resembled their own landscape. Not even this led to any discussion, but I did overhear one comment: "*Ay, sí*, what do we know of those faraway places!" I did not respond but rather continued to point out that in this large format of approximately three feet by five feet, the central picture was framed by two or three bands of attractive repetitive motifs. This appealed to them and drew their attention, leading them to suggest alternate motifs such as crosses, trees, and birds. Nevertheless, they never asked to see the book again.

In hindsight, I suspect their lukewarm response was a kind of defense mechanism. I think they saw themselves as standing apart with their own unique expressions derived from unique experiences. At the same time, curiously, whenever the group assesses its accomplishments, very few stitchers consider themselves professionals. They always say they still have a long way to go.

To begin working on the rugs, eleven embroiderers got together to pool their efforts to create five pieces, each measuring about three feet by five feet. They were worked in cross-stitch on 12-to-the-inch cotton canvas using hand-dyed commercial wool. Ironically, these artisans, so capable with the many intricate stitches used in their embroidered work, had great difficulty learning cross-stitch and keeping the stitches uniform.

To redress these problems, the Vergara sisters, Filomena and Ema, held several work sessions under the grape arbor on their blossom-filled patio (fig. 8.19). Other embroiderers who were not participating in

Fig. 8.19. In December 1999 Filomena Vergara gathered the stitchers to meet in her garden to start the new rug project. After the women agreed on the size of the rugs, the canvas was cut, and Filomena proceeded with tracing the designs from templates. Her disciplined, calm disposition drew the group together. (The tape around her neck shows inches, but it is the reverse side marked in centimeters that is used.) *Photo by author.*

the rug project and some old-timers kept the rug stitchers company, bringing refreshments and baked goods to sustain them. Their friendship, the beauty of the surroundings, and the prevailing good cheer all helped the stitchers overcome the frustrations caused by their frequent mistakes.

For me, these meetings held a delightful surprise and offered a glimpse at a sort of completion. Two of the very first stitchers, who had done only one piece of work that had imprinted the workshops with so much meaning, and whom I hadn't seen in many years, turned up at the sessions. One was Rosa Montecinos, who did *Orange Tree*. Perhaps because she was not from Ninhue, she had recognized the orange tree as a salient characteristic of the village and treated it emblematically, resulting in a classic depiction of the tree of life. Rosa later made Ninhue her home. She admired the work of the women and lamented that she could not join them because of her health, but knowing I would be there, she had come to visit.

The other stitcher was María Cristina Silva (fig. 8.20), who, looking as bright as ever, alert, and proud, had come to introduce her two lovely sons. Seeing her so happy, I reminded her of the letter she had once sent me describing the significance of her one piece of embroidery. "It referred to spring," she wrote; "a kite that soars is an important symbol in my life. At the time it was just an embroidered drawing, but today it is different; it is and continues to be the rising steps of each moment of my life." She went on to explain how she had finished high school and started to study accounting but could not complete that course for lack of funds. She was, however, appointed to increasingly responsible administrative jobs in the public school system, which allowed

Fig. 8.20. María Cristina Silva and one of her two sons. Still interested in participating, María Cristina came to visit and brought with her one of her two sons, who helped her film the start of a new rug project. *Photo by author.*

her to help her parents and put her younger brother through school. Now she was living in Ninhue with her husband and children and had opened the first hairdressing shop in the village. Jokingly she added that she had once more chosen "green" by marrying a policeman. The police in Chile are referred to as *verdes* ("greens") on account of the color of their uniforms.

These unexpected encounters, especially with Rosa, brought back to mind some questions concerning those one-and-only works that were done during the first workshops. Some of those pieces, like *Copihue, Fruit Bowl, Orange Tree*, and others not discussed in this book, showed their creators' deep understanding of embroidery, a discipline they quickly apprehended. Moreover, the richness of their tapestries revealed a self-confidence in their ability to create and design that was highly unusual in beginners, who usually require sustained practice to stay with it. So, I wonder, does a person who works on what turns out to be her one-and-only piece, know it will be so? How did these young women, who seemed to treat the workshops like a game—lightly, spontaneously, and with abandon—still manage to create such masterful work? Could it be that the game was so easy for them, so lacking in mystery or challenge, that it canceled all desire to play again? I have no way of knowing, but these works remain to delight us and confirm that artful abandon can be most fruitful when it contains a good measure of curiosity and good will. These were strange musings in the presence of the others, who had been working for so many years perfecting their craft. Nevertheless, there is no question that play and opportunity can open the door to great inventiveness and creative talent.

Once the women mastered the cross-stitch and were able to perform it uniformly, they actually enjoyed its monotonous rhythm. The format of the rug gave them the opportunity to once more represent their way of life. Here, just as in their earlier tapestries, they were able to combine elements from their experience into stories that they could tell and reflect upon. They found pleasure in working the motifs of the borders that framed the pictures. Some of these were original, others were traditional.

This cross-stitch project represented the first time since the inception of the Ninhue project that the women used geometric designs not of their own. I introduced them to Mapuche, Middle Eastern, and European motifs taken from the books *Textilería Mapuche* and *The Needlepoint Workbook of Traditional Designs*.[23] The women took the designs from these books as their point of departure and then altered their proportions and spacing, finally creating their own original designs. The borders on the rugs are generally made up of three bands of various widths: the widest band sometimes includes a pictorial motif such as houses, flowers, and birds; the adjoining bands, in contrast, are made up of geometric shapes.

To solve the problem of transferring nongeometric shapes to the canvas, Filomena Vergara turned each figure into a cardboard template that could easily be traced onto the canvas. The figures were then outlined in a dark shade that helped to define and adapt them to the geometrical requirements of the grid. The outlining also served to detach the elements of the composition from the background and accentuate the details of the shape itself.

Here are the stories of three of the first rugs embroidered by the stitchers of Ninhue, followed by descriptions of others that richly show the life and work around Ninhue.

Country House, City House

Dina Loyola and Inés Rodríguez's rug features the representation of a country house with adjacent cattle and sheep corrals, all of which contrast with a suburban dwelling with a rug delivery truck parked nearby (figs. 8.21, 8.22, and 8.23). The stitchers achieve depth and perspective through the sustained diagonal positioning of certain elements, such as the country house, a fence, sunflowers, people, and vegetation. The towering Andes at the top of the piece and an impressive cactus at the bottom, treated in a Cubist manner, work to stabilize the picture. The background of the piece is done in a rich copper shade, while the blue

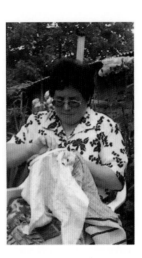

Fig. 8.21. Dina Loyola alternates projects to make her work lighter. For a while she stitches sheep in a series, using a hoop. Then she picks up the rug on her lap that demands a different, heavier grip.
Photo by Roberto Contreras.

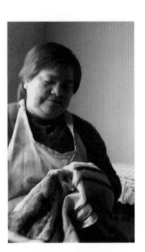

Fig. 8.22. At home, Inés Rodríguez examines her work carefully before making a decision.
Photo by Roberto Contreras.

of the inner border seems to spill from the blue of the sky, refreshing and brightening the whole. White X's crisscross this inner border. The second border uses the Mapuche *wanguelen* (star) motif, which here also emerges as a butterfly pattern. Dina and Inés chose an alternating color scheme of white and mauve for this border, dotting the butterflies with a darker pink. For the third border, the women adapted the common Mapuche design of a cross whose angles are filled in, resulting in a square bordered by a crenellated design. The Mapuche design is usually done in black and white but here Dina and Inés did the center in light blue with copper crenellation against a dark blue background.

Pastoral Scene

Custodia Parada divided her pastoral scene diagonally into an upper section representing winter and a lower section corresponding to spring (fig. 8.24). To divide the seasons, Custodia used a meandering river from which a horse and cow drink. In the winter section, a shepherd—a figure borrowed from the Vergaras' early tapestries—sits under a bare tree while a boy flies his kite, perhaps in anticipation of the early spring winds or perhaps simply because Custodia ran out of room for him in

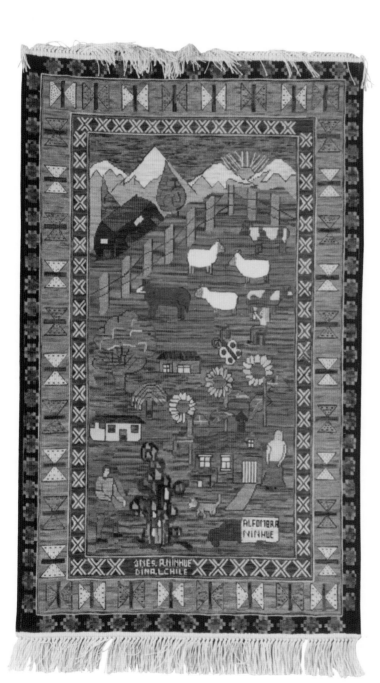

Fig. 8.23. Dina Loyola and Inés Rodríguez, *Country House, City House*. Ninhue, Chile. Cross-stitch tapestry. Intimidated by the size of their new project, many embroiderers like Inés and Dina combined forces to make their first cross-stitched rug. This rug establishes certain motifs that will recur in Inés's future work, such as the butterfly design in the borders and the tree in the lower left. Dina's participation in this project consisted mostly of stitching the background. *Photo by Marcelo Vildósola.*

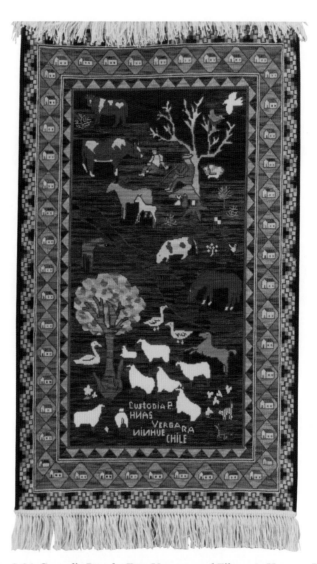

Fig. 8.24. Custodia Parada, Ema Vergara, and Filomena Vergara, *Pastoral Scene*. **Ninhue, Chile. Cross-stitch tapestry.**
This rug is the result of a balanced collaboration between Custodia and the Vergara sisters. They all helped in its design and execution. Notice the weight of the border formed by the house motif and the elaborate, softly shaded zigzag at the edge that holds in the sharply contrasted figures arranged on the dark background. *Photo by Marcelo Vildósola.*

the bottom half of the rug. In the vernal section, Custodia uses the tree, horses, and sheep—motifs she had already stitched as three-dimensional figures—to set the stage for the familiar scene of her dog chasing sheep as they take refuge under the tree. The background is a deep turquoise warmed by borders worked in tans and blues with touches of red. Interlocking triangles are repeated in contrasting colors in the middle border, alternating with little houses surrounded by diamonds. In the third border, rows of small tan squares zigzag along a red line that runs through the center to divide the rows. Ema and Filomena Vergara helped Custodia stitch the rug, and Filomena was also responsible for the design and execution of the borders.

Women Drinking Maté

The Vergara sisters reproduced one of their previous tapestries to create the rug that features two women at home drinking maté (fig. 8.25). The women sit on a bright turquoise rug not unlike a medallion positioned on a rich earth-red background. They are surrounded by their furnishings: a sewing machine, a loom, cuelcha rolls, and a bookcase. In the upper left corner is a view of the village through a window, with an orange tree and the distant Andes beyond. To the right, hanging on the wall, is a miniature version of their own plaza tapestry. A dining room table occupies the lower left corner and balances the composition. The deep coloring of the borders adds to the overall richness of this interior scene. A Persian design in tan, blue, turquoise, and white forms the narrow inner border. Then comes a row of large, deep turquoise roundels that are centered by flowers done in copper. The outer border consists of a row of dark gray S shapes outlined in red on a dark blue background with white dots inside the curves of each S.

During the time the first rugs were being made, Filomena reported to me that "the work on the rugs is very entertaining and we do not like to put it down." She was referring to the time when a rug had to be handed over to another collaborating stitcher. She then continues, "as far as I am concerned they [the rugs] look just beautiful."

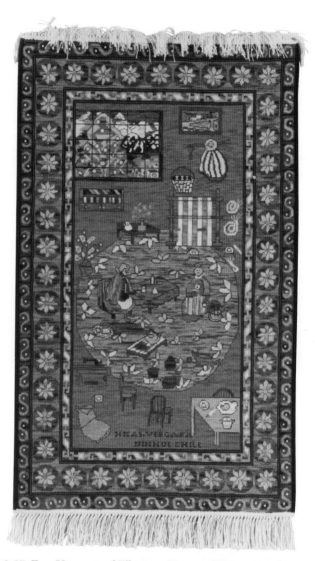

Fig. 8.25. Ema Vergara and Filomena Vergara, *Women Drinking Maté.*
Ninhue, Chile. Cross-stitch tapestry.
Although some elements of the Vergara household appear in this rug, the scene
is an idealized representation of this common Chilean practice. The vivid flame
color aptly suggests the warmth of the tea and the special receptacle, which is
held with both hands to sip the beverage. *Photo by Marcelo Vildósola.*

Farm Activities I and II

In two later rugs, Inés Rodríguez continued to develop the same manner of spacing that she used in her first rug. She broke the vertical and horizontal lines with zigzagging to establish separation of activities and scenic variety. In *Farm Activities I*, the warm orange background sets the mood for a bounded farm that shows a well-tended family garden and a small sheep pen extending before the main house (fig. 8.26). Here, luncheon is being served to two well-dressed *huasos* and a seated woman who seem to own the place. A stable and a caretaker's house are set well into the background behind the main dwelling and separated by a grove of trees.

Inés combined three different bands into the border. Embroiderers typically retain the background color in the middle band, and in this case, Inés repeated the use of the wangulen symbol in a less-elaborate version, alternating a darker orange shade with light green diamond shapes. The linked chain effect of the interior narrow band picks up the pale pink of the main house. The outside band gives the impression of a corded border.

Farm Activities II is done in green with dense applications of copper in different motifs to indicate a fall scene (fig. 8.27). Here, Inés divided the space in half by setting the main house and a gate across the width of the tapestry. The upper half is divided by a semicircular fence set obliquely, establishing an area where horses, sheep, and cattle gather. These are depicted with unusual definition. The caretaker's house and a water tank in the upper section resemble those in *Farm Activities I*. The use of white on the sheep, the house, and the snow-capped mountains brighten and lift the scene while more sedate activities take place in a mood of late-day introspection in the lower part of the tapestry. This mood is suggested not only by the attitude of the figures in the scene but also by the sun's absence behind the *cordillera*. Inés used the wangulen motif again in the central band of the border but this time she presented it as a butterfly with spotted, colored wings, just as in her first rug. It is

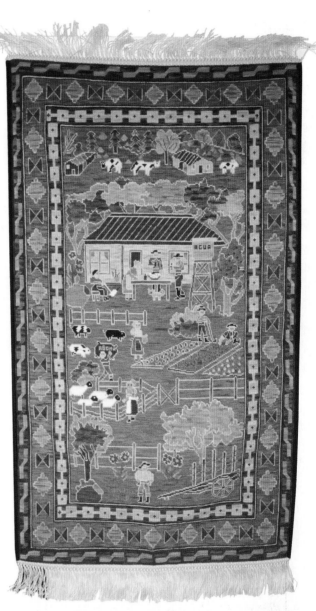

Fig. 8.26. Inés Rodríguez, *Farm Activities I*. Ninhue, Chile. Cross-stitch tapestry. So much activity is represented in this scene that each portion of the rug demands to be observed separately. Notice how the white outlining of the figures lightens the whole and helps individualize each area better. *Photo by author.*

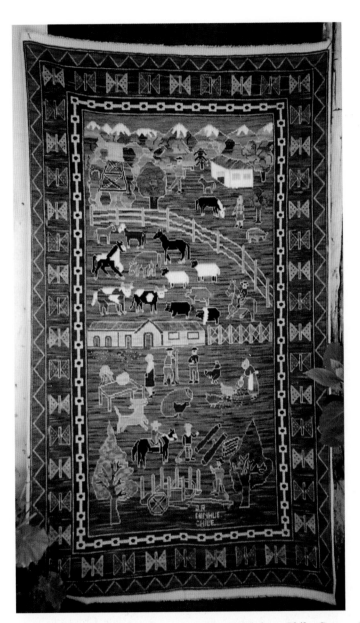

Fig. 8.27. Inés Rodríguez, *Farm Activities II*. Ninhue, Chile. Cross-stitch tapestry. In this rug, Inés has substituted a mellow palette of greens and browns for her usual bright colors. For the border she used an adaptation of the chained motif from her previous *Farm Activities I* rug but retained the light-colored outlining of her figures *Photo by author.*

interesting to note that in these rugs, as in others from the same time period, the depiction of a *casa patronal* surrounded by dwellings intended for laborers begins to appear. In the early tapestries, in contrast, new village dwellings, such as those shown in *Población Chimilto* by Victoria Durán, were represented as individual houses. Interpreting this new phase is a challenge. Is it perhaps the depiction of a wish for a more affluent life using the pattern of the old order?

Farm Scene I and II

Zulema Henríquez's *Farm Scene I*, done in ochre, conveys the feeling of a sunny summer morning (fig. 8.28). At the top of the rug, a contemplative man, who seems to be followed by his wife, appears in front of a row of young trees. Below, next to a mill, a great deal of activity is portrayed: a woman sweeping the ground, a man on horseback, men loaded with heavy sacks, and a woman hanging clothes out to dry. Contrasted with the busy-ness of these activities is a woman comfortably seated, surveying the scene. Zulema is fond of bold contrasts in her borders. She used a delicate curved S motif next to a large stark diamond shape in black and white that picks up the shading of the cattle figures. She finished the edge of the rug with a small checkered design.

Zulema's blue rug, *Farm Scene II*, shows a winding stream at the bottom of the tapestry where a woman seems to be washing clothes (fig. 8.29). The position of the trees stresses the slanting movement of the stream, and the heavy shape of a tractor and a bridge placed horizontally divide the design in half. These work to establish a sparser section above where a pen for animals, a fence, and an arched gate define a second horizontal division. In the uppermost section, the angled road leading to the house and the V-shaped arrangement of the fowl echo the winding movement we see at the bottom of the tapestry. For contrast, a horseman is set above the arch, replicating the horizontal direction once again. A quiet family scene is depicted at the very top, where a couple interact with children. The dense red, white, and blue central band in the border

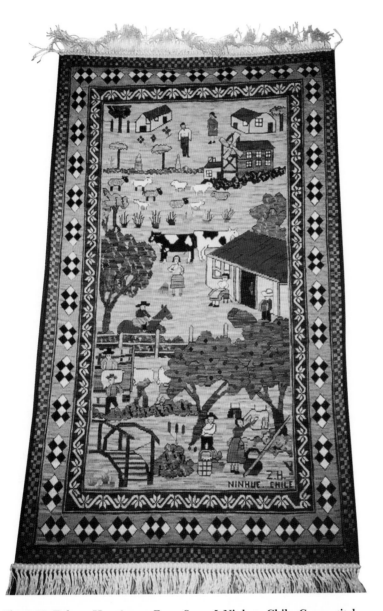

Fig. 8.28. Zulema Henríquez, *Farm Scene I*. Ninhue, Chile. Cross-stitch tapestry. Despite one woman depicted at rest, the layered disposition of the activities in this rug strikes the viewer as an exhausting enumeration of chores, which points to the laboriousness of country work. The woman standing with the broom and facing the viewer suggests work still to be done, as the farm is in full operation midmorning. *Photo by author.*

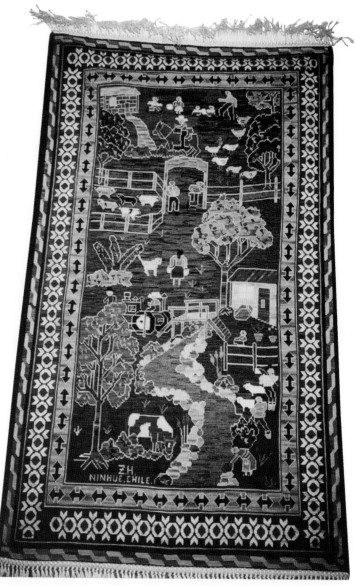

Fig. 8.29. Zulema Henríquez, *Farm Scene II*. Ninhue, Chile. Cross-stitch
tapestry. In this second farm scene, Zulema has chosen a cool blue for the
stream and the background of this rug to relax the urgency of the work being
performed. The central figure of the woman facing away from the viewer
implies the final activities at the end of the farm day. *Photo by author.*

picks up the colors in the middle of the tapestry. Meanwhile, pointed double arrows on the inner narrow band accentuate the length of the rug while the elongated zigzag of the outer band done in red and off-white appears to be a corded edge when seen from a distance.

Vineyard and Grape Harvest

In her informative depiction of *Vineyard and Grape Harvest*, María Tapia (fig. 8.30) shows a vineyard and the grapes being brought in baskets to be crushed (fig. 8.31). Jugs are set out, which will be filled and then transported to the bodega by oxcart. Men are busy performing the work of crushing the grapes, while two women sample a bunch of grapes. The season of the year is suggested by the leaves that have fallen from a tree onto a fenced field. Adjacent to the vineyard are several animals. Distant verdant hills and a row of well-defined trees occupy the top of the design, and what appears to be a white helicopter or plane flies in a golden sky.

Fig. 8.30. María Tapia and her children. María's family has been proud and supportive of her art, but other work opportunities occupy the younger generation, and they do not practice embroidery. *Photo by Judit Hausner.*

The border consists of same-width bands that indicate the time of year and the activity being represented. The outer band features a row of grape bunches against a copper background; the middle band repeats crosses with crenellated borders in a purple shade on the same deep gold background as the main part of the rug. The purple hue of the crenellated crosses seems to call the color of wine to mind. Finally, the inner band is done in a rich brown with an off-white repeating motif.

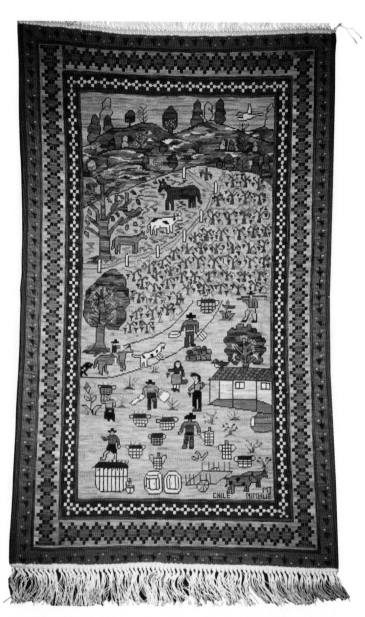

Fig. 8.31. María Tapia, *Vineyard and Grape Harvest.* **Ninhue, Chile. Cross-stitch tapestry.** The presence of two women holding bunches of grapes and staring at the proceedings indicates that wine making is very much a man's job. *Photo by author.*

Other Rugs

Using a bright medium blue background in their piece, the Vergara sisters (fig. 8.32) combined motifs they had each developed earlier. Ema reintroduced her soccer game, while Filomena repeated the figure of the farmer leading the oxcart loaded with wheat. An irregular fence divides the space in half, defining the living quarters and the farming grounds. An attractive and carefully designed border picks up the colors in the central panel, and a band of fluttering white doves adds movement and lightens the whole (fig. 8.33).

Fig. 8.32. Ema Vergara (*left*) and Filomena Vergara (*right*) with Carmen Benavente (*middle*) after the presentation of the Ninhue tapestries to the municipalidad. *Photo by Judit Hausner.*

It has become customary to divide the central panel of the rugs with fences or roads to establish a separation of various activities. Patricia Medina chose a road to both separate and connect the halves of her work (fig. 8.34). In the lower section she portrays more domestic chores, usually done near the farm house by women accompanied by children. Here, men also perform safe jobs, such as attending to a horse that has already been lassoed. A busy scene of wine bottling with the participation of many workers is placed in the upper half. To show the inside of the wine cellar, Patricia has made a top-to-bottom cross section of the brick building. To convey darkness she shows two lighted bulbs hanging from the ceiling. Rich browns and coppers contrast well with the bright blue background. The first border consists of a geometric key design, the second is formed from branches of grapes, and the third from the wangulen Indian motif.

Recent Work

The most recent compositions integrate more detailed motifs, which liven up the action, suggesting movement in the narrative. Different activities are combined, and main characters are easy to identify. The

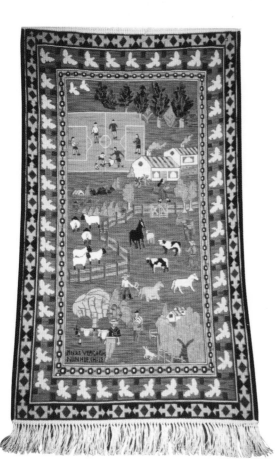

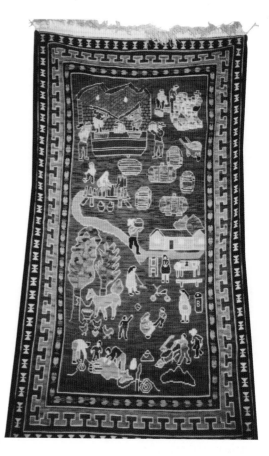

Fig. 8.33. Ema Vergara and Filomena Vergara, *Farm Activities and Soccer Game*. Ninhue, Chile. **Cross-stitch tapestry.** Filomena has brought together many details from her other works as a counterpart to the soccer field where older players seem to congregate. The white doves in the middle band create an illusion of widening the central panel, which is abruptly checked by the heavy border at the edge. *Photo by author.*

Fig. 8.34. Patricia Medina, *Bottling Wine*. Ninhue, Chile. Cross-stitch tapestry. Patricia establishes a separation of activities that seem to take place simultaneously without necessarily being related. *Photo by author.*

subjects are vineyards and wine making, sheep shearing, digging for mud crabs and preparing them, a soccer game, horse racing, social gatherings, meals, and picnics. Humorous touches are also part of the action. The viewer chuckles, for instance, at a child retrieving a kite from a tree or a mother watching her child swim in the river while his clothes have been left scattered on the bank. In another rug we see a lively swimming pool scene with the pink bodies of the swimmers set against the light blue of the water and the navy of the background (fig. 8.35). Trees edge the central panel on two sides, which reinforces the seclusion of the place. The three borders that frame the whole introduce a row of white doves that make the whole scene flutter with life.

On an elegantly designed cushion, Dina Loyola has attempted to create transparency by placing a flock of sheep behind two sparsely leafed trees (fig. 8.36). The controlled color scheme of deep shades of gray, brown, and teal against the deep glowing orange of the background enhance the whiteness of the sheep, which are also part of the outer border.

Rugs typically take 350 to 400 hours to complete, which translates into three or four months of work. In spite of this rather long preparation time, the women prefer to work individually on each rug so they may receive more money at once. This individualized manner of stitching predictably results in rugs that are also more individualized to each stitcher in terms of her choice of subject, design, and color. Trees in particular have become characteristic features of certain stitchers, both in the way they are composed and in the way they are outlined, colored in, shaped, and shaded in the piece. As for the decorative borders, the width of their bands, the motifs, and coloring are all important design elements that each stitcher plans with the utmost care while she is still working on the pictorial portion of the piece. The movement and direction established by these bands, which may complement, restrict, or expand the density of the pictorial area, also serve to identify the creator of the rug, as each stitcher has her own approach to these characteristics.

While the rugs are rich and polished in their presentation, they have accordingly lost some of the spontaneity of the earlier tapestries. In canvas work, spacing and shading must be precisely calculated. It may be

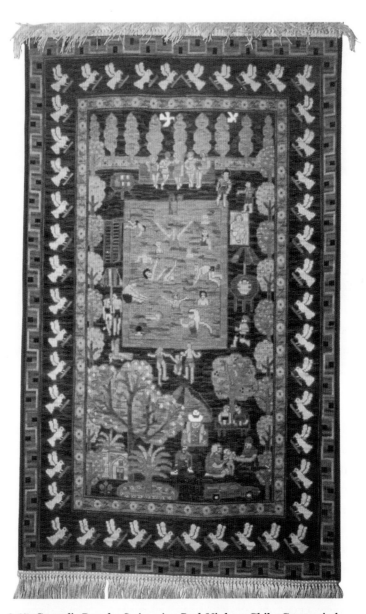

Fig. 8.35. Custodia Parada, *Swimming Pool.* **Ninhue, Chile. Cross-stitch tapestry.** Irrepressible joy is contained in the fun taking place at this public swimming pool. It replicates Custodia's own experience of a vacation she once took. *Photo by Matias Orrego.*

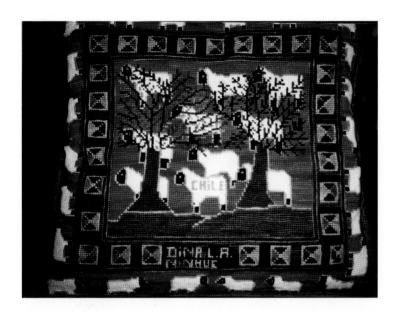

Fig. 8.36. Dina Loyola, *Sheep and Espinos* cushion. Ninhue, Chile. Cross-stitch. Focused planning was a part of the design of this cushion and the choice of colors that interpret it. *Photo by author.*

that the introduction of the geometrical shapes for the borders exerted an influence of uniformity and crispness on the nongeometrical forms as well. The changes are apparent in the way both the human and animal figures are represented. Buildings, on the other hand, have benefited from the precision of canvas stitchery. They emerge true to their architectural design and have become symbols of pride for the stitchers.

Another difference between the rugs and the earlier tapestries concerns the overall mood and expanse of the subjects each treats. The considerably larger surface covered by the rugs and the repeated use of flat uniform stitches allows for a narrative whose subject matter is broad in scope. The smaller-formatted tapestries, on the other hand, with their various textured stitches convey a more charming and intimate mood. Both types are extremely beautiful, though the rugs, of course, cost much more, which can be prohibitive for many prospective buyers. When the women showed their work in exhibits in Chillán and Santiago, they were approached by admirers who could not afford the rugs but loved them so much they wished to buy the patterns. The women refused, and I was comforted by their denial. "These [the designs] are not for sale; these are ours. Besides you wouldn't know how to do them anyway [i.e., interpret the designs]," they said firmly.

Recognition Abroad

As the embroiderers of Ninhue developed their craft from the early spontaneous creations to more and more sophisticated tapestries and then three-dimensional figures and finally cross-stitched rugs, their recognition and fame spread, both domestically and internationally. After the first tapestries were completed, and the embroiderers bid me farewell with their lovely fiesta at the newly whitewashed post office, I returned to the United States with a bag full of embroidered tapestries, some of them new and others borrowed from people who had purchased them in Chile. I showed the pieces at Indiana University in Bloomington and again at the Inter-American Cultural Center in New York before the end of the year. Carolyn Lockwood and Sandy Purrington, who had arranged for my own work to be shown in New York years earlier, suggested I might find an outlet for the embroidery of Ninhue in Santa Fe, New Mexico. Sandy put me in contact with Dr. Yvonne Lange (director of the International Folk Art Museum), who promptly arranged an exhibit in October 1972 after seeing some of the tapestries. The stitchers in Ninhue submitted new works, and the exhibit was a great success. The International Folk Art Foundation bought several pieces for the museum's permanent collection, and for several years offered new pieces for sale at its shop.

The exhibit at the International Folk Art Museum not only benefited the embroiderers directly, it also affirmed my faith in the project. Actually, the display consisted of what had been accomplished in one year's

work. The changes I perceived between the very first pieces and the more recent ones were minute; yet what stood out was the undeniable pool of creativity. The exhibit had such a joyful, fresh, and new tone that I could sense a promise and hope not unlike being in the presence of a newborn. Also, because the exhibit was taking place outside of Chile and in another culture, I knew the warm response arose from genuine and informed admiration and not merely local pride. I recall how my curiosity was piqued at the time, causing me to wonder, What is there yet to come? What will the women dream up next? As I reflect on it, I now realize that curiosity was a strong part of my dedication to the women.

This Santa Fe exhibit made it easier to develop a market in the United States. I distributed most of the embroidery from Ninhue to museum shops, such as the Indianapolis Museum of Art and the Textile Museum in Washington, D.C. The pieces also appeared in several galleries and found homes among collectors of folk art. Back in Bloomington, Rosemary Fraser, owner of The Gallery, made a special exception for the embroidery of Ninhue, allowing it to be displayed in a gallery otherwise reserved exclusively for local and regional art.

Opportunities in Chile similarly emerged. As the stitchers' work became better known locally, people started coming to the village to buy it. Also, when the Catholic university in Santiago instituted the annual Ferias Artesanales there, the embroiderers from Ninhue were asked to participate.[24] These fairs put Ninhue on the map in Chile. Local festivals, such as the annual commemoration of Arturo Prat's death, also provided the embroiderers the chance to exhibit and sell their work. Father Andrés LaCalle, the new priest, also became a staunch supporter of the embroiderers. When Pope John Paul II visited Chile in 1987, Father LaCalle played a key role in arranging the commission of a stole for his Holiness. In gratitude for his help, the stitchers presented Father LaCalle with embroidered vestments and an altar cloth for the parish church.

Distribution of the Ninhue embroiderers' work in Europe has been

rare and based only on personal contacts. In 1987, I gave a Parisian friend a pair of embroidered slippers. She later showed them to a shoe manufacturer who called me in great excitement, wishing to order two thousand pairs! He had thought these slippers were some kind of traditional Chilean footwear and that they would be very popular in France. I had a hard time convincing him that his idea was impossible since there were only two women who made them. When the women heard of his idea to go large scale, they were sorry they could not meet such demand, but they wryly added in a letter to me that it would be "a crashing bore to stitch 1,000 pairs of slippers each!" Working some three hours a day, it would have taken them perhaps twenty years to fill the order. When they found out the manufacturer wanted to pay only five dollars a pair instead of the twenty-five dollars that was their price at the time, all regrets vanished.

This experience gave them a real taste of what it meant to be a commercially successful artisan.

Thirty Years Later

Some thirty years after the embroidery of Ninhue had been introduced to the world in Santa Fe, another important exhibit marked the importance of the stitchers' work in the art world. Between July 2003 and October 2004, Jean Druesedow, director of the Kent State University Museum, organized an exhibit of Central and South American embroidered work under the title Stitches and Daily Life. In that exhibit she presented a retrospective of the embroidery of Ninhue, comprising its three periods, namely, the first embroidered tapestries, the three-dimensional figures, and the cross-stitched rugs. The thematic thread suggested in the title helped the visitor to focus on the inventiveness in depicting a vast spectrum of daily village life, including family, work, pastimes, and community celebrations. This expertly assembled display revealed an important aspect of the embroidery of Ninhue: compared to the embroidered work of Central America, it is a very young craft, taking

its first steps in the creation of its own tradition. The pictorial embroidery of Ninhue was quickly adopted and then adapted by people not acquainted with contemporary art embroidery from other traditions. Similarly, those who practiced it had no past legacies of embroidered folk craft to influence their designs. Hence, the needlework of this small village stands out as a fresh interpretation of present-day reality, full of vigor and devoid of nostalgia.

While viewing the path the embroiderers of Ninhue had taken during these thirty-some years in this special exhibit, I could not help but wish the embroiderers themselves could have been there. I thought of the pride they would have felt at being celebrated in a foreign land while at the same time realizing the marvelous variety and integrity of their work.

I took this early twenty-first-century exhibit at Kent as a precious gift. If the exhibit at the International Folk Art Museum in 1972 made me wonder what the embroiderers would do next, Kent demonstrated that whatever followed would certainly continue to inform and delight.

"No bonito sino bello"

As I look back on those turbulent and ultimately tragic times, I am reminded of how important they were to the initiation of the Ninhue project. The acute pain I felt at the loss of a place so beloved to me made me aware of the characteristics that rendered it the most appropriate location to realize my long-held desire to offer Chile a social service, even if limited in scope. Until that time, I had not recognized the treasure that lay right before my eyes for all those years. Once I realized the great potential of the region I had known all my life, I minimized the apparent impracticality of the chaotic political moment by ignoring it and paradoxically placing myself in its very middle, but not taking sides, for I had no time to lose. I do not feel that I chose the moment but that it chose me, and so I gave myself up to it.

I am glad that the independence and naiveté of my bold move, which disregarded opinions and ignored assumptions about my motives and intentions, permeated the spirit of the embroiderers as well. The practice of their craft has never been affected by politics: their art is one more product of Ninhue, a fruit of the earth, so to speak, affected only by the availability of markets for their work. Times have changed, and Chile is more aware and sensitive to the patrimony of its crafts. In summing up the various aspects of this adventure, I acknowledge that by opening up a small foreign market for Ninhue in 1971, I deprived Chile of some choice exemplars of this craft; on the other hand, again by force of circumstance, I anticipated the popularity of nontraditional exports, which enabled this product of Chile to be bought and appreciated abroad.

It has been the aim of this book to recapture some of the many pieces sold abroad by including illustrations of some of the works that grace the collections of museums and private collectors, and which will hopefully whet the appetite for this craft among stitchers and collectors alike.

Each stitcher in Ninhue has remained free and in control of her time and art—no external demands have blurred her aesthetic sensibility, and she has been allowed to adjust the rate of her productivity to the various stages of a rural woman's life. These fluctuations follow a natural curve that coincides with the specific responsibilities of a young woman before and after her marriage. Typically, she must raise a family, and the children remain part of the household until they leave to start their own lives; she must care for extended family members in their old age; and she must juggle other jobs or occupations pertaining to seasonal farming activities. In addition to all that, several stitchers have generously shared their knowledge with women of all ages who have sought their instruction. Many of these newcomers have contributed fresh, original approaches that counteract the tendency of some stitchers to pattern their work exclusively on the models and techniques of their predecessors.

The first years were characterized by the establishment of individual styles, which soon were associated with various families. However, as I've mentioned elsewhere, others would express their admiration for a particular interpretation of a subject matter and then adapt the style into their own work. All together, this is how the Ninhue style developed. When a theme, such as San Agustín or the plaza, was copied outright, it was because the object was locally important and proven commercially successful. The copy, however, no matter how technically correct, always seems to lack the spirit infused by the originator. This phenomenon is particularly noticeable in some of the religious figures and even in the embroidered slippers. Perhaps this is to be expected, since the copyist neither devised the shape nor anticipated the demands that are made of the stitches that interpret the subject. Therefore, very seldom will the copyist embroider with conscious concern for the role the stitch is to

play. Under close scrutiny, the result is often mechanical. I have yet to encounter a replica more imaginative and functional than the original. I have always insisted that stitchers must tackle new subjects to reexperience the creative process from beginning to end. Nothing substitutes for working a piece that has been imagined and then developed in all its detail by the creator. Such a piece exudes a pleasure that mirrors the path the artist followed when inventing it—the shape and size the piece would take, the weight of yarn and colors that would be used, the texture and the way the stitch would be manipulated to enhance the final product. I am aware that my emphasis on variation and originality might be interpreted as an obstacle to the repetitive flow of habitual folk expression. This is not so. The experiment of introducing wool embroidery where formerly there was none is, after all, only thirty-five years old—still in its infancy as far as folk arts are concerned. The craft movement can still benefit from occasional additions and adjustments by the embroiderers themselves to freshen the vision that defines excellence in their craft.

From the first moment I began teaching embroidery, more than forty years ago, I tried to teach my students the importance of creating their own designs, once they had a basic vocabulary of stitches. I emphasized the unique character of each stitch and its mutations according to spacing, direction, material, and color. In short, I taught only the techniques of the craft. When it came to design, I encouraged my students to be unpretentious, to examine what interested them, and to turn first to what was close to them and what they knew best. I assured them they would instinctively find the capacity to represent these things, and their confidence would take root as they made choices about stitches, texture, and color. In many instances, I told them, the stitches themselves would dictate the design, while even the ripping out of work would reassure them, as it would provide a lesson as well as a second chance. Ripping out what is not liked still allows trying something new without forfeiting the process of selection. Indeed, this process makes the work the stitcher's own.

People surprise themselves when they let go of their inhibitions. They discover their true potential. The variety and adaptability of stitchery allows strong statements to be made, which can then become important cultural documents. Ethnic backgrounds, social and economic levels, physical conditions, states of mind, age—all these surface in the work as the stitchers draw on their own reality. The embroidery of Ninhue lets us partake of the personal and communal life of the small rural society from which it originates. It records and reflects intimate psychological situations that were expressed in the tapestries as well as in the three-dimensional figures. Here, dreams and aspirations are articulated, and current events and significant changes in the stitchers' surroundings appear.

But it is a slow process. Little by little, the artisan develops an awareness of the elements that identify her with her environment in order to feel grounded to create. These early and fragile moments must be nurtured and protected from any intervention that may inhibit them. The stitcher must have plenty of time to reexperience and assess the impetus behind her work, and any judgments that the work is too raw, primitive, or "not in good taste" (therefore requiring alteration to satisfy commercial demands) will diminish and sometimes even kill the authenticity of the work.

No more rigorous critics exist than the artisans themselves. Their displeasure often arises from the realization that their work has fallen short of their inner vision. When this situation occurs, it is essential that the stitcher be permitted the time and space to struggle with her reservations, so she may achieve the form of expression that will satisfy her. In our preoccupation with developing new sources of commercial work, we sometimes lose sight of the soul of the artisans, whose surprising originality jars our sensibilities and differs from the current expectations of the marketplace. When that happens, we are tempted to interfere and make the work conform, but of course, such intervention can only smother a genuine spiritual expression and replace it with a bland, cute image.

I once had the opportunity to speak with Pablo Neruda about the work I was doing in Ninhue. Worried it would become overly commercialized and therefore inauthentic, he said, visibly alarmed, "I hope that what they do is not pretty (*bonito*) . . ."

"No," I reassured him, "it's not pretty, it's beautiful (*bello*)."

"Ah! In that case, that's good," he said, relieved.

No denying it, "pretty" things are easier to sell than "beautiful" things. They are more soothing; they do not disturb us. They give us pleasant, undemanding company and do not ask us to read deeper into their content or consequence. They mostly delight. But if we are interested in furthering the spirit of social and economic development through artistic expression, then we must grant absolute freedom of expression to artisans as they develop their craft. Indeed, diverse and unfettered creativity is the key to the sustainability of the embroidery movement of Ninhue. Just as we are coming to realize the importance and necessity of diversity to the future of our planet and just as genetic diversity makes crops less susceptible to disease and pests, so is variety and innovation crucial to the success of sustainable commerce. Craftwork by artisans communicates a range of ideas and emotions in a unique and exquisite manner that would surely be lost under the exigencies of mass production. As we have so often seen, the latter carries the seeds of its own extinction—it soon becomes boring, commonplace, and the object of our indifference. Conversely, the singularity of each human experience, as conveyed by a Ninhue stitcher, carries with it the assurance of future demand, for there is no end to the novelty and freshness of its expression.

To further reinforce this point, I want to call particular attention to the depiction of trees (figs. 10.1–10.26). The embroiderers' originality has been most eloquent in the imaging of trees. I believe the reason for this expressive variety lies foremost in the essential significance the subject has at a given moment for the individual stitcher.

In the landscape surrounding these Ninhue women—much as in the landscape surrounding any one of us—trees are "beings" they identify

with, symbols of the cycles of life. Trees stand as we stand; they are near us; they sustain us; they are our companions. In the woods, they support each other and remind us of our own communities. We are moved by their vulnerability, and we are aware of how they are affected by weather and climate conditions. We see them buffeted by wind, hail, and rain. We take notice and liken our hardships to theirs. When the embroiderers of Ninhue are imagining trees, they are not always striving for realism but more often trying to convey a feeling. Maruca Bustos told me so when she showed me the *espino* she had stitched to represent the one that stood before the house of Coroney. "It stands for the sorrow of your loss," she said. In fact, a gust of wind seems to be blowing it away.

When an artist identifies with a subject, she lets it speak for herself, pouring into it her mood and emotions. In the dry and unirrigated but arable land surrounding Ninhue, trees are cherished, and their harsh growing conditions mirror the difficult lives the embroiderers experience. Closeness to a symbol establishes a familiarity that allows an artist great freedom of interpretation. At times, it may suffice to merely outline its shape; other times an orderly scattering of leaves will suggest a breeze. A more tortuous shaping may convey stressed growth, while a sophisticated stylization can be used to identify the species. A total abandon into playfulness of color and shape might even acknowledge awe before nature. In these various ways and in others, the embroiderers of Ninhue express their lyricism when stitching trees.

Throughout the years, as the embroiderers changed techniques, they adapted them to their designs so that the attributes pertaining to each mode of stitchery were also reflected in some aspect of their trees. A greater variety in their presentation was achieved when the crewel type of stitchery, which imparts more freedom of line, graded textures, and intricate color combinations, was used. In certain ways it seems as if imagining trees in crewel results in more imaginative trees. But this is not really true. When it was necessary to invent a three-dimensional figure of a tree, the embroiderers rose to the challenge. They used detached stitches of one kind to create the fabric of the bark and of

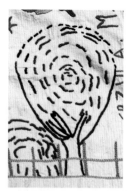

Fig. 10.1. (*left*) Úrzula Manríquez, detail from *Church*. Ninhue, Chile. Embroidery. When representing trees, stitchers typically concentrate most of their ingenuity on the tops. Sometimes the detailing of the tops is accomplished by quick lines or strokes that merely suggest its shape. *Photo by author.*

Fig. 10.2. (*right*) Mercedes Rodríguez, detail from *Landscape*. Ninhue, Chile. Embroidery. Here lines serve to order the unattached leaves that contrast with denser representations in the tapestry. *Photo by author.*

Fig. 10.3. (*left*) Úrzula Manríquez, detail from *Puzzle*. Ninhue, Chile. Embroidery. The repetition of the same motif in the same stitch and color evokes a stirring of leaves. *Photo by author.*

Fig. 10.4. (*right*) Úrzula Manríquez, detail from *Puzzle*. Ninhue, Chile. Embroidery. An agglutination of the same leaf shape done in the same color and stitch and encased within a festooned border boldly establishes the tree's presence. *Photo by author.*

Fig. 10.5. María Ortiz, detail from *Grape Harvest*. Ninhue, Chile. Embroidery. A decorative element in the representation of trees is sometimes exaggerated to further a dramatic tone. In this example, the tree's swaying seems to echo the man's effort carrying the grapes. *Photo by author.*

Fig. 10.6. Mercedes Rodríguez, detail from *Landscape*. Ninhue, Chile. Embroidery. Seasonal changes are suggested by the whimsical sectioning of the foliage assembled in strongly curved, richly colored portions. *Photo by author.*

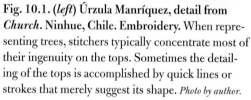

Fig. 10.7. (*left*) Rosa Elena San Martín, detail from *Cowboy*. Ninhue, Chile. Embroidery. This treetop's nonrealistic treatment delights us with its playful make-believe. *Photo by author.*

Fig. 10.8. (*right*) Maruca Bustos, detail from *Wind Storm*. Ninhue, Chile. Embroidery. A dark wind-swept *espino* whose trunk is also bent conveys the turmoil the stitcher wishes to express. *Photo by author.*

Fig. 10.9. (*left*) Maruca Bustos, detail from *Landscape with Hens*. Ninhue, Chile. Embroidery. *Espino* branches that extend like open arms to support a bird's nest suggest the tree's role as a shelter for birds and other species as well. *Photo by author.*

Fig. 10.10. (*right*) Irene Eriza, detail from *Julia and Irene Discussing a Project*. Ninhue, Chile. Embroidery. The fruitfulness of a fig tree is simply stated. *Photo by author.*

Fig. 10.11. (*left*) Margarita Ortiz, detail from *House and Trees*. Ninhue, Chile. Embroidery. Plush textures in dark and light green celebrate the proximity of a young tree to a more mature one. *Photo by author.*

Fig. 10.12. (*right*) Edith Vergara, detail from *Harvest Scene*. Ninhue, Chile. Embroidery. Thick, dense stitches call attention to the vigorous, healthy fullness of an orange tree. *Photo by author.*

Fig. 10.13. (*left*) Custodia Parada, *Tree Surrounded by Animals*. Ninhue, Chile. Embroidery. A three-dimensional strong-limbed yet slender budding tree is wrought to stand like a delicate statuette to proclaim the advent of spring. *Photo by author.*

Fig. 10.14. (*right*) Filomena Vergara, *Flight into Egypt*. Ninhue, Chile. Embroidery. Are we to believe that in Ninhue oranges grow on poplars and pine trees? *Photo by author.*

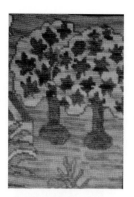

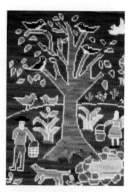

Fig. 10.15. (*left*) María Tapia, detail from *Summer Fun* cushion. Ninhue, Chile. Cross-stitch. The canvas in the rugs has to be completely covered; designs have to be adapted to the grid and to better stand out, they are outlined in another color. The variegated yarns help make shading easier to achieve. Both the foliage and trunk of this tree are given their own specific color. Diagonal lines crisscross the foliage to suggest branches. *Photo by author.*

Fig. 10.16. (*right*) Custodia Parada, detail from *Scene with Horses.* Ninhue, Chile. Cross-stitch tapestry. A sprinkling of dark leaves over a light background may well serve to identify the type of tree. *Photo by author.*

Fig. 10.17. (*left*) Zulema Henríquez, detail from *Farm Scene II*. Ninhue, Chile. Cross-stitch tapestry. The same type of yarn provides the shading for the trunk and the branches. White is used to outline and separate the portions dividing the foliage. This technique creates a subtle depth enhanced by the greens and reds of the fruit. *Photo by author.*

Fig. 10.18. (*right*) María Tapia, detail from *Autumn Scene* cushion. Ninhue, Chile. Cross-stitch. The tree stands bare. Birds seem to have scattered the leaves to make room for themselves, bringing to mind a rush of blackbirds. *Photo by author.*

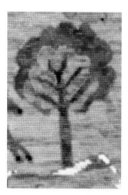

Fig. 10.19. Custodia Parada, detail from *Scene with Horses*. Ninhue, Chile. Cross-stitch tapestry. Here, branches penetrate into the foliage space. A central core is established, which is surrounded by sections of various colors. *Photo by author.*

Fig. 10.20. María Tapia, detail from *Grape Harvest*. Ninhue, Chile. Cross-stitch tapestry. The variegated yarn shades the background behind the foliage, yet a hint of bloom appears at the top of short branches that remain central. *Photo by author.*

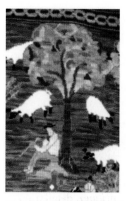 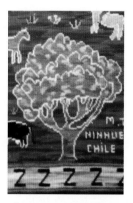 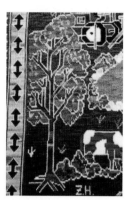

Fig. 10.21. (*left*) **Ema Vergara and Filomena Vergara, detail from** *Fall Farm Scene*. **Ninhue, Chile. Cross-stitch tapestry.** Three dark slender branches rise from the trunk, pointing outward into the treetop, which is richly colored with blues, greens, reds, and golds in irregular stained-glass shapes. These irregular shapes lead the eye to perceive rounded volumes. *Photo by author.*

Fig. 10.22. (*right*) **Ema Vergara and Filomena Vergara, detail from** *Fall Farm Scene*. **Ninhue, Chile. Cross-stitch tapestry.** The scalloped outline, approximated in the shapes of the carefully balanced tawny shadings, adds fullness to this autumnal tree. *Photo by author.*

Fig. 10.23. (*left*) **María Tapia, detail from** *Corral*. **Ninhue, Chile. Cross-stitch tapestry.** A cupola of leaves defined by exterior and interior scalloped lines is supported by a trunk with wide-spreading branches. *Photo by author.*

Fig. 10.24. (*right*) **Zulema Henríquez, detail from** *Farm Scene II*. **Ninhue, Chile. Cross-stitch tapestry.** This riverside tree gains its sense of height and slimness by the openness among the foliage at its center. *Photo by author.*

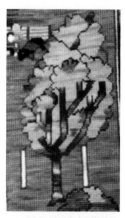

Fig. 10.25. Inés Rodríguez, detail from *Farm Activities*. **Ninhue, Chile. Cross-stitch tapestry.** The sharp contrast between the dark bark penetrating the light foliage accentuates the tree's verticality. (Note: This detail is from a *Farm Activities* rug not illustrated in this book.) *Photo by author.*

Fig. 10.26. Inés Rodríguez, detail from *Farm Activities*. **Ninhue, Chile. Cross-stitch tapestry.** The height and slenderness of the tree are stylized, as is the powerful root system that sustains it. (Note: This detail is from a *Farm Activities* rug not illustrated in this book.) *Photo by author.*

another type to shape the foliage. The rug canvas challenged them once again. This time they were working on a strict grid on which the interplay of curves was difficult to master. At first they circumvented the problem by filling in the outline of a tree, interposing lines to divide it into sections or scattering leaves or fruit shapes to identify the tree type or to render it more interesting. Soon after, the stitchers developed designs in which branches and trunks defined the tree's skeleton, and they made use of the variegated color of hand-dyed yarns to superimpose shading in a most interesting way. This resulted in a painterly effect that has yet to be refined and reenvisioned. Further explorations will bring about adjustments to better accommodate the designs to the grid, resulting in new images.

No doubt, this organic quest for novelty will challenge viewers to open their minds, adjust their vision, and learn to appreciate the honest, refreshing approach of these stitchers who share their stories with us. Their unusualness will force us to reconsider our long-held notions of taste and our expectations of elaboration, use, and application, which will allow us to rediscover our common identity as manifested by the spirit that apprehends it unerringly. To fully comprehend these voices, we must listen to them and trust we can understand them, even if we cannot understand their words, for they represent a language that lies dormant in all of us. Thus does a sophisticated and appreciative public intuit its own creative roots and recognize the flow of its life energy.

The project has been a modest one all along, considering the number of participants, their limited output, and a narrowly focused public interest and readiness to consume this type of expensive craft. In the United States, galleries and museum shops have been ideal venues for people to get acquainted with and to purchase the embroidery of Ninhue. Interior designers, art collectors, friends, and family have been enthusiastic and steady buyers. In Chile, the market is more limited, and the works attain more exposure at seasonal craft fairs or craft shops, where they sell at a fraction of the price that is paid in the United States.

Because of this economic reality, the women preferred to send most of their work to me for marketing.

My desire to help the embroiderers earn more through the sale of their rugs has been possible to fulfill, but sales have definitely slowed. I discussed the problem with the embroiderers, and they decided to continue producing the rugs in hopes of better times. Their decision shows how much they enjoy embroidering rugs, in spite of their bulky format. They are the most expensive item they produce, so that even sporadic sales yield a substantial sum that makes the waiting worthwhile. The women like to depict scenes not only for what they represent but because they combine a variety of pictorial and geometric motifs that make stitching pleasurable. Further, the use of cross stitch, which is easy to execute and maintain in uniform gauge, results in consistently good craftsmanship, which is reassuring to the artisans, for they all turn out equally acceptable work. The stitching has evolved from the early rigid style of the first rugs, which had similarly more rigid design. Now, motifs are more deftly articulated, lending greater movement and playfulness to the piece.

The quality of the stitching on the first flour sack tapestries, on which a variety of crewel stitches were used, was predictably uneven and sometimes even poor. Still, those tapestries expressed a valuable spontaneity that often made up for their less-polished workmanship. Fearing I would discourage beginners who were already scared and nervous about creating their own designs, I chose not to dwell on refining or standardizing the stitches. On the other hand, none of the pieces done during those early years bears any resemblance to traditional crewel: crewel yarn was not used, and the imagery was new and nonderivative.

The women's attitude and engagement with the embroidered figures presents another interesting story. With the exception of Irene Eriza and her late mother, Julia Ramírez, who loved every step of the process, many of the embroiderers did not enjoy the full process of making three-dimensional figures. Most like the embroidering itself, but few like

building the frames, stuffing the figures, sewing the parts together, or adding the finishing touches—especially the legs of the animals. The quality of these pieces is uneven. Some artisans are able to create finer-looking products, and the contrast among them bothers the stitchers. Elena Manríquez (fig. 10.27) says,

> what I like best is embroidering rugs, what I like least is sewing the little animals. I mean I like to embroider and shape them, but not sew them up. My family is very impressed because I used to not like to sew and now they wonder how I can do something so beautiful (the rugs), with so much patience and care. They also say they look as if they were made by machine.

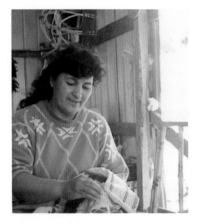

Fig. 10.27. Elena Manríquez particularly enjoys working on her rug and finds affirmation in the enthusiastic support offered by her family and friends. *Photo by Roberto Contreras.*

The fourteen women who were still stitching regularly in 2009 do so because this type of work provides them with extra earnings that improve the quality of life for themselves and for their families. María Tapia feels "well and happy doing something I like that fills me with personal and family satisfaction." She considers herself "a professional stitcher for 32 years, day in and day out, having raised this art to a national and international level. At the beginning when I was young," she explains, "thanks to the embroidery, I covered my basic needs. Then, with the passing of years, this became part of my daily life and I have perfected myself, creating new things that I have been able to send away (for sale)." Patricia Medina expresses herself in these terms: "I feel happy and proud to be able to do something so beautiful and precious like the rugs. When looking at them, it doesn't seem to me I've done them by hand; it only seems a dream and not a personal reality." Although she stitched before joining the Asociación de Bordadoras, Eugenia Andrade does not feel she is a professional—"just a woman who embroiders." Nevertheless, she considers herself "useful because I am able to create sketches which can be rendered into embroidery."

These responses show that the sale of their work has never quite defined professionalism for some of the embroiderers of Ninhue.

Luisa Quijada says that if she hadn't taken up embroidery, she would have spent her time "spinning, knitting or inventing something else," but she adds that by stitching she "feels more whole as a person and more in communication with other people." On the other hand, Dina Loyola says that if she hadn't embroidered, she would have taken up knitting or cuelchas to help her family, work she does not much enjoy doing. For her, a life without embroidery "would have been really boring, without much fun." Filomena Vergara explains, "I embroider because I like it very much and for the income; if I hadn't embroidered I would not have been able to live in Ninhue. I would have had to leave in search of other horizons in order to subsist." It is surprising she does not consider herself a professional: "although it's true I master the technique very well, I still lack the ability to design and (achieve) proportion. But I am able to teach all I've learned in these 35 years. My life has totally changed. Before, I lived inside these four walls; now I am a woman known in my village, in my country and most importantly, I have crossed the border and am known in many countries—especially in the U.S. and this fills me with pride." When asked when she likes to stitch she replies, "This question is quite relative. I stitch when I want to and when I don't feel like it, I don't. That's why I thank God, I have this very free work. But there are exceptions: when I am working on a commissioned piece, I work whether I want to or not." Other stitchers echo Filomena regarding the advantage of working on their own time.

Many of the women can seldom afford to embroider for themselves. Those works that happen to be on display at home are intended for sale. The pieces that remain in the family have been for the most part commissioned by independent members who feel very proud of their relatives and are in a position to pay for their work. These tapestries are considered heirlooms and are treated as such. I've been happy to learn that little by little some embroiderers, like Ema Vergara and Elena

Manríquez, have been able to stitch some things for their own homes. Some, however, take pride in sending all their work out into the world, as Inés Rodríguez shows when she proclaims, "Every embroidery I've done I've had the satisfaction of selling or giving away!"

Listening to the embroiderers reflect on the meaning of their experiences with the project—why they stitch, what embroidery has meant to them, how it has affected their lives, how they see themselves, how they perceive others seeing them—offers an insight into the measure of this project's significance. As essential as the financial return for their work has been to their satisfaction, perhaps the most rewarding aspect of the project has been the joy they have derived from truly creative work performed at their leisure and the refreshing and empowering discovery of themselves in the process. This has been the privilege and joy I have been fortunate to savor and be a part of.

The public relations department of the municipalidad of Ninhue has published an illustrated booklet on the work of the embroiderers, intended to publicize their work widely. The women are understandably happy with this homage, and I am grateful they are being recognized as a unique and valuable asset not only in their own community but also in the context of Chilean and Latin American crafts. It means that Ninhue has finally accepted their work officially and after these many years is not only welcoming it but supporting it.

One Last Stitch

One day Julia Ramírez invited me to come see her at the new place her family had acquired after selling their home in Collipeumo. They had chosen a place up a steep path on the southern slope of the hill of Ninhue. This part of the hamlet was unknown to me, but as is the case with all its higher elevations, the view was spectacular. I love these views and seek them out wherever I can find them.

Julia and I sat under the arbor adjoining her house, and since I had never seen her stitch, I asked her to show me how she had created a particular textured effect that showcases her turkeys. She graciously shared her technique with me and after a while she told me she wanted to show me something else. She led me toward the edge of her property and invited me to look some distance below, where a sizable, well-tended young vineyard grew on flatter land.

I looked at her, and she held my gaze and explained, "I brought them from over there," gesturing toward Collipeumo, "from the vineyard over there." She was referring to the original plants my grandfather had imported from France and established at Collipeumo.

My eyes clouded. That's it, I thought: cherish, preserve, transplant, transform—quietly within the fluctuations of time. Julia had just revealed to me how she had extended, simply and firmly, my ancestors' and my brothers' legacy.

That night, falling asleep in the snug bedroom of Ema and Filomena's friendly, welcoming home, listening to the ebb and flow of country

noises as they played alongside the receding sounds of the village, I slowly realized that I, too, had been transplanted from Coroney to Ninhue for no other purpose than to become firmly grounded again and to be able to give thanks.

Epilogue
The Severed Threads

In early 1971, when CORA (the Commission for Agrarian Reform) decreed Ninhue County as a massive expropriation zone, a subterfuge was engineered that allowed the expropriation of many farms without conceding legal reserve status to the owners.

The 1,800 hectares (approximately 4,500 acres) of the Hacienda Collipeumo that were expropriated from my family were never paid for in their entirety. My brother Juan bought 60 hectares (approximately 150 acres) on the outskirts of Chillán that he later increased with the sale of the land that was partially restored to him from Collipeumo under the military government of General Pinochet. The workers who were granted the carved-up pieces of Collipeumo incurred oppressive debt, which ultimately led them to sell their shares. In the end, they abandoned the land, leaving the farm in the hands of a single owner until his death. In 2006 it was sold to a forestry corporation that removed the vineyards to plant pine trees.

Although the land reform law under the government of President Frei (who governed in the mid-1960s) had declared the Hacienda Coroney exempt from expropriation, its 2,476 hectares (approximately 6,119 acres) were expropriated in toto with no recourse for appeal. An arbitrary sum was offered for the land that did not correspond to its actual commercial value. Therefore, years later, my brother Federico was unable to claim fair compensation retroactively because the government deemed he had already received compensatory payment for the land.

The present owners of Coroney constituted a society of some twenty-three members with plots averaging 46 hectares (approximately 114 acres) each. Some members are descendants of the old families that lived and worked at Coroney plus a few outsiders who came in and shared in the land distribution. They own a few animals, cultivate wheat and legumes, and tend the vineyard but produce no wine. As the years have passed, they have sold the hill of Coroney to a forestry corporation that has replaced the native forest with pine and eucalyptus trees. They have sold smaller lots as well. The family house, which still stands, is well taken care of and appreciated.

Acknowledgments

It has been a pleasure to write this book. It could not be otherwise when it is about people I love and when I have been surrounded by people who love what the embroiderers of Ninhue do, demanding that I tell their story.

Friends—some of them collectors of the embroidered work—have supplied me with helpful advice and insightful critique at all times. I am grateful to Paula Duggan, who insisted I incorporate my personal memories of Coroney as background to the story. I thank Alfonso Montecino, Malcolm Brown, and Angela Pérez Casado for reading the book and Milagros Sánchez de la Cuadra for her enthusiastic support and help in translating an earlier version into Spanish. I also thank Ünni Rowell for her critique. Siri Montecino, an admirer of Úrzula Manríquez, is to be thanked for identifying her mysterious two-headed figure; also Lucía Wrestler for her infinite patience in typing every change and addition to the book; and to John Clower for reading the book and finding me the best and most sensitive editor, Eric Metzler. Eric is a writer and an instructor at Indiana University. He speaks Spanish, is familiar with the risks and practices of farming, and appreciates textiles. In short, he is a luxury editor from that magic circle of Ninhue helpers who have always sprung to my assistance. Eric has metamorphosed my "English" into English and tidied up (his explanation!) its construction. Further, he has mollified my Hispanic exuberance with such tact and felt his way into

the subject matter so that I have experienced no sense of intrusion but instead an insightfulness that has clarified the text.

Jean Druesedow, who has kept an eye on the Ninhue project since its birth and collaborated with invaluable suggestions periodically, is, in fact, the godmother of this book, as she brought it to the attention of Texas Tech University Press for publication. The preparation of this book has been a most rewarding learning experience, thanks to the constant help and caring suggestions of editor in chief Judith Keeling and managing editor Karen Medlin. They have helped greatly in shaping this publication, and I am most grateful to both of them and their staff. I also thank Shehira Davezac for her perceptive eye in assisting me with the difficult choices of illustrations I had to make. To Linnea Fredrickson, my copyeditor, my thanks and admiration for her sensitive suggestions, impressive organization, and acute eye for detecting errors. Peggy and John Woodcock are also to be thanked for a last-minute photography session of three-dimensional figures. To Justin Goodwin and Nova Crevier at Quick Pic I owe special thanks for their excellent photographic work over the years.

It was an indebtedness to family that inspired the Ninhue adventure in the first place, and the memory of my late brothers Juan and Federico especially sustained me in my writing. My brother Felipe and my immediate family—above all Juan, my husband; Francisca, our daughter, and her husband, Julio Alamos; our sons, J. Cristian, J. Felipe, J. Miguel, and J. Matias; and J. Matias's wife, Beverly Colin, and our grandson Daniel and Jean Schelm-Blackwell, his mother—have cradled every aspect of this work from the beginning. Their involvement has contributed to the molding of this narrative. Special thanks to Beverly and Matias for their support in making this project more visually appealing.

I want to add that some years ago, when I began to write this book, I was at a loss as to how to give it shape. Serendipitously once again, I laid hands on Julia Cameron's book *The Artist's Way*. For months, I surrendered to her early morning writing exercises, which set me on my way with joy and assurance. To Julia, my deepest thanks.

Notes

1. The *Diario Oficial* publishes all new laws and decrees. The Itata district is situated in the province of Ñuble, now called the VIII Region.
2. *Espinos* are thorny native trees that bloom with fragrant, puffy, ochre flowers in the springtime.
3. "El Camino Real" translates as "the Royal Highway." It was the main road running north to south in Chile.
4. *Torito* ("little bull") is a common adult-child game in which the adult expresses affection by gently butting his or her head against the child's while saying "*torito, torito, torito.*"
5. "Tweeds" was the name we used to describe the twilled woolen fabrics woven solely for home use by Tía Elvira.
6. "Filed" bread is fresh baked with a scored top crust that allows the soft center to better absorb butter. *Natas* is boiled cream.
7. This fantasy was suggested by an illustration in a Spanish storybook, *Bertoldo y Cacaseno*.
8. *Comadre*, literally "co-mother," and *compadre*, literally "co-father," are names by which godparents and parents address each other.
9. *M'hijita* literally means "my little daughter," but here it is used more in the sense of the endearment "honey."
10. Filomena insists that things happened differently. According to her, when she saw me entering the village, she recognized me and went out to greet me, and I informed her of my project.
11. "Santiaguinas" are women from Santiago, and "La Hebra," the name of the group, means "thread" or "fiber."
12. Straight stitch also produces a painted effect, but the women of Ninhue did not employ this stitch, or the satin stitch, because these required the use of an embroidery hoop, which they had avoided using. However, the increasing demand for embroidered sheep has convinced the women of the advantage of using a hoop. By tracing a series of sheep figure halves on a large cloth, they can work the French knots faster and more easily.
13. *Cuelcha* is a straw braid used to make straw hats or bags.
14. The definition of *monos* is "monkeys," but in this context the word carries a slightly derogatory tone and refers to imperfect depictions or representations.
15. Three hundred to three hundred fifty pesos was about ten dollars then.
16. The pricing method based on a tapestry's size and amount of stitchery is no longer used. Tapestries are now valued based on their intrinsic artistic content.

17. The "popular art form" is in reference to Violeta Parra's original designs portraying aspects of her life. Violeta Parra is a Chilean icon. Born in Chillán, she was a magnificent, multifaceted artist—a poet, singer, guitarist, researcher of oral tradition, potter, and tapestry embroiderer who depicted the joys and struggles of the dispossessed.

18. *Puebla* is the name given to a small farm property consisting of a main house surrounded by separate buildings such as a kitchen, outhouse, and barns.

19. The title of this piece plays on the Spanish word *parra*, Adela's family name and also the Spanish word for (grape) vine.

20. In this context, *monos* means "cute little things."

21. In Chilean Spanish, *huasos* are "cowboys" and *chinas* are their "companions."

22. A *trilla* is an old-fashioned method of threshing wheat using horses.

23. "Mapuche" is the name of the indigenous Chilean people.

24. The Ferias Artesanales is an arts and crafts fair featuring various Latin American crafts. Lorenzo Berg, a well-known authority on native crafts, was its creator. He was pivotal in getting this particular festival off the ground.

Sources and Further Reading

Clabburn, Pamela, and Helene Von Rosenstiel. *The Needleworker's Dictionary*. New York: Morrow, 1976.

Collier, Simon, and William F. Sadr. *A History of Chile: 1808–2002*. 2nd ed. New York: Cambridge University Press, 2004.

Davis, Mildred. *The Art of Crewel Embroidery*. New York: Crown, 1962.

Eaton, Jan. *The Complete Stitch Encyclopedia*. New York: Barron's Educational Series, 1986.

Enthoven, Jacqueline. *The Stitches of Creative Embroidery*. New York: Van Nostrand Reinhold, 1964.

Felcher, Cecelia. *The Needlepoint Workbook of Traditional Designs*. Stroud, U.K.: Hawthorn Books, 1973.

Gostelow, Mary. *Embroidery: Traditional Designs, Techniques, and Patterns from All Over the World*. London: Marshall Cavendish, 1977.

Loveman, Brian. *Chile: The Legacy of Hispanic Capitalism*. 2nd ed. New York: Oxford University Press, 1988.

Markrich, Lilo. *Principles of the Stitch*. Chicago: H. Regnery, 1976.

Paine, Sheila. *Embroidered Textiles: Traditional Patterns from Five Continents, with a Worldwide Guide to Identification*. New York: Rizzoli, 1990.

Sagredo, Rafael, and Cristián Gazmuri, eds. *Historia de la vida privada en Chile: El Chile contemporáneo de 1952 a nuestros días*. Santiago: Aguilar Chilena de Ediciones, 2007.

Saint-Aubin, Charles Germain de. *Art of the Embroiderer*. Translated and annotated by Nikki Scheuer. Additional notes and commentaries by Edward Maeder. Los Angeles, CA: Los Angeles County Museum of Art, 1983. Originally published as *L'art du brodeur* (1770).

Smith, Barbara Lee. *Celebrating the Stitch: Contemporary Embroidery of North America*. Newtown, CT: Taunton Press, 1991.

Synge, Lanto, and Royal School of Needlework. *Art of Embroidery: History of Style and Technique*. Woodbridge, England: Antique Collectors' Club, 2001.

Watt, Melinda, and Andrew Morrall. *English Embroidery from the Metropolitan Museum of Art, 1580–1700: Twixt Art and Nature*. New Haven, CT: Yale University Press, 2008.

Willson Aedo, Angélica. *Textilería Mapuche: Arte de mujeres*. Santiago: Ediciones CEDEM, 1992.

Wilson, Erica. *Crewel Embroidery*. New York: Scribner, 1962.

———. *Erica Wilson's Embroidery Book*. New York: Scribner, 1973.

Index